Get **more** out of libraries

Please return or renew this item by the last date shown.
You can renew online at www.hants.gov.uk/library
Or by phoning 0845 603 5631

APRIL 2014

Hampshire
County Council

Bird Photography

Choosing the best destinations • Planning a trip • Taking great photographs

Bird Photography

Choosing the best destinations • Planning a trip • Taking great photographs

David Tipling

photographers'
pip
institute press

First published 2005 by
Photographers' Institute Press/PIP,
166 High Street, Lewes,
East Sussex, BN7 1XU

ISBN 1 86108 302 5

Production Manager: Hilary MacCallum
Managing Editor: Gerrie Purcell
Editor: Clare Miller
Designer: Fineline Studios

Typeface: Neo Tech

Colour origination by Icon Reproduction

Printed and bound by Hing Yip Printing Co. Ltd.

Foreword

David Tipling's name first came to my attention in the late 1980s, when he started submitting photographs of rare birds to the newly-launched monthly magazine Bird Watching, which I was editing. The magazine's stock-in-trade was to provide practical advice for active birdwatchers, plus topical information and photographs of significant species.

He was the youngest member of a trio of bird photographers – the others were David Cottridge and Tim Loseby – who were prepared to travel the length of the UK to the sites where twitchers clustered to get a sighting of the latest avian waif to arrive on our shores.

David and his colleagues were the prime sources of images for news-hungry bird magazines and journals, but to help pay the bills they also sold prints of the rarities to the twitchers who had neither the skills nor the equipment to take their own photographs.

Of course, David moved on in his career to become one of the nation's most respected wildlife photographers, but it is interesting to compare that early part of his career with the current birding scene. Today, the advent of digital photography and digiscoping (attaching a digital camera to a telescope) has spawned an army of enthusiasts who are now capable of capturing frame-filling images of the smallest birds.

Every week my magazines are inundated with CDs of images or e-mailed jpgs sent in by eager amateurs hoping their work will be selected for publication. Already, many of them show a high level of proficiency, but I'm confident that reading this book will encourage them to stretch their thinking to reach new levels of creativity and technical competence.

It would be wrong to think this is the basic 'how to' primer. David is aware that bookshops are already laden with instructional books aimed at complete beginners. Within these pages he is striving to share with others his own personal response to the task of creating memorable images of the marvellous birds that share our world.

He also highlights some of the places he has visited in his photographic career and offers advice on how to make the most of your visit if you plan to follow in his footsteps.

Some people will argue that photography lacks the individuality exhibited by painters. They argue that any two people pointing a camera at the same scene will end up with indistinguishable images, but as you read the pages of this book you will gradually come to a very different conclusion. It may take a fraction of a second to press the shutter, but the most successful photographs are the product of much thought, planning and patience.

The fact that modern-day photographers can enhance their images on a computer instead of in a darkroom opens up all sorts of possibilities for increasing the uniqueness of the photographer's vision. David shows that it is possible to produce commercially appealing work without betraying the trust that needs to exist between creator and viewer that the picture is true to nature.

On every page David provides a mass of useful tips and insights, but I feel the real strength of the book is the fact that the author's passion for birds and photography come through so strongly. I'm sure you will find it an inspirational read and even if you only apply a handful of the techniques and visit a fraction of the sites mentioned within these covers, I feel certain your photography will be lifted to a new and higher plane.

David Cromack
Editor of Bird Watching and Birds Illustrated magazines

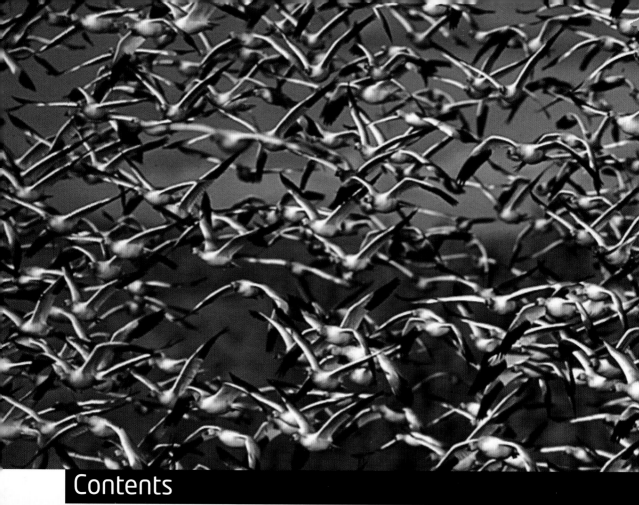

Contents

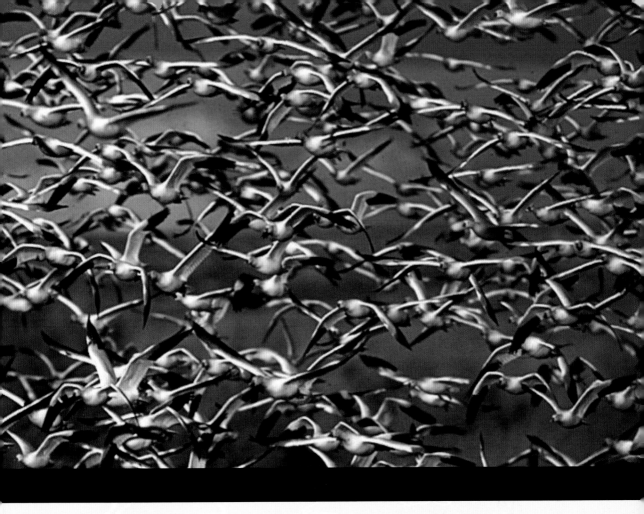

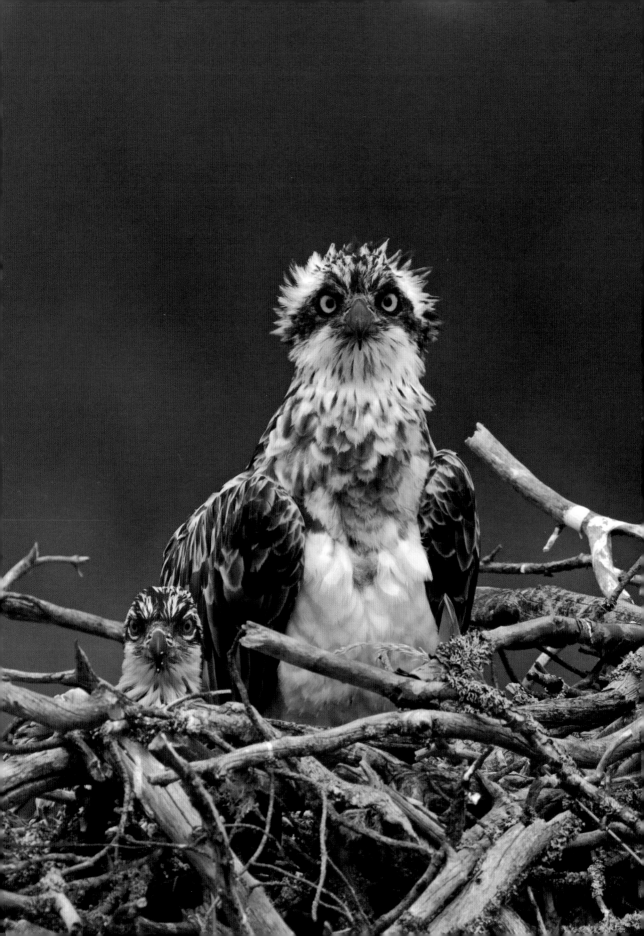

Introduction

My thirst for photographing birds has been with me since I was a teenager. It is a passion; quite simply it dominates my life, and although I like to think I lead a balanced life with a healthy interest in much outside of photography and birds, it is never far away. If I go a few days without taking pictures, then I suffer withdrawal symptoms as though denied a fix. I know I'm not alone; most who enter the world of bird photography become pleasantly addicted.

There are many reasons why people choose to photograph birds – from satisfying a hunting instinct to following a creative urge. To photograph birds in the wild is an art that has to be learnt. Many of the finest bird photographers' careers began with an interest in birds. Having an understanding of how birds behave brings with it far greater opportunities. You only have to look back 100 years to the days of the Kearton brothers, RB Lodge, Bentley Beetham and others for examples of this. The equipment they had at their disposal makes the photographs they produced seem even more remarkable, but it was their sound background in their chosen subject that enabled them to produce such excellent results.

Since I started photographing birds some 25 years ago, many technological advances have aided the process. Colour film emulsions have steadily improved, effective autofocus systems have revolutionised action photography, and most

recently the digital age has dawned. Digital cameras combined with the lenses now available are helping images to be created with an ease that once took much planning, perseverance and luck.

My aim when photographing birds is to create images that are visually arresting, whether I succeed is down to the viewer - as with any art form, it is subjective.

The first half of this book explains how I go about doing this. I hope, over the following pages, you will get a feel of how I view the life of birds through a lens. The second half of the book is a guide to offer inspiration and advice on where to go and what is possible, drawn from my own experience.

All the images in this book are as I viewed them through my camera and, unless stated in the captions, are photographed in the wild. I have not manipulated any, and although I can see a place for creating a 'perfect' image by combining it with others or changing elements in the picture, I believe that to do so could damage the integrity of wildlife photography.

If a photographer routinely manipulates their images, then in my view the integrity, and therefore much of the appeal, of the scene represented is lost. Furthermore, if the photographer is not enirely open when using such practices, it could be suggested that the viewer is being somewhat cheated.

Left **A female Osprey and one of three young peer at my hide from their tree-top nest. Taken in Finland, the female is actually staring with menace at a Raven that had landed on the roof of my hide.**

Kodak DCS Pro 14n with 500mm lens and 1.4x teleconverter, 1/180sec at f/11, ISO 250

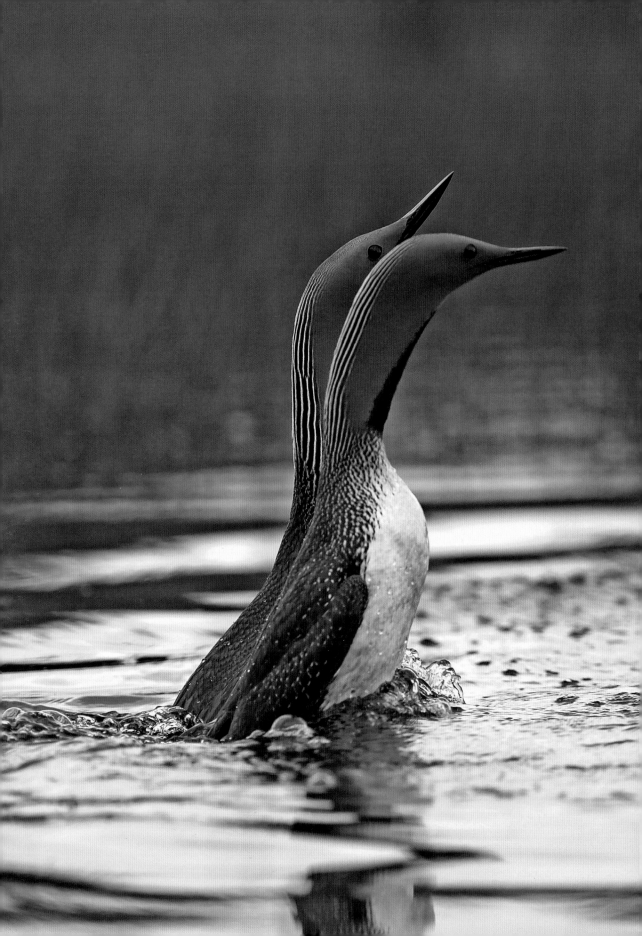

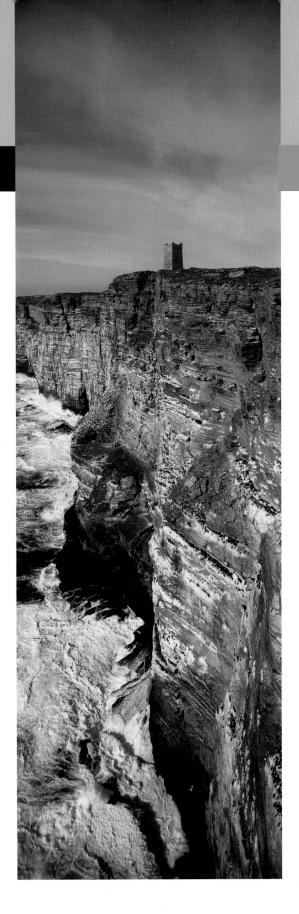

Chapter 1 Entering the world of bird photography can seem daunting, with so many important decisions to be made as to which equipment is best for the job.

Equipment

For bird photography, what you do need is an SLR (single lens reflex) camera rather than a compact. The main advantage of an SLR is its versatility, ease of handling, and capacity to use a wide range of lenses, partcularly long telephoto lenses. Although there are lots of compact cameras around with great zoom lenses, they will not deliver the versatility required for bird photography. The early bird photographers used huge plate cameras and moved through other cumbersome setups as cameras developed. Some still do use medium-format systems, and although this system may produce superior results, with today's film and digital technologies, these advantages are marginal at best, while an SLR system is normally smaller, lighter and easier to operate.

The next big decision is how much to spend and which system to go for. When I started, Olympus manufactured great camera bodies and lenses for wildlife shooting. Since then Nikon and Canon have come to the fore and, although their systems are not cheap, they offer the most complete range of

Left **A pair of Red-throated divers display on their breeding pool in Finland. Bird Photographers are often privileged with moments of rarely seen behaviour, such as this graceful courtship dance.**

Kodak DCS Pro 14n with 500mm lens, 1/350sec at f/4, ISO 320

Right **For me, cameras and lenses are just tools. I take pictures because the pursuit takes me to places such as this; the seabird cliffs at Marwick Head on Orkney.**

Fujifilm GX 617 panoramic camera with 90mm lens, 1/60sec at f/8, Fuji Velvia 50, neutral-density centre-spot filter

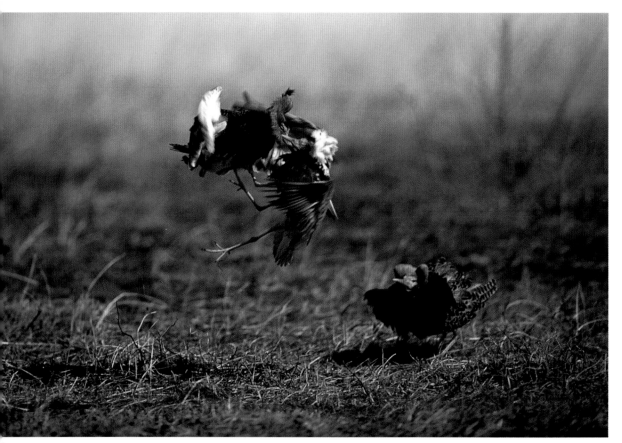

Above **When choosing a camera, how many frames per second and with digital how long it can continue this sequence for are important considerations if you intend to attempt to capture images such as this one. This action shot of two Ruff fighting at a lek in Finland was the result of half a roll of film shot in around three seconds, with this being the best image.**

Nikon F5 with 500mm lens, 1/1000sec at f/4, Fuji Sensia 100 pushed 1 stop

lenses, and are at the cutting edge when it comes to introducing new technology. The products each of these manufacturers offer are very similar and opinion differs as to which is best. Which make you go for is a matter of personal preference but it is worth bearing in mind that ultimately it is the person behind the camera and not the equipment that will take great pictures.

So what should you look for in a digital or film SLR body? There are so many custom settings and modes that choosing a body might seem daunting. Ignore most of these as you will not need to use much of what is offered. There are only a few really important points to consider.

Firstly you should be sure that the camera feels comfortable in your hand with a long lens on it. Photographing birds in flight requires a good autofocus system, which should be both accurate and fast, however you should also be able to switch easily to manual focus if you need to use it. Also check that the frame or burst rate (how many frames per second the camera shoots) is enough

to capture action sequences. Whatever body you choose, make sure that it has a depth of field preview button to allow you to see how much of your subject is in sharp focus, a useful tool if photographing big birds closeup, or checking to see what a background will look like in the finished picture. (Depth of field is covered in more detail in chapter 2, page 28.) Finally you should also consider the build quality of the body especially if you are going to take your camera to some extreme situations.

Digital cameras

Digital photography is the future and is not as daunting as it might first seem to a photographer unfamiliar with its jargon. If you are just starting out then I would say bypass film altogether and start as a digital photographer. Digital now has so many advantages, not least the ease of reviewing captured images instantly, thus making learning your craft a faster and arguably more enjoyable experience. Choosing a digital SLR body is a little more involved than choosing a film camera.

There has been a fair amount of misinformation about the pros and cons of digital photography. The fact is that digital photography is the future, and is a very effective weapon in a bird photographer's armoury. It could be argued that digital capture has been the biggest revolution in photography since the advent of colour film.

So what is a digital image? Put simply, it is a string of binary code which, when translated by software, reproduces as an image. This image is captured by a sensor, which sits in the same place as film would in a film camera. The sensor is an array of light-sensitive photodetectors (normally numbering millions), the output from each of which is commonly known as a pixel. Each pixel is a value for the intensity of the light falling on the photodetector, which is often filtered to either just red, green or blue light. The information from each pixel is then interpolated to give a full colour value for each pixel (although there is an exception, of which more later).

The number of pixels in an image is known as the resolution, normally given in milions of pixels or megapixels (mp) or as the sides of a grid, for example a 13.5 megapixel image is 4500 pixels wide by 3000 pixels high or 4500 x 3000 pixels. The higher the resolution (the more pixels your sensor produces), the more detail there is in your captured image. This means that an image from a high-resolution sensor will generally be of better quality than one from a low-resolution sensor, particularly when reproduced at large sizes. There are exceptions to this rule, as some SLR cameras produce superior results to compact cameras that have much higher resolutions due to the quality and size of individual pixels.

However don't get too caught up with this anomaly; the basic fact is that the higher the resolution the bigger a picture can be printed without showing individual pixels, or 'pixellating'.

How you use your images will determine the resolution you will need from your camera. If all you want to do is print up to A3, then a 5mp camera may be adequate; if like me you want to produce fine art prints perhaps to A1 or A0 in size, then an 8 or 10mp plus camera will be required.

You can make an image file bigger by a process known as interpolation. Pictures captured digitally interpolate better than those captured on film. The basic idea is that the computer adds pixels to the image by sampling original neighbouring pixels. In my view, interpolated data can never be quite as good as raw data, however interpolation programmes are now so good that being able to spot a difference is a challenge.

When you read the specifications of a digital SLR (D-SLR), you will notice some bodies have a different type of sensor from others. There are two main sensor types: CCD (charge-coupled device) and CMOS (complimentary metal-oxide semiconductors). CCD sensors tend to use more battery power than their CMOS equivalents, but other than that there is little difference for you to be concerned with. Currently the vast majority are Bayer Mosaic sensors, so-called because their photodetectors are displayed in a grid system underneath a mosaic of colour filters

Recently a new CMOS-type sensor, the Foveon, has arrived on the scene, and this could well become the sensor of choice in the future. The reason for my enthusiasm for this new sensor is that the Foveon has three separate layers of photodetectors embedded in silicon, with each

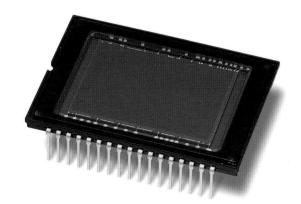

Right **The heart of a digital camera is the sensor. The quality, size and type makes a huge impact on the final image so choose carefully.**

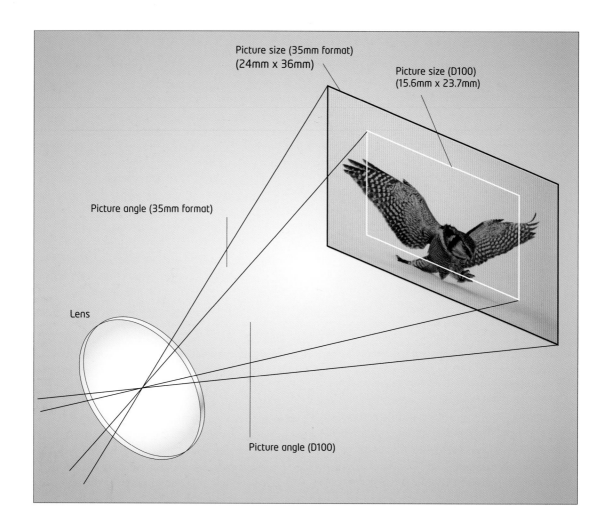

Picture size (35mm format)
(24mm x 36mm)

Picture size (D100)
(15.6mm x 23.7mm)

Picture angle (35mm format)

Lens

Picture angle (D100)

layer capturing a different primary colour, so each pixel produced is a full-colour pixel, rather than coated in one colour as in the Mosaic system. This in theory should produce an image with more accurate colour detail.

Different digital cameras use a range of different sensor sizes. Generally the most expensive type replicates the format of a 35mm film frame; these are known as full-frame sensors. Far more common are cropped sensors of various sizes that are smaller than a 35mm frame. A cropped frame sensor, when used with a particular lens, decreases the angle of view with a similar effect to multiplying the effective focal length of that lens. With the most common type of cropped sensor this effect is typically 1.5 times, therefore your 500mm lens has a similar effect to a 750mm lens used with

the 35mm format. The advantage is that – unlike when using teleconverters – you retain the lens's maximum aperture enabling faster shutter speeds.

A final consideration with digital cameras is the burst rate and depth. The burst rate is the number of frames per second that a camera can shoot while the burst depth is the number of frames you can shoot before the camera's buffer (internal memory) fills and prevents you from firing any more shots, or the burst rate slows significantly. That is, until enough images have been processed to free up more space. If shooting an action shot such as birds in flight, then the burst rate may be important and for long sequences the burst depth will be as well. As technology continually improves such constraints are diminishing, but they are certainly worth bearing in mind.

Above **You may not have to worry about film with digital, but a laptop computer or portable downloader or even both can be essential when travelling.**

Digital storage

Once your camera has processed the image it has to be stored. Before you download your images to a computer, they are stored on a removable and reusable card within your camera, known as storage media or memory cards. They come in a wide variety of types, the most numerous of which is a CompactFlash card (CF card). The type of card that you require depends on the type of camera you use; however some will offer you a choice.

Although the type of card is determined by the camera, cards come in various sizes and speeds so you will still have to make a choice. The minimum capacity I would advise is a 512MB card, while I use 1 and 2GB cards. The larger the card the more images you can shoot without having to change cards or download. Also, the faster your card is the better your camera's performance will be. Look in the back of your camera's manual to see what the manufacturer recommends for use with that model.

The next stage is to download your images to a computer. There are different ways of doing this. If you are on a trip, or shooting lots of images during the day, having a portable downloader that fits in a pocket is a good option. This can then be plugged into your laptop or workstation, once shooting is over. These devices are made by many different manufacturers, all are quite similar, some have very good screens that allow you to review your images and do some limited editing. Other options are to plug your camera directly into your laptop or workstation with a supplied USB or Firewire cable. This is often considered the least attractive option due to the danger of damaging your camera connection. For PC laptops a PCMCIA adaptor can be used, which slots into a port on the side of a computer. These are cheap and work quite well.

However the most popular and fastest method is to use a card reader. I use a Universal Card Reader, and this is a trouble-free way of downloading. The card simply slots into the reader which is a small box, which in turn is plugged into a computer, and the pictures are then downloaded.

Lens choice

Next up is which lenses to acquire. You will have one main lens that will act as your everyday bird photography lens, the one you will use for 80 per cent of the time. This should be long enough to capture good sized images of small birds in the frame, but not so big that using it is a major drama. During the 25 years I have been shooting birds I have chopped and changed, but only very infrequently, when some new technological advantage has come along. For many years I used a 300mm f/2.8 lens with teleconverters, before reverting to a 600mm and then a 500mm lens, my current lens.

Below **With the advent of the medium length anti-vibration zoom lens, handholding is a viable option. However in most situations there is no substitute for a good steady tripod.**

When deciding what to buy, there are three main considerations to take into account. They are the focal length (and therefore the magnification you will achieve or how far away you can capture your subject from), the size of the maximum aperture and the weight.

The higher the focal length the higher the magnification of the subject from any given distance. This means that the subject will either appear larger within the frame or you can capture a similarly sized image from further away.

A wide maximum aperture (a low f-number such as f/2.8) enables you to obtain very shallow depth of field that can be used to isolate the subject from its surroundings. It also allows the use of relatively fast shutter speeds which can be used to freeze the action, often even in lowlight. However, the larger the aperture, the larger the glass elements in the lens, and so usually the heavier and bulkier it will be. Lenses with wide maximum aperture are also relatively expensive, particularly long telephoto lenses, so a compromise is necessary, which is why I use a 500mm f/4 lens. It is light enough to carry all day, and because it has a maximum aperture of f/4, I can keep relatively fast shutter speeds even when using teleconverters.

Different photographers will give you different reasons as to why one particular lens is better than another. Just remember that if you find it is so heavy and cumbersome that it makes carrying it a chore, then the chances are that your photography will suffer.

The first choice is between a zoom or fixed focal length (prime) lens. A zoom gives flexibility in lots of situations, the main disadvantage is that they rarely exceed 400mm. Having said that, if, for example, you are using a 200–400mm f/4 lens with a D-SLR that has a cropped sensor, this can effectively give you a 300–600mm f/4 lens, which is an awesome combination for birds. If however you are using a film camera or full-frame D-SLR, I would suggest going for a 500mm or 600mm lens. Very few serious bird photographers use anything less than a 500mm lens. The alternative is to do as I did and go for a 300mm f/2.8 lens. If you like shooting other wildlife this is a very useful lens as coupled with teleconverters, you have a 300mm, 440mm and 600mm range, and of course with a D-SLR even more reach.

The introduction of anti-vibration lenses, has helped enormously in attaining sharp images when camera shake might otherwise be

Above **Whenever I am out shooting birds I always have a short lens with me. This vagrant Baillon's Crake turned up in a park in the middle of Sunderland, UK one May. Hundreds, if not thousands, of people enjoyed seeing this bird, which seemed oblivious of it's admiring crowd. With my wideangle lens I stood back to take this image which helps tell the story.**

a problem. Particularly when using teleconverters with longer lenses. A 500mm anti-vibration lens plus a 2x teleconverter is a formidable setup for photographing hard-to-approach species.

However, anti-vibration lenses although attractive are not a necessity. You can live without them, and my longest lens does not feature anti-vibration technology. You should remember that they will help prevent camera shake, but will not stop the movement of a bird – you still need a fast enough shutter speed to stop motion. They also use up power more quickly and add bulk and weight to the lens.

Teleconverters

A teleconverter is a small optical device that is placed between the body of the camera and the lens in order to increase the lens's focal length. They can be really useful, especially if you can't

afford a long telephoto lens. Remember that the teleconverter must be both compatible with the lens and with the camera, as some combinations either may not fit or may not retain all of the camera's functions. The most common teleconverters are 1.4x and 2x teleconverters. These magnify the focal length so that, for example, a 300mm lens becomes a 440mm or 600mm lens. However, there are two disadvantages to using teleconverters. Firstly, a cheap teleconverter may cause the image quality to deteriorate. Secondly, they decrease the maximum aperture. Assuming that the same 300mm lens has a maximum aperture of f/2.8, using a 1.4x or 2x teleconverter will cause this to narrow to f/4 or f/5.6 respectively. This means that the minimum depth of field will not be so shallow and the maximum shutter speed available will be slower.

Tripods

One final item of gear, the tripod, is usually the item that beginners end up compromising on, whether on cost, weight or both. This is a false economy as a good sturdy tripod equals sharp pictures. Camera shake may be your worst enemy when using your biggest lens. Many bird photographers, especially in the USA, use the Wimberley head on their tripod. This allows a long lens to pivot and move in both the horizontal and vertical axis with little resistance. It is a great piece of kit for action photography. However it is heavy and requires a very sturdy tripod. For my taste it is too heavy to carry all day, but if your photography never takes you too far from a vehicle it might well be the head for you. An alternative, which is lighter and almost as effective, is the Sidekick, a small simplified Wimberley that behaves in the same way. This attaches to a ballhead, giving the added advantage of having a ballhead available for other subject shooting.

I use an Arca Swiss ballhead and for flight shots I hand hold my lens. There are a couple of other alternatives, the traditional pan-and-tilt head that I used for years and, the same design in principle, the fluid or video head. I have tried the latter and could not get on with it. They allow smooth panning and good firm support. It is worth trying the various options before buying.

Whatever combination you decide, you should ensure that your tripod legs and head are big and sturdy enough to take the weight of your heaviest camera and lens combination. There are some good carbon fibre tripods, they are light and sturdy, but this convenience comes with their much higher price compared to traditional metal based designs.

When choosing a set of tripod legs, I would suggest going for a model that does not have a central column, and which allows its legs to be spread at right angles. This is a great attribute for lying down and taking low-level shots. The ability to spread the legs of your tripod is a big help if you find yourself perched on a steep slope, or other uneven ground.

My choice is a metal Gitzo, and in a 15-year professional career, during which my tripods have travelled the world, I have only replaced them three times, testament to how tough and reliable they are.

How you decide to attach your lens to your tripod head is important, as when speed is required pictures can be won or lost. All of my lenses have quick-release plates attached to them that fit a quick-release head. This means I don't need to laboriously unscrew a lens when changing, and it means that if I have the camera fixed to a tripod and a flying bird comes into view, I can immediately release camera and lens for hand-held flight shots.

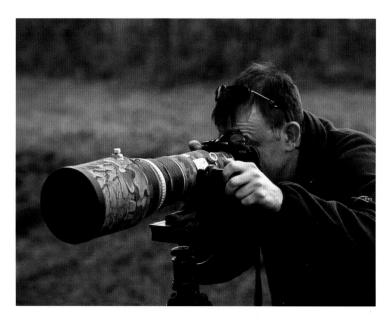

Left **The Wimberley head comes into its own when tracking flying birds with a big and heavy telephoto lens.**

What's in the bag?

Over the years I have accumulated a vast array of lenses and accessories. For travel, a compromise on what to take has to be made. I limit taking only what I can carry in my photo backpack. In addition a spare camera body is packed securely in my suitcase.

With the exception of the tripod and spare camera body and laptop, all my kit fits into a photo backpack, which is designed to fit under an aircraft seat. The two zoom lenses cover most eventualities, enabling me to shoot habitats and work with very tame birds.

Life is getting easier all the time as far as equipment choice goes. With technology advancing all the time, cameras and lenses are becoming lighter. Lenses are also becoming more versatile, particularly with the new super telephoto zooms that a range of manufacturers produce.

Basic travelling kit

○ two camera bodies

○ waist level viewfinder

○ 17-35mm lens

○ 70-200mm lens

○ 500mm lens

○ 1.4x teleconverter

○ flash gun

○ tripod and head

○ portable downloader and laptop computer

○ spare batteries

○ 4 x 1GB CompactFlash cards

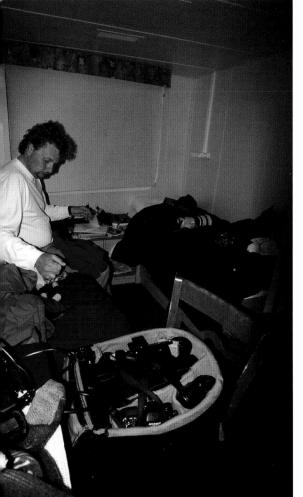

Handy extras for the bag

Apart from the photo gear there are a few handy extras I always pack. A roll of duct tape is likely to get used at least once on a trip. It is useful for tripod repairs, holding cameras or lenses together, attaching props; the list is endless. Large Ziploc bags are very handy for protection of equipment against dust and storing exposed film. Similarly large rubbish bags are another essential, especially useful for putting over your lens and tripod in wet weather. Jewellers' screwdrivers have been known to save the day when vital bits on cameras or lenses have loosened after long journeys on bumpy roads. Finally pack a set of adapter plugs, so that cameras and other paraphernalia can be recharged when necessary.

Left **I'm pictured here sitting in my shared cabin on the icebreaker The Polar Star, on a trip down to the Antarctic. The kit I took for this trip can be seen on the bed next to me.**

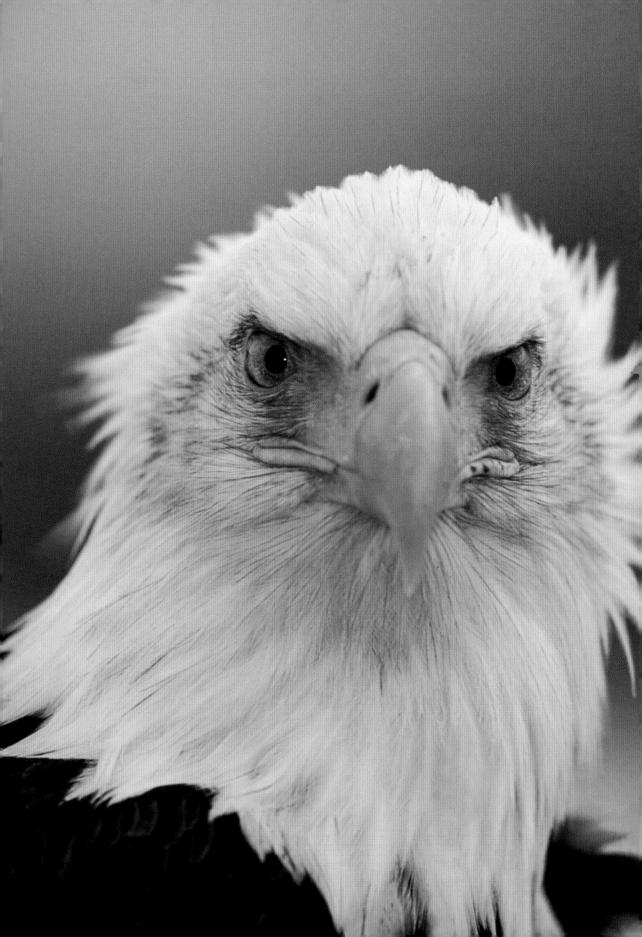

Techniques

Focusing

When looking at pictures of birds, we are often drawn to the subjects' eyes. If on a portrait the eyes are out of focus, the picture will rarely, if ever, work. Therefore it is usually effective to make the eye your point of focus.

For anyone with less-than-perfect eyesight, autofocus is a huge help. It can also be very useful when photographing birds in motion, especially when they are flying. Most cameras have a number of points within the viewfinder that can be individually selected and used to autofocus. While it may seem straightforward to use the central point, this often leads to poor composition; a picture of a bird stuck bang in the centre of the frame rarely works well aesthetically. In general I use manual focus unless I am attempting to photograph a very active bird or taking flight shots.

Working this way allows me to free up my mind to composing the picture without worrying which bit of the bird the autofocus system is focusing on.

Left **If the beak of this wild Bald Eagle – photographed in Homer, Alaska – had been in focus and the eyes out of focus, then the image would not have had the impact that it does. I don't think it matters that the bill is out of focus, as more attention is drawn to the bird's menacing eyes in this way. This was a conscious choice that I made as I took the picture.**

Nikon F5 with 500mm lens, exposure details not recorded, Fuji Velvia 50

Below **This dramatic image of a Hawk Owl about to swoop on movement detected under the snow has become one of my best-selling images of recent years. To freeze the action I had to use a fast shutter speed, and autofocus was vital to ensure a sharp image. I was able to lock on to the bird's fast straight flight, then keep my finger on the button as it swooped in.**

Nikon F5 with 500mm lens, 1/4000sec at f/4 with Fuji Sensa 400

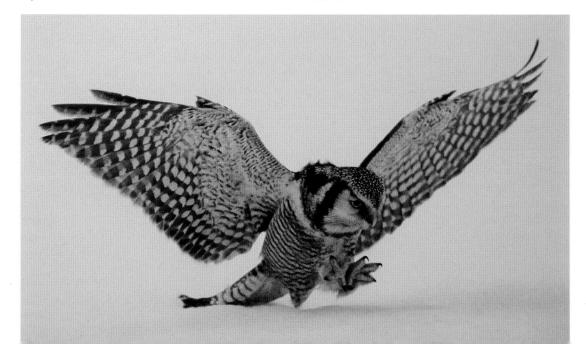

If you don't feel confident to focus manually then, by using the various autofocus sensor points within the viewfinder, a more dynamic looking image can be achieved.

Many lenses and cameras have a focus-lock facility that allows you to use the autofocus to focus on a particular area of the image, then lock the focus in place, before recomposing for a more aesthetically pleasing image.

When you are focusing an image, bear in mind the effect of the aperture that you have selected on the depth of field. For more on depth of field see page 28.

Exposure

In bird photography, there will be times when chances to get a great picture are fleeting, and being able to get it right first time is imperative to secure that shot. You can spend a small fortune on cameras and lenses, then spend the same again on a dream trip to a far-flung corner of the globe, to take those dreamed-about images. So it is vital that you understand how to expose correctly before you find yourself poised to take your sought-after image. Digital photography is a big help as you are able to check exposures as you go.

What is a correct exposure? Quite simply it is producing a picture with your subject rendered in the way you want. Exposure theory is not rocket science, but is often made to sound far more complex than it really is. The basic fact to remember is that there is a reciprocal relationship between your shutter speed and aperture; every time you adjust your shutter speed, your aperture will have to change to keep the overall exposure constant, and if you change your aperture then your shutter speed will have to change to compensate. They are intrinsically linked.

To achieve the effect that you desire you can choose between many combinations of aperture and shutter speed without altering the total amount of light hitting the film or sensor. These effects are discussed in detail in the sections on shutter speed and depth of field (see pages 27–28), but for now here is an example. A Kingfisher lands on a perch in front of your hide, there are no tricky decisions on exposure, all is mid tone so you can take a reading of the scene with your camera's light meter. It tells you that at f/5.6 the correct shutter speed is 1/500sec. However, you don't need such a high shutter speed to freeze motion as the bird is still on its

perch. But what you do want to do is include some of the scene behind the bird, so you need more depth of field than that given by the recommended aperture of f/5.6. By narrowing the aperture (increasing the f-number) to f/8 you are increasing the depth of field and the amount of your subject and scene that will appear in focus. In order to retain the correct overall exposure value your camera will recommend a slower shutter speed of 1/250sec. This means that although you are narrowing the aperture to let less light in, the shutter is open for longer. This is known as the law of reciprocity. The same overall amount of light strikes the film or sensor, so you will still achieve a correct exposure, however, by manipulating the shutter speed and the aperture you have changed the appearance of the image.

One last general fact about exposure before we delve into the detail is that the standard unit of measure is the 'stop'. Every time a shutter speed doubles or an aperture or ISO rating halves, this is a one-stop decrease in exposure. While every time a shutter speed halves or an aperture or ISO rating doubles it is a one-stop increase.

ISO rating

The sensitivity to light (or speed) of a sensor or roll of film is a measurement recognised by the International Standards Organisation, and known as an ISO rating. Daylight balanced transparency films (the kind used by most amateur and professional photographers) are available in speeds ranging typically from ISO 25 to ISO 1600, while most D-SLRs have a range of between ISO 100 and ISO 200 to ISO 1600 or ISO 3200.

The film speed, or D-SLR ISO rating, that you choose, is the basis of your exposure. The higher the rating the more sensitive (faster) the film or sensor is to light, while the lower the ISO rating is the less sensitive (slower) the film's or sensor is. The ISO rating doubles every time the film or sensor's sensitivity doubles, for example an ISO 400 film is twice as sensitive as an ISO 200 film.

Films or sensors with high ISO ratings allow faster shutter speeds and smaller apertures to be used. But there is a drawback, as with fast films – typically ISO 400 and above – you start to notice the film's grain structure in the image. Similarly, with D-SLRs the downside to using a high ISO rating is increased signal noise, which has a comparable effect to grain. The majority of D-SLRs

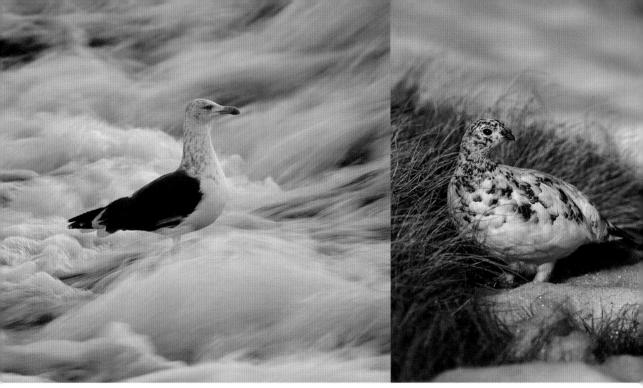

Above left Exposing for this scene was far from straightforward. The Lesser Black-backed Gull is standing in white water, which was fooling my light meter into underexposing. By taking a meter reading off a midtone, which happened to be a house opposite, I was able to keep the white water white and produce a correctly exposed image. If I were taking this image today, I would photograph the bird and the scene, once I had decided on a reading, but would check my histogram on the back of my digital camera to ensure the exposure looked good.

Nikon F4 with 300mm lens, 1/250sec at f/4, Fuji Velvia 50

Above right There will be times when you are in an environment that does not have any midtone objects to meter off. This was the case with this Ptarmigan photographed in the Cairngorm Mountains in Scotland. Even the grass was too pale. Here I used my experience and took a centre-weighted meter reading off the mottled bird, allowing for the darker spring feathers to affect the reading. I then overexposed by 1 stop.

Nikon F4 with 600mm lens, 1/125sec at f/11, Fuji Sensia 100

show very little, if any, discernible noise when used up to ISO 250, while others are good to ISO 400 before noise becomes an issue.

Slower films such as Fuji Velvia 50 have better resolving power, less grain and higher colour saturation than their faster counterparts. Films at around ISO 100 are often best for bird photography, they are fast enough to allow use in most situations and have excellent colour saturation.

Metering

To understand how you arrive at these values in the first place, it helps if you know how a camera's light meter works. It is calibrated to give an exposure reading on the assumption that your subject is a midtone, it measures the amount of light reflected by your subject. Midtone is 18 per cent grey, in other words it reflects 18 per cent of

the light that strikes it. So in assuming the subject is midtone the camera's meter will recommend an exposure to render it as midtone.

This is great for a midtone subject. But what if your subject is an extreme such as black or white? In such cases your camera will give you a reading that will let in the wrong amount of light, making your white subject underexposed and your black subject overexposed, as it will be attempting to turn both these extremes into a midtone grey.

So sticking your camera on automatic and firing away is not a good idea. The way I and many other professionals used to work when using film was by shooting in manual mode, and checking meter readings from the available midtone areas of a scene. This might have been light green grass if not dark green, it might have been the bark of a tree in the same light as the subject. By working in this way, if your subject was not a midtone or was

Techniques

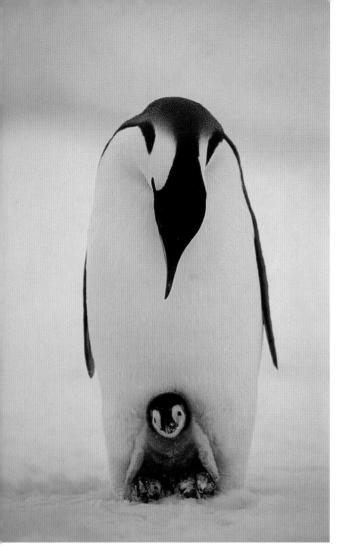

Exposing white and black and working in snow when exposing whites, are some of the biggest challenges for the film-based photographer. No camera manufacturer, despite some of their claims, has ever developed a camera that is foolproof. Light meters in modern-day cameras are excellent and it is comprehending how these work that will give you a basic understanding as to how to arrive at the correct exposure in any given situation.

But what do you do when you have a white swan amongst snow for example? A meter reading from the scene will be way out, as your light meter will be attempting to turn the scene into a midtone grey. Therefore to reproduce the tonal range seen by your eyes and to keep those whites white you have to apply exposure compensation.

Compensation for such scenes is not a science. Different photographers follow slightly different formulas, but all will give you a rough ball-park figure. You need to tell your camera to let in more light, to keep your whites white and prevent them from going grey. I would advise you ignore camera manufacturers claims that their multi-segment metering systems will render whites white in a scene. The fact is they are not that clever, so it is best to take a centre-weighted reading. I would suggest avoiding taking spot meter readings, as the area of the spot is usually so small, that it may be difficult to get a uniform area of the bird, and you need to be very experienced at judging tones.

Be careful to avoid overexposing the scene and letting too much light in as your whites will lose detail, detail which cannot be reinstated at a later date. If using a digital camera this process is made far more simple by ease of checking as you shoot. Many digital users regularly underexpose snow scenes and lighten them later on computer.

Exposing with film

Transparency film is quite unforgiving, so it is important to get it right. My technique is to use the centre-weighted meter, metering off the brightest

in a situation with a light or dark background that could fool your meter, you would have the correct exposure. The trick was to learn what was and what was not a midtone. This process has changed a little since many of us have switched to digital.

The majority of cameras give three metering options: a spot meter, which allows a small percentage of the frame to be evaluated; a centre-weighted meter, which weights its reading in the central area (usually a circle in the viewfinder); and finally a multi-segment meter, which divides the frame into a number of portions and evaluates the whole scene. While the spot and centre weighted options will give you a reading based on a midtone, the way multi-segment metering works depends on how the camera's software computes an exposure value. This is an important consideration when it comes to exposing for whites, one of the bird photographers most troublesome challenges.

white part of the picture that I want to retain detail in, and then 'opening up', meaning letting more light in. The minimum I would normally open up is one or two stops. So in other words, if my meter reading tells me that the brightest part of the swan should be exposed at 1/500sec at f/5.6, I might decide to add two stops of light which would make the exposure 1/125sec at f/5.6.

For black birds use similar but reversed formula, in other words underexpose. If I photograph a crow and want to keep the detail in the feathers I would take a reading from a typical area of the bird where detail is needed and underexpose by between a third of a stop and one stop, depending on the background and tone of the subject.

In such situations it is good practice to bracket, in other words take pictures at exposures above and below the values you think are right, taking notes as you go. With practice you should soon have the confidence to judge exposure in any eventuality.

When photographing a bird in a situation where compensation is needed, you might find that speed is of the essence and you have not got the time to worry about making the right camera settings. Many authors suggest using the camera's compensation dial. This to me seems not only awkward and cumbersome, but confusing too. I find it easier to work in manual mode, and compensate by changing either the shutter speed or aperture. This is less confusing as you can see the effect you are having and you don't have to remember to reset your compensatin dial to zero, when you move on to another subject.

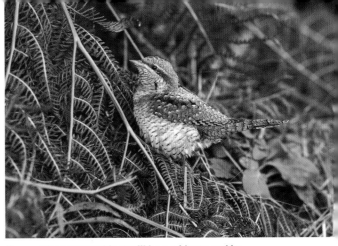

Above **Often your subject will be a midtone and its surroundings will be too. For this Wryneck photographed one autumn on the Isles of Scilly, I set my camera to auto and fired away. The key is learning to identify a midtone. Once you can do this you have just about cracked exposure when using film. Using a digital camera and shooting on auto for this shot would have been fine too.**

Nikon F5 with 500mm lens, 1/125sec at f/8, Fuji Velvia 50

Exposing with a D-SLR

While the same principles apply to both film and digital capture, with a D-SLR you have the advantage of checking your exposure at the time of image capture, and so can adjust to ensure you get it right.

The LCD screen on the back of a D-SLR, although helpful, cannot be used with confidence to determine your exposure. However most D-SLRs display histograms, and this is the tool you should always use to determine your exposure.

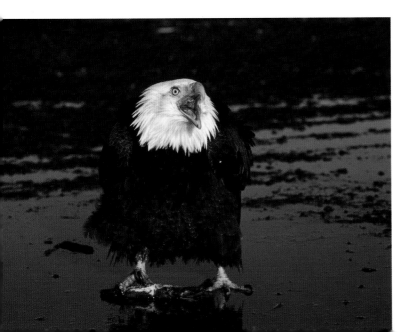

Left **Sometimes a compromise is required. With this Bald Eagle, shot at Homer in Alaska, I wanted to keep plenty of detail in the bird's white head-feathers. This meant exposing for these and not worrying about how the eagle's brown body would look. If photographing a bird such as this, that is both white and very dark, then you need to expose for the white to ensure these areas are not burnt out and the feather detail lost. Many digital photographers routinely underexpose by a stop or so, lightening the image later.**

Nikon F5 with 70–200mm zoom, 1/125sec at f/8, Fuji Velvia 50

Techniques

25

Reading a histogram is simple: the horizontal axis indicates brightness and the vertical axis tells you the number of pixels used for that level. The light end of the spectrum is to the right of centre, the dark to the left, therefore if your histogram peaks right of centre then the shot has a lot of bright areas within the image. When a lot of pixels appear at the extremes ends of the histogram the image may either be under- or overexposed.

When working digitally it is normally better to slightly underexpose as detail can easily be brought back with imaging software. If you overexpose, detail in your subject can be lost and may be irretrievable.

When shooting digitally, I underexpose white subjects as a matter of course, not by much, but enough to ensure I can achieve the detail that I want when I process the image. If you end up with washed-out highlight areas then this detail is impossible to restore. Equally you should try to avoid your blacks becoming blocked (showing no detail). The answer is as when using film, to shoot correct exposures. The less work you do in editing software to restore a poorly exposed image the better. Not only for the time factor, but the more work you do on a picture the more likely you are to compromise its quality.

At the start of a shoot I take a couple of test exposures of midtone areas, and so fine tune my exposure with the histogram ready for the action. Illustrating how a histogram shows a correct exposure is complicated by the many kinds of different images. But the instant feedback when shooting digitally can remove that nagging doubt about your exposure that I certainly suffered from on occasions when shooting film. Do not rely on the review image as the histogram will better reflect what is happening in the image, showing peaks at the far right-hand end for highlights and peaks to the left for dark and shadow areas. An evenly spread histogram will reflect a well-exposed midtone scene. If that scene is rendered in your histogram as peaks to the right (overexposure) or to the left (underexposure) then you know you may need to adjust your exposure value. However, it is always better to underexpose than overexpose, as with the latter any detail blown out in highlight areas cannot be recovered.

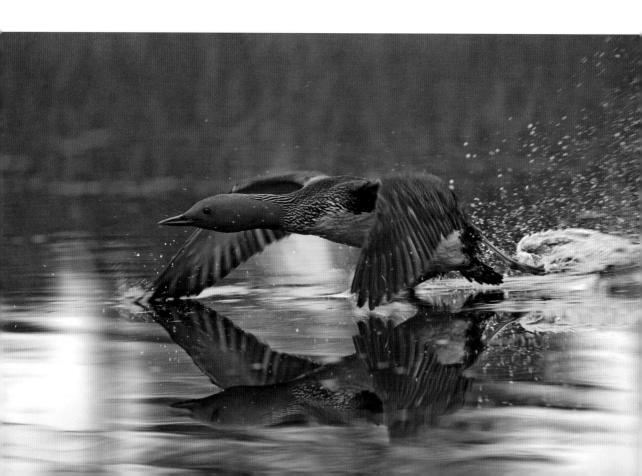

Digital capture – jpeg or raw

One of the first and most important decisions to be made by photographers who are new to digital capture, is whether to use jpeg or raw as a storage format. Some photographers will tell you that raw is much better quality than jpeg. This is not really true; there are advantages to both, and the factors discussed below will help you to decide which is best suited to your purposes.

An image taken in raw mode is a bit like a piece of undeveloped film. By its nature a raw image requires work using image editing software to knock it into shape. Although parameters such as white balance, sharpening and the various other settings can be set in the camera, these are sent to the camera's buffer with the image, but no processing of the image is made at this stage; however, the data is stored for application. If necessary new parameters can be applied on computer, although some elements are limited.

A jpeg image has these shooting parameters applied and they cannot be changed. The image is then compressed into the jpeg format, and is immediately ready for use or can be worked on in PhotoShop. However, your control over the finished image is much less than with a raw file.

A big argument put forward for shooting raw files over jpeg is that each time a jpeg file is saved after work being undertaken there is a loss of image data. However this is not as much of an issue with the latest D-SLRs.

I shoot raw as I want the maximum amount of control over my finished image and with continual advances in software it is likely that in years to come I will be able to revisit my older images and improve them still further.

If you are not a professional but a keen amateur then shooting in the highest quality jpeg setting is likely to be more than adequate for your needs.

Left **A Red-throated Diver rushing across the surface of the water for take-off requires a fast shutter speed to freeze the action. However, I had to compromise with this image by making sure I had sufficient depth of field too. Because of the speed of the action, the brain has difficulty in gauging which part of the autofocus is on, so by using enough depth of field to keep the whole bird in focus, this worry is taken away. The image was taken on a remote bog in Finland, from a hide.**

Kodak DCS Pro 14n with 500mm lens. 1/500sec at f/8, ISO 320

Shutter speed

The shutter speed you choose may be determined by a number of factors. As I've already discussed there is always a trade-off between shutter speed and aperture setting. Most importantly the shutter speed determines the depiction of motion within the image. A relatively long shutter speed will allow motion to blur while fast shutter speeds will freeze the action. Obviously the effect of the shutter speed depends a great deal on the speed of the motion depicted.

Another factor when choosing the shutter speed is the rule of thumb often quoted, that to avoid camera shake when hand holding a camera you should use a shutter speed that equates to the reciprocal of the focal length of your lens. If you are using a 500mm lens then a shutter speed of 1/500sec should prevent camera shake. This is a useful rule, although I regularly achieve sharp images hand holding my 300mm lens, at shutter speeds of 1/250sec and below.

When using a lens on a tripod it is unlikely that camera shake will be a consideration and instead you can think about the effect on the movement of the bird. I often see people using shutter release cables with long telephoto lenses. This is not only totally unnecessary, but also impractical, as it is harder to react quickly when following a bird through the viewfinder.

Freezing flying birds

Flying birds present particular problems as the shutter speed required to freeze their movement depends on the speed of the wingbeat. Typically for a large bird that is flapping slowly you will need at least 1/250sec to freeze wing movement and even then the wingtips are likely to be blurred. However showing movement in this way often enhances an image. For a bird flying towards you, or one with fast wingbeats such as a wader or small duck, then a minimum shutter speed of 1/500sec will be required. During a recent shoot in Finland photographing flying Hawk Owls I needed a shutter speed of 1/2000sec to stop movement.

When photographing birds flying by, the typical method is to pan with the camera, following the bird through the viewfinder. However, unlike the technique discussed for motion blur (see page 54) you should set a fast shutter speed to freeze the image. The trick is

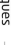

is to pick up the bird in your viewfinder as early as possible to allow your autofocus to lock on, then, once the bird approaches the intended point, fire away. The more images you take when photographing birds in flight, the more chance you have of gaining one that works well.

Depth of field

Depth of field is the distance between the nearest and farthest point in the photograph that appear in focus. Depth of field relies on three factors: aperture, focal length and subject distance. The narrower the aperture (high f-numbers), the lower the focal length and the further away the subject the greater the depth of field. Conversely I regularly create a shallow depth of field by shooting a bird close to with, say, a 500mm lens set at f/4. This can create striking effects and help concentrate focus on the eyes of your subject, or as previously mentioned, to emphasise a strongly coloured foreground as a colourful wash.

The depth of field available can be increased by making the lens aperture narrower (selecting a higher f-number), moving further away or selecting a shorter focal length. Of course a large depth of field is reliant on good light or a fast film to keep a reasonable shutter speed, as each time you increase the depth you lose on shutter speed.

By playing with depth of field on a telephoto lens, you can create a very different look to a picture. By using wide aperture, such as f/4, distracting

backgrounds can be softened to a diffused backdrop. A shallow depth of field can allow creativity too, throwing out foregrounds to appear as a soft wash of colour, or allowing all the attention to focus on the eye of the bird. Conversely, with big birds close to, or in situations where the background is impressive and an integral part of the image, then a large depth of field can make a picture.

I regularly use a shallow depth of field to create impact and drama in an image. Photographing a bird close to with, say, a 500mm lens set at f/4, will give you a shallow depth of field and the

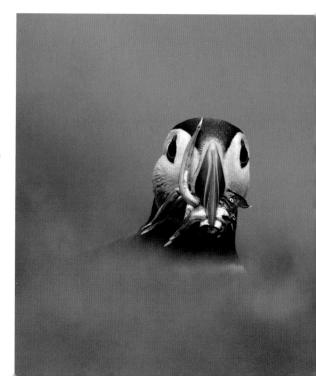

Bird Photography

ability perhaps just to concentrate focus on the eyes of your subject or, as previously mentioned, to emphasise a strongly coloured foreground.

If you have a settled subject, use your depth-of-field preview button to give you a good idea of just how the resulting image will look. Unless you decide to use a shallow depth of field for artistic reasons, make sure as much of the bird is in sharp focus as possible. If you are taking a portrait of a bird perched side on, it can be very distracting in the image to have the eye and head sharp, but the wing and body out of focus.

Digiscoping

Digital cameras have opened up a new world to many bird watchers who can now take pictures of the birds they go to see. For the serious bird photographer digiscoping should not, in my opinion, be dismissed as a novelty. It could well be a means to an end for photographing some species. While SLR cameras and lenses will always rule for the serious bird photographer, on occasions when you need a portrait of a very distant bird that cannot be approached, digiscoping could be the answer.

What is digiscoping? It is the use of a compact digital camera coupled to a telescope. Some digiscopers just hold the camera over the telescope's eyepiece and fire away, while the more serious use special adaptor kits to attach the camera to the scope's eyepiece. While this may sound unprofessional, some digital compacts now rival the specifications of D-SLRs, making pictures of a reasonable and publishable quality feasible.

The main advantage is that far greater magnifications than with even the longest lens can be achieved. The standard compacts used by most digiscopers are the Nikon Coolpix range, which have small front elements, internal focusing, are robust and feature high resolutions. The drawbacks are that your subject has to be static or moving slowly, heat haze can be a big problem, camera shake needs to be overcome and focusing is not as easy as with a conventional camera.

Despite the disadvantages, this method may allow you to capture subjects that, for whatever reason, cannot be approached. In Europe digiscoping is currently extremely popular for capturing images of vagrants (rarely recorded species). Bird magazines are now full of images taken in this way, and the results are often spectacular. Images can be produced that can easily be printed to A5 in a magazine, with no obvious difference to an image that may have been

Below **For shy species such as the Golden Plover digiscoping can capture an image that might otherwise be unattainable. A digiscoped image will never come near the quality of a conventionally taken image such as this one, but it may be sufficient for small reproductions in magazines and prints up to 10 x 8in (25 x 20cm).**

Nikon F5 with 500mm lens and Fuji Velvia 100 film

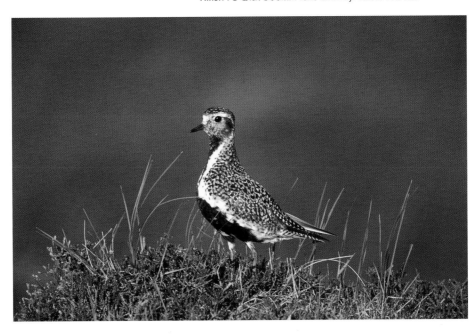

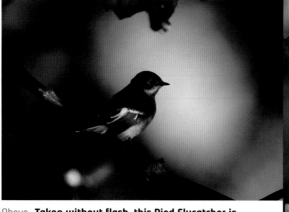

Above **Taken without flash, this Pied Flycatcher is partly in the shade. Although the image is more than acceptable, the second image** Above right **shows how fill-in flash takes away some of the shadow and just lifts the image a little.**

Nikon F5 with 500mm lens, 1/125sec at f/5.6, Fuji Velvia 100, fill-in flash

Right **A small amount of fill-in flash has been used on this captive Barn Owl, just to lift the image a little to give it an extra 'pop'. Working with captive birds is not something I do often, but it does allow a degree of creativity not always possible with wild subjects.**

Nikon F5 with 300mm lens, 1/60sec at f/8, Fuji Velvia 50

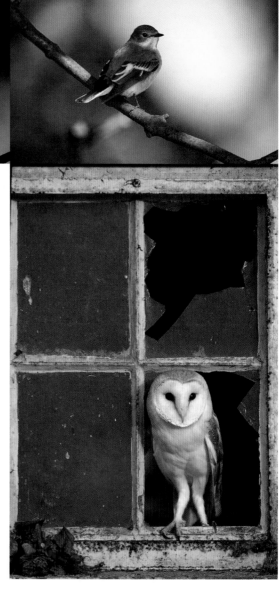

taken conventionally with film or a 10 million pixel camera. Indeed prints larger than A4 can be produced using this method, so depending on what you wish to do with your images, digiscoping might well be a technique worth exploring.

If you wish to explore digiscoping further there are a number of good websites giving plenty of technical advice on how to get started.

Fill-in flash

During the late 1970s when I started bird photography seriously, I never bothered with flash. I read about the advantages of using fill-in flash in some situations, wondered what it was all about, but soon dismissed the technique due to the maths needed to work out how to set the flashgun. Even today, such maths are beyond my comprehension! However in the '80s came some wonderful new flashguns that made fill-in flash an easy option.

I should first explain what fill-in flash is, and how it might enhance your bird pictures. First, full, not fill-in flash, is that which is used as the main light source in dark situations or at night.

It illuminates the subject, and because of the fall off of light behind the subject, if just one flashgun is used you end up with a black background. Unless I am shooting nightjars or owls at night when black backgrounds look appropriate, then I don't like this unnatural effect.

Fill-in flash, on the other hand, is used during daylight; it enhances the light already falling on your subject and gives the ambient light an extra 'pop'. It's great for putting catch lights in eyes and if shooting in harsh overhead light, it evens out

the light. On dull days it can add a bit of sparkle to a picture. Your backgrounds will always look natural, exposed by the ambient light. My view is that if you use fill-in flash properly, no one should be able to tell that flash has been used at all.

Using fill-in flash will enhance your pictures on cloudy days with flat light, if shooting in the shade, shooting a strongly back-lit subject or shooting a bird with the sun overhead. Another use is illuminating the underside of flying birds; if photographing them whilst the sun is high in the sky, this technique can give detail to the underside of a bird that would otherwise be in heavy shadow.

To use fill-in flash successfully, first find your correct exposure for the ambient light, in other words the exposure you would use if you were not using flash. If you are using a relatively modern flashgun you have two options: you can either shoot with fill-in flash by setting your gun to TTL mode (or your flashgun's equivalent); or you can use the automatic daylight-balancing mode. The latter is good for when shooting action and the scene is constantly changing, as the fill-in flash in this mode is programmed to give you a fill-in flash level that falls around two-thirds to one stop below your ambient light reading. This means that the flash effect will not be too harsh, and you will retain some shadow detail, giving you a fairly natural-looking image.

If however you have a subject that is fairly static, then by applying flash compensation you can be more accurate with the effect you create. If flash compensation is left at zero, the flash will attempt to fill in all the shadows. This will make the bird look unnatural, and so you have to reduce the amount of flash to keep your shadow areas, then the decision is just how much shadow area you want. In most situations I set my compensation dial to between –1 and –1.7, with the latter being used most. This normally gives a natural-looking shot with that added sparkle. However it is worth experimenting with this as your taste may be different from mine.

Flash accessories

One of the most useful flash accessories a bird photographer can have is a flash extender. When a flashgun is fired even at the highest zoom setting, the light is spread over a wide area, illuminating a far bigger area than you need. The flash extender concentrates the light from the flash. There are a number of these available commercially, with the most user-friendly being the Walt Anderson Better Beamer extender. This folds away flat, so can be easily stored in your pack. The great thing about concentrating the light like this is that you gain two or three stops of light,

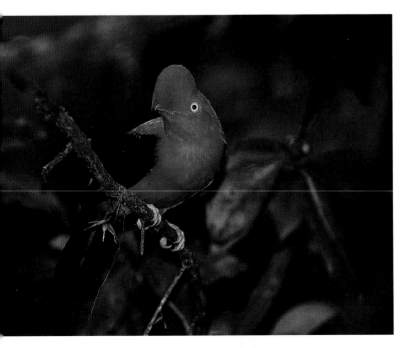

Left **I took this male Andean Cock-of-the-Rock from the viewing platform I was using. Due to the distance and the fact that it was deep in the Peruvian cloud forest in very poor light, I used a flash extender to ensure the flash would reach effectively and illuminate some of the background. If I had just used a flashgun on its own then the bird would have been poorly exposed and the background would probably have been black.**

Nikon F5 camera with 300mm lens, exposure details not recorded, Fuji Velvia 50, fill-in flash, 1/60sec at f/4

allowing you to use fill-in flash or main full flash at greater distances (ideal for rainforest work) and when the light is not great. Other benefits include faster recycling time and using a smaller aperture for greater depth of field.

There are times when using flash that, because of the power you are asking your gun to pump out, recycling times become frustrating leading to many missed shots. The answer is a separate high-voltage battery that attaches by means of a cord to your flashgun. In fill-in flash mode the battery will allow you to fire off continuously, and in full flash, recycling is almost instant. The danger of using one of these is to get carried away, and melt your flash head!

Finally, on the subject of flash, there is one last accessory I always pack; an extension cord allows you to shoot in TTL mode but hold the flash away from the lens axis. This is useful for photographing some species of owls and nightjars, which when photographed with flash positioned over the camera can suffer from red-eye or other unnatural colours (often green in some nightjar species). This is caused by the light reflecting off the lining of the retina. The further your bird is away from the flash the more angle you need between flash and camera lens. Around 2ft (60cm) is good enough for most situations. I normally just hold the flash with an outstretched arm or get my companion to do so, otherwise you can use brackets or an adaptor arm.

Shooting from a vehicle

A vehicle can be the perfect mobile hide. Often, wary birds can be approached in this way. Many of my favourite bird photography sites in Britain are well suited to shooting from a car. One of the keys to success is, after spotting a perched or feeding bird that you want to photograph, you need to place your vehicle within photographic range, with the light direction that you want and without disturbing the bird.

I know a number of photographers who seem to find this very tricky! They invariably stop too short, then have to restart the engine to move and so flush their subject, or they get the vehicle into the wrong angle. Often once they are in position, they then spend the next five minutes fiddling with their equipment or loading a film, as they were not prepared to shoot, upsetting other photographers in the vehicle as they rock it like a boat!

Before approaching a bird in a vehicle I check my

Above **Measuring just 4in (10cm), the Fantailed Warbler is one of Europe's smallest birds, and one of the most difficult to photograph. During a trip to the Greek island of Lesvos, I noticed an individual using an area of scrub by the roadside. By using my car as a hide I was able to get close enough to shoot this portrait.**

Nikon F5 with 500mm lens, 1/250sec at f/5.6, Fuji Velvia 50

exposure, get everything ready to shoot, and then with my beanbag on the door-frame and camera and lens resting on my lap, move cautiously but decisively within range, before cutting the engine and firing off a few shots immediately. Some photographers use camouflage netting (scrim) draped over their windows. No doubt for very shy species this is a good idea, however I rarely use this technique having found that it makes little difference. If you refrain

from waving your lens around, and keep your arms and elbows inside the car, then most of the time a bird is not going to associate a vehicle with danger as they do when a person approaches on foot.

Some photographers like to set up tripods in vehicles and this is often possible. However I favour using a beanbag – a simple cloth bag filled with dried beans or in my case rice. Rice is my preference as the beanbag can be taken on travels empty to save on weight then filled on arrival. A polite approach to one of the kitchen staff wherever you are staying will usually result in your managing to get your beanbag filled.

Left **I used an extension cord so that I could hold my flash away from the lens axis to photograph this Tengmalm's Owl in Finland. This technique has kept the eyes yellow, rather than suffering from red-eye, which would have been evident if I had left the flash on the camera**

Nikon F4 with 300mm lens, exposure details not recorded, Fuji Velvi 50, fill-in flash with extension cord

Below **This image was taken more than 20 years ago. It shows a Snow Bunting feeding on grass seeds, at Penninis, St Mary's on the Isles of Scilly. I managed to capture a number of images of this individual, which fed just a few yards from where I sat. At first it had been impossible to approach, but after spending a couple of hours sat quietly close to it's favoured feeding site, the bird accepted me. Successful stalking such as this brings great satisfaction when it works.**

Nikon FE2 with 600mm lens, 1/125sec at f/5.6 lens, Kodachrome 64

Stalking

Carefully creeping up on birds on foot, or stalking, is my favourite type of bird photography. There are few more pleasurable occasions in bird photography than stalking a bird successfully and gaining its trust. It often pays not to approach your chosen quarry directly, but choose an angle that will take you close. Keeping low and slow with frequent stops will help settle your subject. Wary birds can often be approached by first sitting at a distance that the bird is comfortable with and just letting it accept you into its environment. Over time and with careful

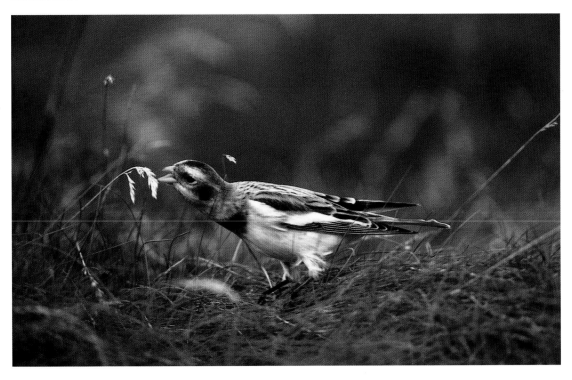

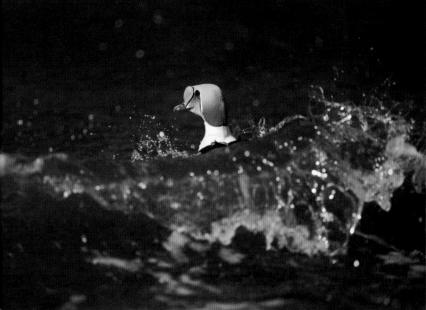

manoeuvring, chances are you will have more success than just hurrying in and causing it to fly. Stalking is not about pretending you are making an SAS raid! Crawling in a manner that mimics a stalking predator, such as a cat, may not be as effective as being more upright and walking at an angle to your subject. After all the bird can see you, so the less menacing you look the more chance you may have of getting close.

Diving birds such as grebes and diving duck can be stalked by waiting for them to dive and then moving in close to the water's edge. Each time the bird dives you move, making sure that when it surfaces no sudden movements are made. If you are stalking a feeding bird, it can be productive to sit on the edge of its feeding area and wait for it to come to you. A good example of this are the Red-necked Phalaropes that feed around the shores of Loch Funzie on Fetlar in Shetland. The phalaropes pick flies from the stones along the rock shore and are constantly on the move, often working particular stretches of shoreline. The technique for success here is to watch which way the phalarope is heading, move ahead and sit down on the shore. It will come right past you and at this location they are so tame they have even plucked flies from my tripod legs!

Watching what birds do is invaluable in planning an attack. Just like humans, birds have routines; favoured sites to rest, eat and roost. In my younger days I was a keen photographer of rare birds. Every weekend I would dash to some part of the country that hosted the latest rare bird, all my concentration for that day would be on securing an image of that

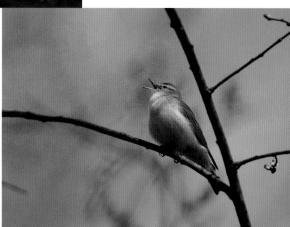

Above **Birds often stick to a particular route, and if on territory will favour certain song posts. I watched this Wood Warbler for a while noting its favoured perches, then positioned myself close to the one most suitable for photography. It was not long before the warbler was performing for my lens.**

Nikon F5 with 500mm lens, 1/250sec at f/5.6, Fuji Sensia 100

bird. Such focus was great training as a bird photographer, as I learnt that by watching intently where the bird went, I would be able to select a perch, patch of mud or water that the bird would consistently return to, often at consistent time periods. This was most true of individuals that stayed for a few days or more, as they soon developed into having a routine foraging route.

If stalking in heavy vegetation or over rough terrain tripods can be difficult to manoeuvre. In these circumstances a monopod can be useful. Also useful are the medium-length telephoto lenses that employ image stabilisation and so can be hand held.

Right **The wooden hide overlooking the divers' breeding pool on a remote Finnish bog.**

Red-throated Divers, Finland

In July 2004 I travelled to Finland to photograph a pair of nesting Ospreys. On my arrival I was taken to a Red-throated Divers' nest by my host, as there was not enough time to visit the Ospreys that day. It became apparent as I sat in the hide that evening that this was a unique opportunity to obtain some great images of divers; a species that had been high on my hit list for quite some time. So rather than spend the week photographing the Osprey nest (in the end I spent just one day in this hide), I concentrated my efforts on the divers.

The birds' nest site was a small sedge-lined pool on the edge of a large bog. The hide, which overlooked it, had been put in place during the winter, so it was part of the birds' landscape from the first day they returned to breed after a winter spent out at sea.

Below **An adult with one of the chicks. I had a mixed bag of weather during my week at the diver site, this image was taken on a perfect summer evening.**

Kodak DCS Pro 14n with 500mm lens, 1/500sec at f/4, ISO 160

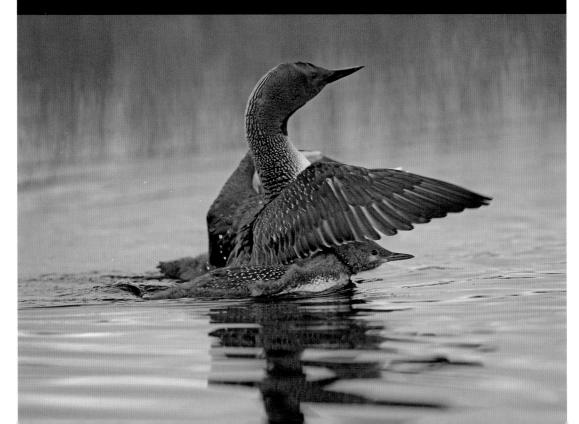

Techniques

35

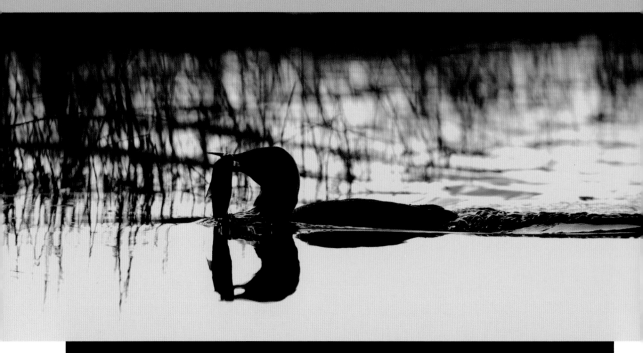

Above **This was a rare occasion when the adult was left holding a fish for any length of time. Normally the chicks would scoot across the surface of the pond grabbing the fish away within a second or two.**

Kodak 14n with 500mm lens, 1/250sec at f/8, ISO 250

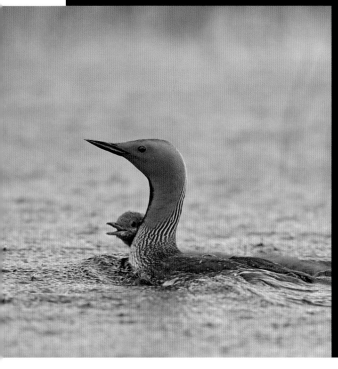

My first long session in the hide gave me a good feel for the birds' behaviour. The parents would arrive every two to three hours with a fish, sometimes staying for a few seconds, on other occasions for a few minutes. I was able to start predicting their take-off and landing paths, and so started to plan the images I wanted to capture during the next few days. If concentrating on a specific subject for a period of time, I always think about the possible images I may be able to take, and usually work accordingly, trying to give myself the best opportunities I can.

During periods of no wind, there were some beautiful reflections created by the birds, particularly as they streaked past my hide, running across the pond surface, until they had achieved enough momentum for lift-off. The digital camera I was using was delivering just over a frame a second on its continuous motor drive mode,

Left **A chick begs for food during a torrential downpour.**

Kodak DCS Pro 14n with 500mm lens, 1/125sec at f/4.8, ISO 320

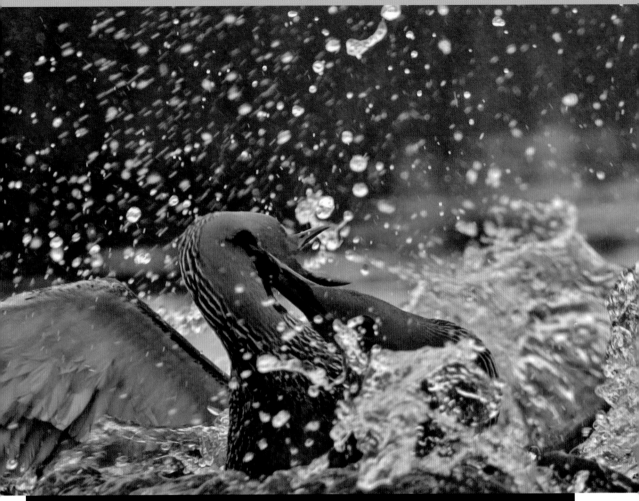

Kodak DCS Pro 14n with 500mm lens, 1/500sec at f/4.8, ISO 320

not ideal for such action photography, as it meant I grabbed just a couple of frames for each take-off. However I was able to check after each one whether I had bagged the shot I was after.

On my second session in the hide it all came together: my panning was at the perfect speed and the shutter fired at the right moment for the perfect take-off shot. After being in the hide all night and all the following morning, I decided to return to base for a meal and some sleep. I returned in the early evening, as there is no real darkness during Finland's summer nights I was able to take pictures until 10.30pm, I then lay down to sleep awaking at 3am to the sound of a calling diver approaching. After this first visit I decided to move to the smaller portable hide erected on the side of the pond.

This decision later turned out to be inspired, as at around 4am two divers circled over the pond calling, then a second pair appeared. All landed and a fight between all four birds erupted. Never had I witnessed quite such a spectacle and right in front of the hide in which I sat. The attacks were extremely violent followed by the birds giving spine chilling calls, but what followed was just as dramatic.

Techniques

Right **An adult Red-throated Diver splashes down with a fish. The shallow pools in which the divers breed have few if any fish living in them, so the adults travel a few miles to a larger lake to fish.**

Kodak DCS Pro 14n with 500mm lens, 1/250sec at f/5.6,

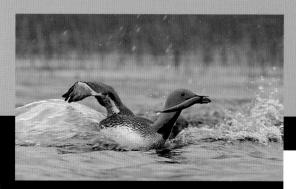

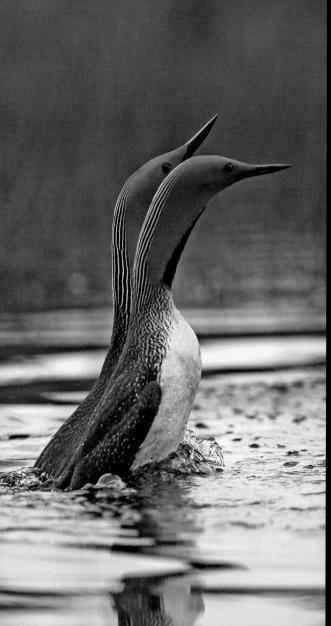

In one of the most exquisite courtship performances I have witnessed, both adults swam together with outstretched necks. They ceremoniously paraded down the pool, before calling triumphantly and then departing. I was by now shaking with adrenaline. I knew that such behaviour had rarely, if ever, been photographed, as courtship displays take place on large lakes or out at sea. It had been a very special encounter and I had captured it all with my camera.

Working from a hide in this way, is a great insight into a bird's private life, and as with these divers allows images to be captured that would not be possible any other way. What is important if you intend to photograph nesting birds is to be aware of the law in the country you are in. In Britain for example I would have needed a license to photograph Red-throated Divers at or near a nest. The other vital necessity is to plan carefully, and if introducing a hide to a nest, to do so over a number of days, bringing it closer each day, so that the birds accept this intrusion into their world.

Left **Using a digital camera allows instant gratification. This pair of Red-throated Divers suddenly displayed with little warning, it was an adrenaline pumping moment that has rarely been seen, least of all photographed. After checking the image and histogram on the back of my camera seconds after the behaviour had ceased, I punched the air in euphoria. I knew I had the image in the bag. If I had been shooting film it would have been a few days before I could know the fruits of my encounter.**

Kodak DCS Pro 14n with 500mm lens, 1/350sec at f/4, ISO 320

Using hides

Portable hides, or 'blinds' in America, are an integral part of the bird photographer's armoury. They are less commonly used by photograhers in America, an indication of the degree of difficulty encountered in approaching European species as opposed to the often tame North American species. I not only use hides frequently in Britain, but often travel with one too.

They can be indispensable, particularly in hot countries where a small drinking pool can be made. Water in a dry environment will soon attract birds, and with decent perches in place, some great images can be secured. Equally for waders and waterbirds on wetlands, or at specific feeding sites, a hide can secure images often beyond the reach of stalking or using long lenses.

When placing a hide you might need to leave it for a couple of days before use, for the birds to grow accustomed to it. This depends on the species of course, as some will return to a spot immediately after the hide is erected. For some wary species it might be sensible to gradually move it into position from a long distance back, perhaps slowly erecting it and moving it over a period of a few days. With wary species, try camouflaging it with local materials, such as reeds or tree branches, to break up its outline.

Occasionally of course, there are elements beyond your control outside the hide. On one occasion in China three children came upon my hide. No birds were going to come near while they stayed close to investigate, so I decided to pop my head out of one of the windows and the children were so scared at the sudden appearance of a blonde curly haired figure that they ran away in shock. I was able to resume my photography, until later in the day when they returned with a disbelieving father. My appearance once more caused not only the frightened children to run, but the father too!

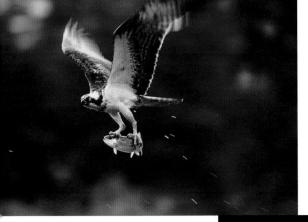

Left **An Osprey clutching a fish will always take off into the wind. To get this shot I simply positioned myself, concealed, on the flight path of the birds leaving a pond at a trout farm in Finland.**

Nikon F5 with 300mm lens, 1/250sec at f/4, Fuji Velvia 50

Right **'Kingfisher with a fish' is a popular subject. This image was taken from a hide by erecting a perch at a favoured fishing location during the breeding season. By photographing the bird well away from the nest there was no danger of any disturbance to the nesting pair. You should note that some species in some countries are protected by law, and a permit is required to photograph them at or near the nest (this includes the Kingfisher in Britain). This bird readily used its new perch and many pleasurable hours ensued as both parents came and went with fish.**

Nikon F5 with 500mm lens, 1/125sec at f/8, Fuji Velvia 50

Above **I have a permanent hide placed in an orchard close to my home. Each autumn I collect the apples and use them as bait throughout the winter. During cold weather a variety of thrushes, such as this Redwing, visit to feast on the fruit. Permanent hides become a fixture in the landscape and may be more readily accepted by shyer species.**

Nikon F5 with 500mm lens, 1/250sec at f/5.6, Fuji Velvia 50

The most important consideration when placing a hide is to ensure you have the sun in the right position for when you want to use it. There is nothing more frustrating than putting up a hide on a cloudy day, then sitting in it on your first available sunny day and finding the lighting is not quite right.

Finally make sure you have a comfortable seat. If you are enclosed in such a small space for hours on end, the last thing you want to be is uncomfortable; it will not help your photography. A comfortable chair will make all the difference.

Wherever you put your hide, you should check first that it is permissable. Many reserves and National Parks outlaw erecting hides. The ideal is to secrete it away from the public gaze. Not only

will curious onlookers ruin your photography, but if you leave it up overnight, you may encourage vandalism or theft. Where hide erection is outlawed, taking a camouflage net to drape over yourself and break up your outline is often a good alternative.

There are many nature reserves with hides that can be very good for bird photography. The drawback is that they are used by the public and often placed in poor situations for photographing in good light. Why some hides are still erected to view into the sun all day is beyond me, but they are, so not all of them will be ideal. On the plus side, public hides are usually well established and birds are used to them. The downside of this is that birds may keep an annoying distance from them due to noise levels and people sticking their arms out of viewing windows to point. They can often be raised too, giving an unnatural view. Despite these reservations, some are good for photography, and you just need to seek out those that are.

Baiting

Baiting is the practice of putting out food or providing water that will attract birds to a designated spot, often somewhere where you can erect a hide. Creating drinking pools is very effective in dry countries where water is scarce. The sudden provision of water can often have instant results. Using a small piece of pond liner, obtainable at any good garden centre, or the sinking of a dish or other receptacle that holds water will suffice. A perch can be placed close to the water on which to photograph the birds as they arrive. Birds are often attracted to dripping water, so suspending a large water-holding receptacle above a dish, dustbin lid or similar, and making it drip, will often prove irresistible. This is a technique often used by American photographers when shooting migrant warblers, and it seems to work equally well for many other passerine species.

Putting out food at a regular site is often very rewarding. If you have a garden this is a great place to start. A couple of feeders or a bird table will attract the birds to a given spot at which you can place a perch on which you want to photograph arriving birds. There are many creative possibilities when working in this way, as you can vary perches and backgrounds and attempt to create images that have impact and look a bit different. If creating a feeding site, it is important to replenish your feeders regularly. Choose a location where the sun will be behind you for much of the day, and place your feeders not too close to trees or bushes, so that the birds visiting are tempted to use your chosen perch.

I have used a feeding station to attract British garden birds for many years. It is a great way of photographing woodland and hedgerow species that would normally be difficult to approach. The trick is to provide a wide variety of foods and plenty of feeders. This will attract a diverse range of species and good numbers of birds. To get them to land on specially placed perches I then remove all the feeders except for one, which is placed close to the perch. The birds then need to queue up to get on to the feeder and should land and linger on the perch.

When travelling, if you are due to stay at a location for a few days, it may be worth scattering some seed or, if in the tropics, putting out some fruit to see what you can entice. Pieces of banana and other soft fruits can be an effective lure for rainforest species.

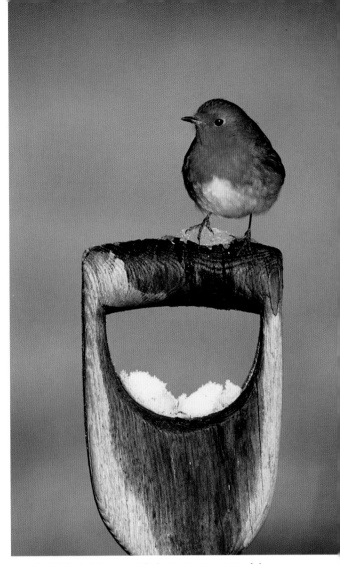

Left **A cliché shot, but nonetheless a very commercial and, to my eyes, endearing image - the Robin on a gardener's fork handle. The Robin was lured on to the handle by a pot of meal worms placed on a low bird table just in front of the fork. I chose my fork handle carefully for added appeal, making sure it was a traditional wooden design. I did not need to use such a fast shutter speed, but I wanted a shallow depth of field to throw the background out of focus, creating this nice smooth green wash behind the bird**

Nikon F5 with 300mm lens, 1/500sec at f/4, Fuji Velvia 50

There are some famous bird photography locations featured in the Site Guide section of this book (see page 66), which rely on baiting to attract spectacular concentrations of birds. Common Cranes in Sweden is one such example, as are the growing of crops at Bosque Del Apache in New Mexico for geese and cranes.

Techniques

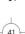

Tape luring

The luring of birds by playing back a bird's song is a controversial subject to many. Some bird photographers frown on this technique, however I have no qualms with this method as long as it is used judiciously. If it is likely to work at all it normally does so instantly, with the bird appearing and searching for its invisible rival. If, however, after a couple of plays the desired reaction is not forthcoming I would suggest moving on. It is irresponsible to play a tape repeatedly in a bird's territory, as it may have detrimental effects. But by limiting your playing to a couple of bursts, then I see no harm. After all if the bird is breeding it is likely to be at a healthy peak so letting it think it has chased off an intruder won't do it any harm.

Tapes and CDs are available covering most species in the northern hemisphere. For tropical and southern hemisphere species recordings are harder to find, however some countries such as the UK have sound archives from where recordings are available. More effective, and the method I normally use, is the playing back of a singing bird's own song. My outfit consists of a small compact tape player with inbuilt speakers, a small directional microphone and a supplementary speaker on a long lead if needed. The speaker can be placed close to your desired perch and, if your lead is long enough, controlled from a reasonable shooting distance.

Below **This Robin was lured by using a tape, just a ten second burst did the trick. It flew into the tree in front of me and sang for a couple of minutes, before resuming its duties.**

Nikon F5 with 500mm lens, 1/250sec at f/8, Fuji Velvia 100

Feeding stations, Great Britain

In recent years feeding stations have become popular attractions to many nature reserves across Britain in winter. Their aim, apart from helping garden, woodland and farmland birds get through the winter, has been to bring birds closer to people, providing often exceptional viewing opportunities. Feeding birds does not of course have to be confined to the winter months, and indeed in many countries around the globe including those in the tropics they prove popular and a valuable way of bringing sometimes hard to photograph species within range of a camera.

Below **More akin to clinging to peanut feeders, this Great Spotted Woodpecker struggles to keep its balance as it lands on a seed feeder. Whenever I can with feeder shots I try and create some dynamism in the pictures, capturing action or interaction.**

Nikon F5 with 500mm lens, exposure details not recorded, Fuji Velvia 50

Right **A Nuthatch hangs off a nut feeder. Backgrounds are always important and here I have positioned the feeder so that I get this green wash, the uncluttered background ensures the feeder and birds are shown off to their best.**

Nikon F5 with 500mm lens, 1/125sec at f/5.6, Fuji Velvia 50

If you have a garden or access to an area not too disturbed by people, the setting up of a feeding site and hide is a great way of taking pictures. A few years ago I started to look around my local area for a suitable site as my garden was not suitable due to lack of light and its small size. I did not have to look far, as at my local nature reserve I had access to an old orchard fenced off from the public. It proved to be the perfect spot. I found a location where the sun would rise and be either to the side of or behind the hide all day. A small clearing in front of the hide was ideal for placing props as perches – for example a log for woodpeckers to perch on. During the first couple of years I erected a small canvas hide, however when

Right **My converted shed in the orchard, a home from home!**

the offer of an old garden shed came my way, it was readily accepted and converted into a very comfortable hide.

Many years later the feeding station is still going and because I photograph bird feeders commercially for Jacobi Jayne, a major European conservation retailer, I use it regularly during the winter. A wide mix of foods is put out - the more diverse the feed available, the wider variety of species that will be attracted. Because the site is in an orchard I have a ready supply of apples, which I collect up and place in front of the hide. These are always a hit with thrushes, particularly Fieldfares and Redwings. On some days during winter over 200 birds of more than 15 species

may be present. I attract a lot of birds purely because I put out a lot of food and I am not far from big woodland areas. It is important to keep feeders topped up during the winter, as if a few days are missed and there is no food the birds quickly disperse.

Apart from the feeder shots I photograph birds on various perches. By placing a perch in the desired position in front of the hide, the birds can then be manipulated to land on the perch, by placing food in front of or below it. When doing this I usually take down all the feeders, leaving just one by my chosen perch. This creates a queuing system that makes the birds land and wait before being able to get onto the feeder.

Techniques

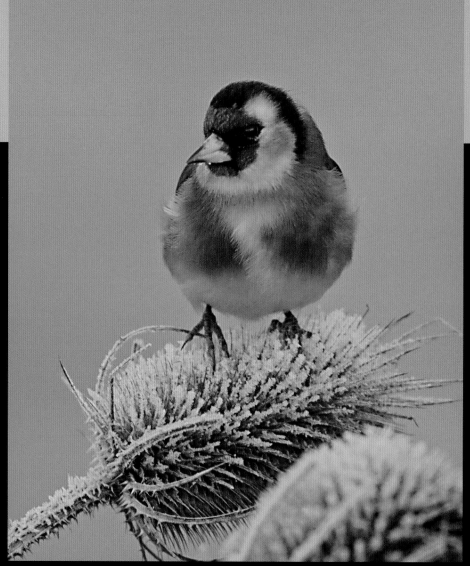

Above **This Goldfinch was enticed onto the teasel head by regularly sprinkling niger seeds within the seed heads. The frost sets the shot off and says winter.**

Kodak DCS Pro 14n with 500mm lens,

Living in Southern England, snow and even heavy frosts are now rare events, and because the addition of either can really set a winter scene for a picture, when such an event does occur I always try to get to my feeding station. The frosty effect can be helped by spraying props with water the night before a frost is forecast in order to give a bit more of an effect. Snow on the ground gives off a beautiful reflected light that gives pictures an additional quality. This can be recreated by placing a reflector to reflect light on to the subject, I currently have a large piece of plywood that is covered in silver foil that I sometimes place below a perch or feeder.

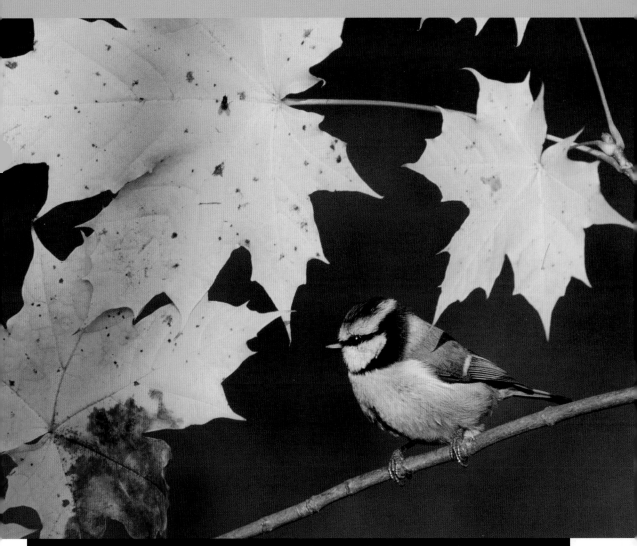

Above **This Blue Tit was tempted to perch amongst these autumnal Sycamore leaves by placing a nut feeder just out of shot.**

Nikon F5 with 500mm lens, exposure details not recorded, Fuji Velvia 50

Now that I shoot digitally, I set up my laptop computer in my hide and can edit the images as I go, this is particularly useful if I am trying out a new technique and need to take a lot of shots to get the image I am after, and it is very helpful for taking the feeder product shots for Jacobi Jayne. I know exactly when the shot is in the bag, as opposed to the days when I used to shoot film and would continue until I was sure I had the image, the new way of working certainly saves me time in the field, although that saved time is quickly used up once the pictures are downloaded to my computer!

Techniques

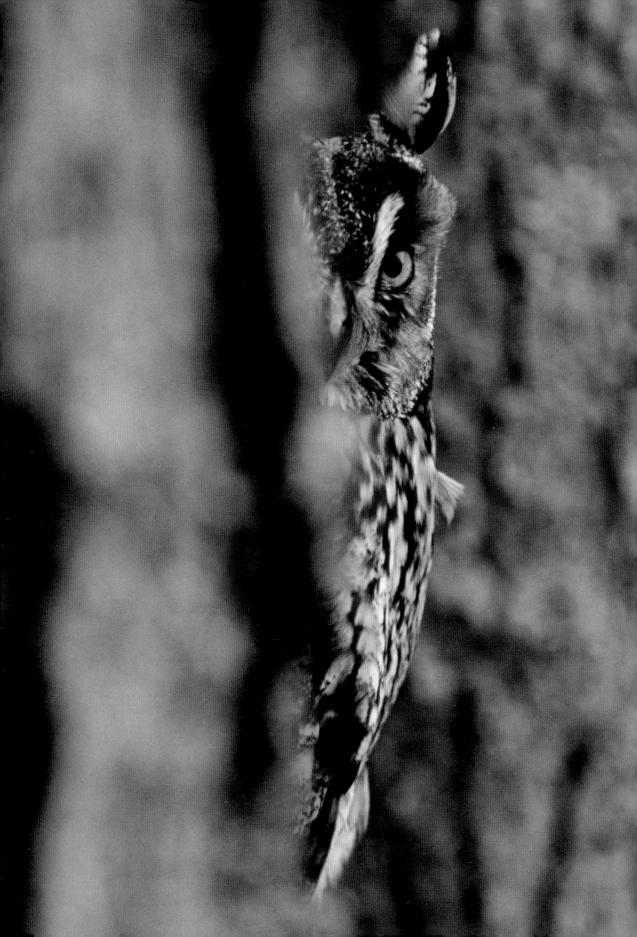

Chapter 3 For me, photography has always been about making art. I try to shoot pictures that will stand out from the crowd and that means thinking about composition and using techniques that give the picture that extra something; we can call it the 'X-factor'. It is difficult to measure, but when an image evokes a reaction in the viewer and holds their attention, then I know I have succeeded.

Being Creative

Composition

If all you want to do is make a record of a bird, then it is of less importance how you frame your subject, as long as it is clearly in shot.

However, for many of us, bird photography is a form of art, and to make a picture aesthetically pleasing consideration needs to be given to composition. Some people are born with a natural ability to compose a picture; for others it is a skill that needs to be learned and worked at. However hard or easy you find composing an image there are certain techniques that will assist in making pleasing looking pictures.

There can be an overriding desire to try to make the bird as large as possible in the frame. Try to resist this, as some of the most memorable bird images are those in which the bird is part of a much larger scene. Whenever possible the bird, if not looking straight at the camera, should be looking into space. Take a look at the examples on this page. One of the shots feels balanced, the other does not. If a bird is looking in a particular direction in a picture then our eye follows that direction, so if it is looking out of the picture and not into space, our eye wanders out of the picture.

When concentrating on a bird through your viewfinder, it is easy to neglect the background, or intrusions such as twigs across a body, or branches directly behind, that appear as if they are growing out of the bird's head. It is often a simple matter of moving a few steps one way or another to lose such distractions to gain a better background. Shooting with a wide aperture on a long telephoto lens will give a shallow depth of field that will help throw out of focus what might be a fussy, distracting background. Conversely you might want to include the background as a compositional element of the image.

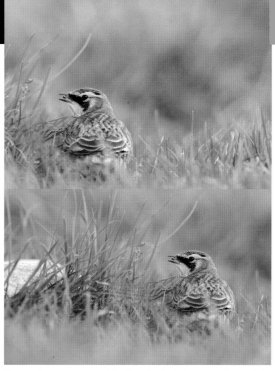

Above **I came across this Shorelark during a walk on Holy Island in Northumberland. These two shots show how a subject looking into space is far more pleasing to the eye than one where the subject is looking off the page.**

Kodak DCS Pro 14n and Nikon 500mm lens

Opposite **Working with a captive bird such as this Long-eared Owl can open up all sorts of creative possibilities, that might be difficult to reproduce with a bird in the wild.**

Nikon F5 with Nikon 500mm lens, exposure details not recorded, Fuji Velvia 100

If photographing a bird, it stands to reason that the bird is to be the focus of the image. The camera will record all you see through the viewfinder but this might be quite a chaotic scene. The key is to go some way to isolating your subject. Distracting out of focus foregrounds or an interfering background will lead the eye away from your subject. Less is almost always more; in other words don't have too much visual confusion in your image. It is usually the case that the more simple the image, the more powerful the image will be.

Right **Illustrating the rule of thirds, the overlay shows the intersections at which the image can be placed, of course the bird should be looking into space wherever it is placed.**

The rule of thirds is a method of creating pleasing asymmetry in your image. By dividing the image into thirds, as shown above, in your mind and placing the main features of the image at the intersections rather than in the centre, the picture can be given an attractive balance. The subject can be placed at any one of the intersections for appealing results, depending on how the rest of the scene works best in the frame.

The Wider Picture
– Creating Panoramics

Making a picture that illustrates a bird within its environment can be a big challenge. With very approachable subjects, such as penguins or nesting seabirds, a wideangle lens may be used and, with a narrower aperture to give a large depth of field, the bird can be portrayed within its environment. However, this technique is not always ideal as the standard format of a 35mm or digital frame can leave a lot of space wasted within the picture.

Back in 1997 I realised that the panoramic format might be my answer to creating the kind of images I visualised. At the time the best panoramic camera available for what I had in mind was the Fuji GX 617. At approximately 2½in deep by 5in long (6 x 17cm), the letter-box shaped image created by this monster of a camera looks mightily impressive on a lightbox. However panoramic photography for the wildlife photographer has been revolutionised by the Hasselblad Xpan. Compact, light and with three interchangeable lenses plus good close focusing capabilities, this camera has opened up new opportunities.

For digital photographers Adobe PhotoShop and a number of other imaging software packages offer great opportunities for 'stitching together' individual frames, either scanned or captured digitally, to make panoramics. There are also specific 'panorama' programs available that will create panoramic images automatically with the minimum of input from you; however, these may not give you as much control as a complete imaging package. The main advantage of using software to create panoramas is that you don't need any extra kit with you on a trip, and mostly this works well and it is impossible to tell when panoramics have been made by this method.

Bird Photography

Below **Antarctica lends itself well to the panoramic format, with vast vistas and often very tame birds, the letter-box shape helps to keep emphasis on the birds while still conveying the vastness of the landscape. This picture shows a line of Emperor Penguins returning across the frozen Weddell Sea to their colony.**

Fujifilm GX 617 with 90mm lens, 1/60sec at f/8, Fuji Velvia 50

Above **While it is normally best to avoid placing your subject in the middle of the frame, particularly with panoramics, rules are always there to be broken. Here I have placed the Great Spotted Woodpecker in the centre of the frame, balancing the composition with the wheelbarrow and watering can in the background. I could not have got the garden feel to this image without using a short focal length lens and, as woodpeckers in Britain are shy creatures, using a remote control was the best option. This was a commissioned shot for a book on attracting birds to your garden, and was partly shot in the panoramic format to fit a space the designer had made on the page.**

Hasselblad Xpan with 90mm lens, 1/60sec at f/11, Fuji Velvia 50, remote-control shutter release

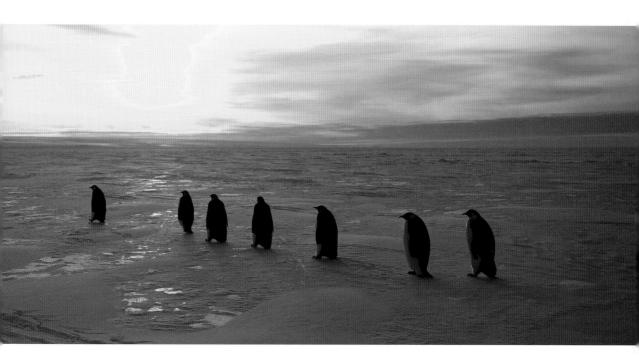

Above and below **A female Wandering Albatross lifts up into the wind on Albatross Island in the Bay of Isles on South Georgia. Here the focal point of the picture is to one side of the frame. I left much of the left-hand side of the frame empty to convey the vast windswept landscape with the aim of portraying the inhospitable world these birds live in. The image also works well as a cropped shot too, focusing attention on the bond between the birds. The bird circling in the top left was not planned, but doesn't detract from the overall image.**

Hasselblad Xpan with 90mm lens, 1/250sec at f/5.6, Fuji Velvia 100

Not all situations lend themselves to panoramic formats. If you are photographing a lone bird, careful placement within the frame is needed. For it to work it generally needs to be to one side and looking into the picture. It also helps to have a strong landscape as a backdrop, but of course this is not always necessary. You can compare looking at a panoramic image to looking through a car windscreen. It is a similar field of view and so, unlike with a standard format frame where your eye assimilates the image without it having to roam, with a panoramic, the eye naturally roams across the image taking in the picture.

Panoramic images of birds work best when they are depicting a bird within its environment or when recording a breeding colony or other large gathering, which can be made an integral part of the image. It is also helpful if your subject is approachable to within a few metres. Inevitably situations in which there are mountains or other notable landforms work best. Icy environments such as the Arctic and Antarctic lend themselves to this format particularly well, as the immense feeling of space and the beauty of the landscape can be shown to good effect. The format helps to illustrate the attractiveness and the extremes of your subject's environment.

Wideangle lenses

Occasionally you may come across an extremely tame subject or you will want to record a scene, perhaps a bird within the landscape or a breeding colony, that will lend itself to a wideangle shot.

For really tame subjects positioning the lens so it is really close to your subject makes for a strong foreground exaggerating the bird's size and giving an added three-dimensional effect. Focus is critical in such images, and as the focal point on any bird is its eyes, these should therefore be in focus. As for keeping everything else in focus, this is not always necessary, and it can be effective to throw as much out of focus as possible, or to have as much in focus as possible. It is worth experimenting with the available depth of field.

If photographing a seabird colony, flock of birds, or other such scene where the landscape is to be included, then a strong foreground can really make a picture. If you just place your subject in the middle of the image with equal foreground and background, the picture may lack any impact. By finding a strong compositional element to the foreground, you are able to lead the viewer's eye into the picture. If using this method then the placement of the depth of field is crucial. An out of focus foreground and sharp background will look odd, whereas a sharp foreground will be far more pleasing to the eye, and reproduce more closely how we view scenes in everyday life.

Above **You don't have to travel to exotic locations to find tame birds. Town and city parks are great places to get creative with your camera. This Canada Goose was in London's St James Park. By dangling a bit of bread above my wideangle lens, I got the bird to extend its neck and open its beak.**

Kodak DCS Pro 14n with 17-35mm lens, 1/250sec at f/8, ISO 200

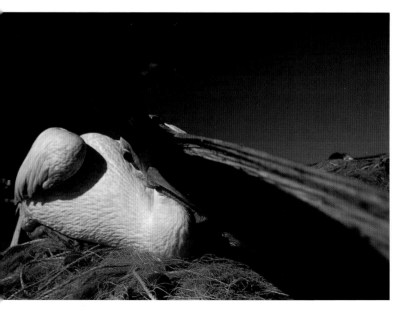

Left **This tame White Pelican was hanging around a small fishing harbour on the Greek island of Lesvos. By getting one of the fishermen to dangle a fish just above my 24mm lens, I was able to get this dramatic view. I used a polarizer to darken the sky and accentuate the bird. Whenever you come across a particularly tame bird such as this, it really is worth exploring all the possibilities, and by using a wideangle, some dynamic and wacky images are possible.**

Nikon F4 with 24mm lens, exposure details not recorded, Fuji Velvia 50, polarizing filter

Being Creative

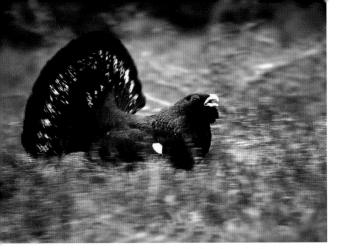

Above **Hand holding my anti-vibration telephoto zoom, I panned at 1/20sec to capture this rogue Capercaillie which was charging towards a frightened dog walker! Take as many images as you can when shooting motion blur as there will always be a lot of wastage.**

Nikon F5 with 70-200mm lens, 1/20sec at f/8, Fuji Velvia 100

Below **Motion blur is always a gamble, you never quite know whether the picture will work until you see the results. In this situation, with the Osprey exploding out of the water, I did not have enough light to freeze the action, so instead of compromising and using a shutter speed that would have made some of the bird sharp I went for broke and lowered my speed to 1/30sec. I was delighted with the result, and this image went on to receive a 'Highly Commended' in the Wildlife Photographer of the Year competition.**

Nikon F5 with 300mm lens, 1/30sec at f/5.6, Fuji Velvia 50

Motion blur

Some photographers I know scorn this technique, believing a picture of a bird should be sharp from beak to tail. I am a keen motion blur photographer and will use it when the opportunity arises. For me motion blur can often turn what might be a good but not exceptional image into something that leaps from the page, more as a piece of art than a photographic record. One of the great attributes of the motion blur technique is that it is not only easier to perform on dull days, but it can make an image that may have suffered due to poor light into an image that is a winner.

Motion blur enthusiasts have received a boon with the arrival of anti-vibration lenses, as these now allow key elements in a picture to remain sharp, while the other parts, background or subject, are allowed to blur. The technique can be very hit and miss, and inevitably many images in a sequence will fail, so it is important to shoot as many frames – at a variety of different shutter speeds – as possible for success.

There are two main techniques. The first, and the simplest, is to use a relatively long shutter speed while keeping the camera still. This can be used to accentuate the movement of parts of an otherwise static subject, for example a bird that

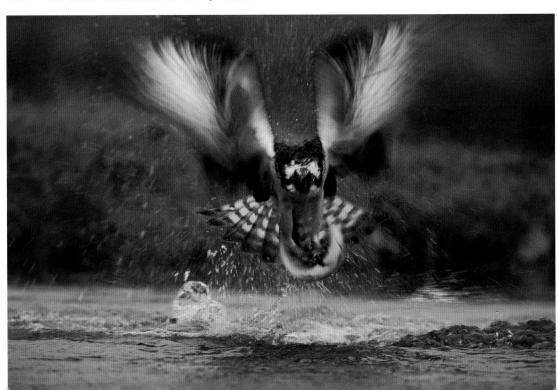

flaps its wings while sitting on a perch. The second, and slightly more difficult, technique to master is panning. This is one of the most common methods of depicting movement and involves following a moving subject with the camera while using a relatively slow shutter speed. This is most effective when the main subject remains fairly sharp, while the background is allowed to blur.

With my 70–200mm anti-vibration zoom I can hand hold it as slow as 1/15sec, and pan successfully without the effects of camera shake becoming visible. But more commonly, and when using non-anti-vibration lenses, I either place the lens on a sturdy tripod with a head that has a smooth panning action, or rest it on a beanbag, my preferred method as I feel this gives more stability.

Different shutter speeds will give different effects. I rarely, if ever, go below 1/8sec, as the effect of the motion blur can then make the subject indeterminate. Shutter speeds of around 1/15sec to 1/30sec have given me my best results.

Motion blur can also be created when using flash. If your camera and your flash offer you the option you can choose the rear-curtain sync setting. Normally the flash illuminates the subject just after the shutter has opened, however when set to rear-curtain sync the flash is set off at the tail-end of the exposure. This technique works particularly well with shutter speeds below

1/30sec. The subject's outline from where it is moving will appear as a blurred shape or series of lines, but the main part of the subject will retain some sharpness. To ensure you don't have black backgrounds, you should combine rear-curtain sync with the fill-in flash mode.

Lighting effects – silhouettes

The direction of light falling on a subject affects our perception of that final image. For example an owl shot in late evening, front-lit, will be a nice portrait of an interesting bird. But move behind and silhouette the same owl against the setting sun, and you have a very different picture that tells more of a story, has more atmosphere and may have more visual impact.

Some of my own favourite images are silhouettes, and are usually the result of planning ahead. Silhouettes are most easily made with co-operative subjects or large flocks in open environments, such as on the coast, by water or in areas such as desert or grassland – wherever there is the opportunity to see the sun sink low or rise. If you are after plenty of colour in your picture then silhouettes at dawn need to be taken soon after sunrise before the sun becomes too harsh. It is less hectic to shoot silhouettes at sunset and there is often likely to be more colour in the sky.

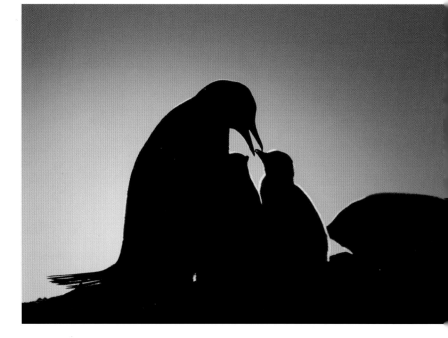

Right **A tender moment between mother and offspring. I was able to hide the sinking sun behind this Gentoo Penguin family, photographed on Petermann Island in Antarctica. I used a light reading taken from the sky above the birds.**

Nikon F5 with 500mm lens, exposure details not recorded, Fuji Velvia 50

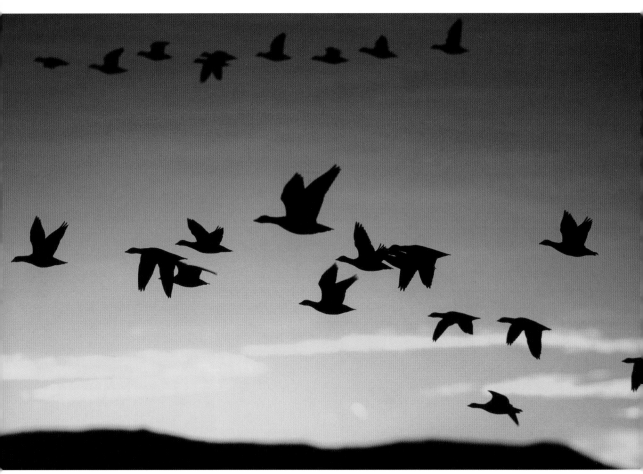

To create your silhouette you need to underexpose the scene. The amount that you underexpose dictates the effect you will get. There is no science to creating a good silhouette and so experimentation with exposure times as you shoot may give you a whole range of acceptable images. What you must do is base your exposure on the sky that your bird is to be silhouetted against. If you take meter readings from the subject then it will fail to be an effective silhouette as some detail will remain in the subject while the background will be badly overexposed.

If I am shooting a bird silhouetted against the sun, when using film I normally take a reading from the sky close to the sun, not allowing the sun itself to influence the reading. If silhouetting a bird against a sky where the sun has already gone down, or the bird is in a good position and I don't want the sun to appear in the shot, then I take a reading off the brightest part of the sky in which

Above **Bosque Del Apache in New Mexico is a prime spot for silhouette shots. These Snow Geese are leaving their roosting ponds prior to sunrise to feed in the surrounding fields. I metered for this shot by using the light reading taken from the middle of the frame, through which the geese are flying, and used that. Creating such shots is not a science and exposures either side of the reading I decided on would have worked, albeit different effects would have been created.**

Nikon F5 with 500mm lens, 1/500sec at f/8, Fuji Velvia 50

the bird is framed and underexpose by two or three stops, sometimes more. The more you underexpose, the stronger the colours will be.

There are some internationally famous sites for obtaining great silhouette images. These include Bosque Del Apache in New Mexico. Here, large concentrations of relatively tame birds can be photographed at dawn and dusk, against water and big open expanses of sky. Combine this with great weather and clear skies for much of the time and you have a premier location for silhouette shooting.

Rim-lighting

While similar to creating silhouettes, in that the bird is lit from behind, rim-lighting is the technique of photographing a subject while shooting against the light, but still retaining detail in the subject itself. Rim-lighting an image can make it into a far more interesting picture. The bird's outline should glow with the light that is hitting it from the opposite direction that you are shooting. With very strong backlighting, if the sun is high in the sky, you might want to use a bit of fill-in flash, to give the bird's plumage some detail, otherwise you might find that you have an image that is halfway between a silhouette and a rim-lit image. Conditions are not always suitable for rim-lighting and if the facing side of the bird is in such heavy shadow, or it is so far away that fill-in flash has little effect, the subtle effect may be lost. In these situations try creating silhouettes instead, if they are possible.

Reflected light

One of the reasons I enjoy shooting pictures in northern latitudes during winter so much, is the wonderful quality of light obtained when sunlight reflects off snow on to a perched bird. Contrast is reduced, and with shadows eliminated a colourful bird can glow. White sand or any other bright surface such as salt flats will have the same effect. Reflected light like this is ideal for photographing flying birds, as undersides are perfectly lit.

Above **While photographing Puffins on Fair Isle one July, I noticed that the fish the birds returned with were translucent when viewed against the sun, so I repositioned myself to shoot them backlit. I took a meter reading of a midtone scene with the sun behind me, and used this for my exposure. For added impact I made sure I was on the bird's level. I also needed to do this to ensure effective backlighting. Always explore all the angles when set up on a subject that will allow you repeated opportunities, such as at a puffin colony in summer.**

Nikon F5 with 500mm lens and 1.4x teleconverter, 1/250sec at f/5.6, Fuji Velvia 100

Below **Snow is a wonderful reflector of light, as illustrated here where the snow on the ground has illuminated this Siberian Tit photographed in Finland.**

Nikon F5 with 500mm lens, 1/500sec at f/4, Fuji Velvia 50

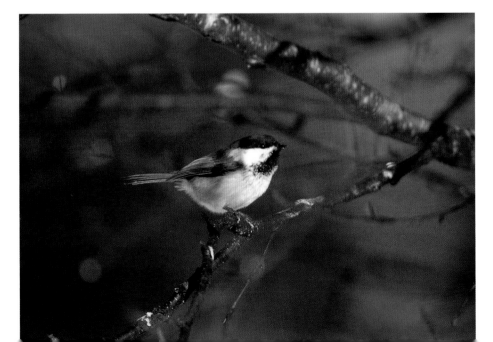

Being Creative

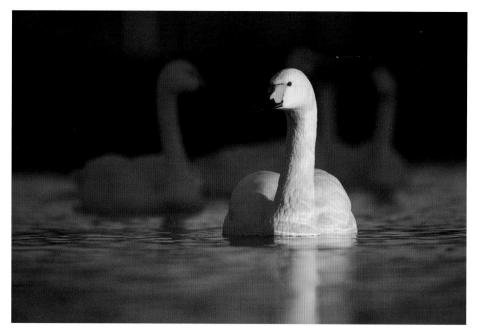

Above **I could only lie in one spot to photograph these Bewick's Swans, and because they only visited this pond at the end of the day when the sun was from the side I had no choice but to take them side-lit. However I feel it is quite effective, and I have exposed by over-exposing by one- and two-thirds of a stop from a meter reading taken on the brightest part of the plumage. Using an angled viewfinder I was able to lie on the ground and rest my lens on a small stone at the side of the pool.**

Nikon F4 with 300mm lens, 1/125sec at f/2.8, Fuji Velvia 50, angled viewfinder

Side-lighting

Side-lighting can be used to great effect in giving an image a bit of atmosphere. It works best when the sun is low, throwing shadows and enhancing plumage detail and colour.

It also helps if you are shooting at a low angle, increasing the intimacy of the moment. Unlike rim-lighting where fill-in flash can be desirable, it is certainly not with side-lit subjects. It is normally far better to accentuate drama in the image with harsh shadows than attempt to relieve them.

Right **Side-lighting can create drama in an image that might ordinarily be quite uninteresting. If I had photographed this Pochard with the sun behind me, it would have been a pleasant enough portrait. But by moving around so that the subject is heavily side-lit, a more eye catching image has been created. This bird, although wild, was photographed at one of Britain's Wildfowl and Wetland Trust centres. The captive birds attract wild birds into the pens each winter by the provision of plentiful food, and because many people visit they soon become tame, allowing good photographic opportunities.**

Nikon FE2 with 600mm lens, Fuji Velvia 50

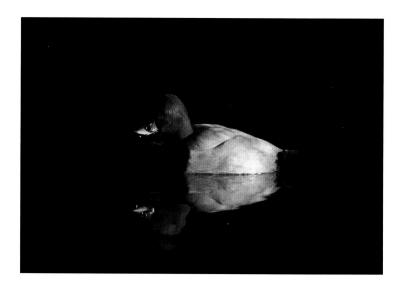

Bird Photography

Above **An ideal subject for remote control photography are birds that have to return to exactly the same spot regularly such as at a nestbox. I introduced my tripod into the bird's environment, and then over a period of three days moved it to within a few inches of the box. Using a 17mm lens I wanted to illustrate the habitat in which the bird was nesting. The bird was soon using my camera as a perch as it approached the nest.**

Kodak DCS Pro 14n with 17-35mm lens, 1/125sec at f/8, ISO 160, remote-control shutter release

Remote control

Getting close enough to photograph birds with a wideangle lens within their environment is not a problem if your subject is tame. However, to do this with shy birds you may need to use a remote-control rig. There are two options for firing the camera, although which is available to you depends on the model of camera you are using. Older cameras tend to use a remote-release cable – typically this is a lead with a pin at one end that screws into your camera's remote release socket. At the other end is a rubber air-filled bag that you squeeze to fire the shutter. More modern models tend to need electrical cables, which you should make sure are fully compatible with your camera when you purchase. Some models of camera are also compatible with wireless units that can trigger a camera at up to 400 metres away.

The trick to successful remote control photography is to have a spot such as a regular perch or perhaps a rock where your chosen subject regularly returns. Secondly the camera needs to be concealed (although this may not always be necessary) and the bird accepting of the set up. When it works this form of bird photography is very rewarding and produces eye-catching results, as few photographers persevere in capturing such pictures.

Shooting low

Whenever I can I shoot from a low perspective. Why? Well, because if you can shoot at eye-level to the bird you are photographing, the resulting pictures take on a far more intimate feel with the observer. A wader photographed at eye-level is a far more arresting image than one taken where the viewer is looking down on the subject, the latter gives a detached feel to the subject of the image.

To shoot low an angled viewfinder is useful and often essential, it also saves your neck and back from taking too much punishment. It is also useful to have a tripod where the legs splay out flat, with no central column, such a tripod can give good support.

The majority of my low angle shots are taken by placing the lens on a beanbag on the ground. When using this technique, a shallow depth of field can create strong out of focus foregrounds that are an effective compositional element within the picture.

Right **A begging Emperor Penguin chick taken using a waist-level viewfinder. If I had taken this image at a higher elevation, I believe the intimacy and much of the impact of the shot would have been lost.**

Nikon F4 with 300mm lens, 1/125sec at f/8, Fuji Velvia 50, angled viewfinder

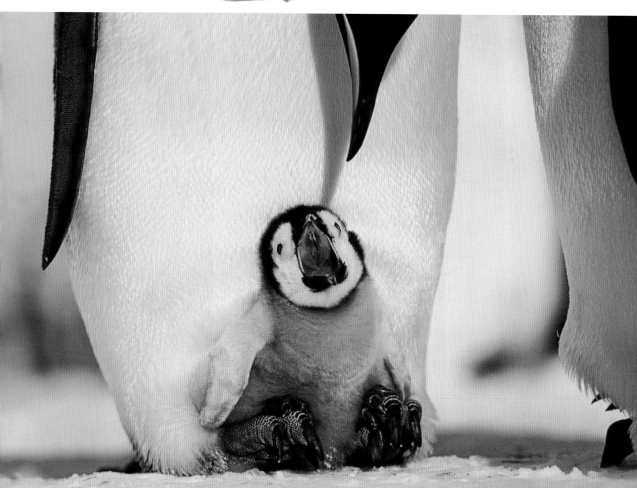

Right and below **Two very different images of the same bird. During the writing of this book, this female Kestrel took up residence along a stretch of road close to where I live. I made frequent visits attempting to photograph her, these were my more successful flight shots, taken by hand holding my 500mm lens. When opportunities arise my aim is always to maximize the variety of images possible. The hovering image was taken late in the day against the light. To create this silhouette I simply used the meter reading recomended by the camera which I knew would underexpose the Kestrel and bring out the colour in the sky.**

Kodak DCS Pro 14n with 500mm lens,

Chances are I may not get another opportunity to photograph a hovering or flying Kestrel this well ever again. Taking opportunities as soon as they arise is one of the ingredients of success.

Kodak DCS Pro 14n with 500mm lens,

Being Creative

In the Field

Shooting in the freezer

The world's cold places are some of my favourite destinations for photography. The birds, such as penguins, are often approachable and the addition of snow and ice gives extra creative possibilities for making pictures. In sub-zero temperatures a basic knowledge of how to keep warm will free your mind up to concentrate on taking pictures. Cold feet or hands will soon make photography feel like a chore, so good boots and gloves are essential.

When photographing in sub-zero temperatures I wear Sorel boots, which are manufactured in Canada. They are fleece-lined for extra warmth, and have soft rubber-studded soles, which give superb grip on ice. Gloves are an important consideration, as you need to be able to operate a camera without exposing your hands to the cold. I use a combination of thin fingered gloves that are good enough on their own in temperatures down to just below freezing. For colder conditions I then wear a large pair of mittens over the top and remove these when taking pictures.

Around 50 per cent of body heat is lost through the head. Woolly hats are great for chilly climes but not for sub-zero temperatures. When the mercury plummets I resort to wearing a Russian ex-army fur hat with ear-flaps. These can be found in shops selling ex-army gear. Derivatives without the fur can be found in outdoor shops. In really extreme conditions I add a balaclava, that

Opposite **While on a trip to India to photograph Tigers, I came across this displaying Peacock late one afternoon. Peacocks always seem to prefer to display in the shade, this bird was no exception, so I used fill-in flash to help bring out some of the irridescence in the plumage. Rather than using a short focal length lens to get the whole bird in the frame, I opted to use my 500mm lens, and kept a tight crop on the bird's head for impact.**

Nikon F5 with 500mm lens, exposure details not recorded, Fuji Velvia 50, fill-in flash

Above **Living in extreme conditions such as these is a challenge. This was a spectacular storm at Patriot Hills, Antarctica, the base we used from which to fly to an Emperor Penguin colony. Winds exceeding 70mph (112kph) ripped through the camp and the temperature plummeted. Photography was difficult in these extreme conditions, but very exciting.**

Nikon F5 with 24mm lens, 1/250sec at f/5.6, Fuji Velvia 50

Below **Finland is a cold place in winter, but the Finns know how to build hides for bird photography. They are not only luxurious but extremely well insulated. Once a heater is going, even if it's -4°F (-20°C) outside, you can strip off and have a snooze when things are quiet!**

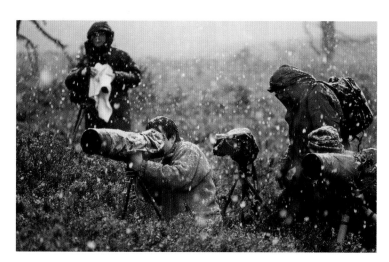

allows exposure just to my eyes. In interior
Antarctica, when frostbite of any exposed skin
was a real possibility, then even this opening was
protected by a pair of goggles.

Wearing the right amount of clothing is key to
striking a happy medium. You have to balance being
too hot when you are walking, with being too cold
when you are standing still. The trick is to wear
a few layers that will trap warm air. My typical
clothing for a trip into sub-zero temperatures
consists of a T-shirt followed by a light long-sleeved
top designed for climbers, then a fleece, followed by
a lined jacket that comes down to just above the
knees. On my legs I wear thermal underwear, a pair
of light trousers and often a pair of ski salopettes
over the top that are water- and windproof.

My lined jacket has lots of internal pockets that
are ideal for keeping batteries warm in cold
weather. Battery usage is the biggest challenge in
the cold, and they can deplete at an alarming rate.
Depending on your camera you may have dedicated
rechargeable power packs, as well as a facility to
use normal batteries. Power packs work well in the
cold. The alternative is to use lithium batteries and
although these are expensive they are worth it for
their extra longevity over alkaline batteries.

Sudden temperature changes, such as going out
into the cold from a warm building and vice versa,
will cause condensation on your lenses and
cameras unless you take precautions.
Condensation is a big problem as it can introduce
damp into electronics and lenses if it forms in
warm surroundings. Conversely, condensation
forming on lenses in a cold environment can quickly
freeze; a problem I encountered in the Antarctic

when I inadvertently breathed on my camera's
viewfinder, in a -40°F (-40°C) temperature.

To avoid condensation if going from a warm to a
cold environment, I place my kit in a plastic bag and
wait for the temperature to equalise, or gradually
decrease the temperature in the vehicle that I am in
before venturing out. Many modern-day photo
bags are very well insulated and will retain cold or
warmth for quite a time. If you don't use a plastic
bag when coming in from the cold it is worth trying
to find a cooler room, such as a garage or lobby,
where your gear can gradually acclimatise.

Often when the weather is bad great
opportunities present themselves; penguins
huddled in a blizzard or heavy snow falling on a
sheltering bird. While you might be fully protected,
your gear needs protection too in order to continue
operating. There are some excellent camera and
lens covers sold, that will protect the lens from
snow or rain, but will still allow operation. A large
dustbin liner or plastic bag are good makeshift
covers that can easily be transported.

Another tip is to wrap one of the top segments
of your tripod leg in tape or insulating foam so that
it's more comfortable to carry in the cold. It is
amazing the difference this makes even on just
a cold frosty morning.

Using a tripod in deep snow creates a couple of
problems. The legs of your tripod are likely to sink
and as they do, will attempt to spread even wider
than they are. If pulled out fully they may crack the
top casting of the tripod, something I have seen
happen both in snow and also in deep heather,
which creates a similar problem. The trick is to leave
some room for the legs to spread as they are placed

in the snow. To stop your tripod from sinking you can either make or buy tripod shoes. These fit over the feet and spread the weight.

Moving around in a few inches of snow is no problem, but visit Canada, Alaska or Scandinavian countries in winter, and chances are that away from the roads snow may lie more than a metre deep. This becomes impossible to walk on if wearing just boots, so the answer is snow shoes. These spread your weight and allow you to walk over deep snow without disappearing. They take a bit of getting used to, but once mastered, access to just about anywhere opens up.

During one of my trips to Finland in winter, a Finnish friend took me to a remote cabin by a lake to photograph White-tailed Sea Eagles. We reached the cabin on snowmobiles. This was my first experience of riding one of these machines. It proved very difficult to drive on soft powder snow, a surprise as when I had set out driving along ice-covered tracks, it seemed simple and I was able to have some fun opening up the throttle. On the snow however, it was a different ball game. I fell off on numerous occasions, including one spectacular crash that saw me flying through the air. So if your trip includes driving one of these in deep powder snow, make sure you get some tuition first!

Above **Snow shoes allow access to places that, when in deep snow, normal boots will not.**

Below **This Snow Bunting was photographed from the car during a heavy snow shower in northern Finland. The falling snow lifts what would have been a pleasing portrait, to a picture that also illustrates the conditions the bird lives in.**

Nikon FE2 with 600mm lens, exposure details not recorded, Fuji Sensia 100

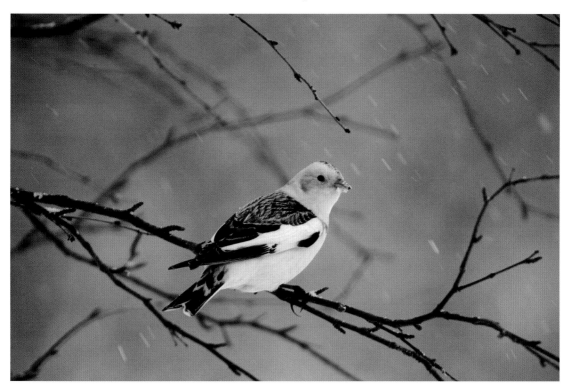

In the Field

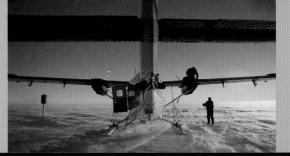

Emperor penguins, Weddell Sea, Antarctica

During the summer of 1998 an opportunity arose for me to join an expedition to Antarctica. The aim: to reach an Emperor penguin colony in the Weddell Sea where we would camp on the sea ice. The chance to be able to photograph one of the most sought-after subjects in the wildlife photography world, something that few others had ever done, was too good to miss.

The members of Scott's ill-fated 1911 expedition to the South Pole, were the first humans to witness an Emperor Penguin rookery. In the past decade, however, with the break-up of the Soviet Union and the resulting availability of Russian ice-breakers suited for Antarctic exploration, reaching Emperor colonies has become a viable proposition. However the earliest that such boat-based trips can reach colonies is usually mid to late November, while time at the colonies is limited.

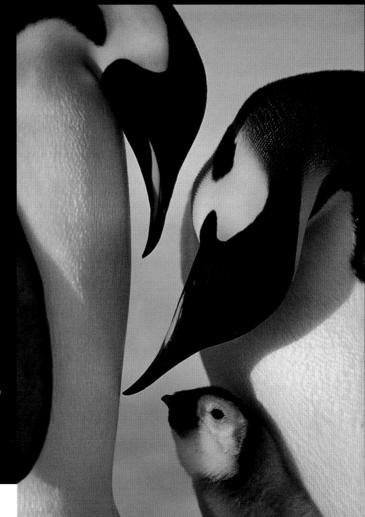

Right **Capturing an image such as this of an Emperor Penguin family, can take many hours of patient waiting until all the key elements of the image come together. Time to explore all the creative possibilities is one of the reasons a fly-in expedition is preferable to visiting a colony from a cruise ship.**

Nikon F5 with 300mm lens, 1/125sec at f/8, Fuji Velvia 50

The expedition I was joining planned to fly in to the interior of the great white continent to Patriot Hills, a temporary summer base just 680 miles (1094km) from the South Pole. We would reach the colony early in November, giving us a chance to find young chicks still being brooded on their parents' feet – the penguin photographer's ultimate trophy!

Travel in Antarctica is at the mercy of the weather, and trips that start on time are just about unheard of. We had a delay of six days before, on 4 November, we boarded the Hercules C-130 for our southbound flight from Chile to 'the ice'. But not before spending a couple of stressful days prior to our departure agonizing about weight problems.

We were told before our departure that we were limited to a 50lb (22kg) weight limit. Clearly for such an important and costly trip, I wanted to take all the photographic gear I could in order to cover any eventuality. I settled on a 20mm wide angle, 135mm f2.8 and 300mm f2.8 lens, plus 3 camera bodies, a flash gun, tripod and 200 rolls of film. With clothing as well, this far exceeded the luggage limit. However we discovered that the operators taking us never weighed sleeping bags, which were kept separate from the main luggage as they were useful for keeping warm on the flight. Come departure time, we all weighed in under our allowance, but struggled on to the plane with very heavy sleeping bags!

The flight took six hours, and not long after crossing the Antarctic Circle we had our first views of the Antarctic Continent: Alexander Island. The Ellsworth Mountains, the highest range in Antarctica eventually came into view. Nestling at the base of the Ellsworth's, the blue ice runway at Patriot Hills sparkled in the sun. If you have a fear of flying, then landing on a blue ice runway is not recommended. The Hercules lands on wheels and, as the ice is like a skating rink, no brakes are used in the landing. It's certainly not for the fainthearted!

Patriot Hills is a tented camp run by an organisation called Adventure Network International that lies at 82 degrees south. It is the main access point for expeditions to various sites on the continent. We had hoped to fly straight out of Patriot Hills, but due to poor weather at our final destination we were once more delayed, this time for five days. Our first night under canvas was the coldest night we experienced, with a temperature of -0.4°F (-18°C) inside the tent. A couple of days later a storm ripped through the camp with winds exceeding

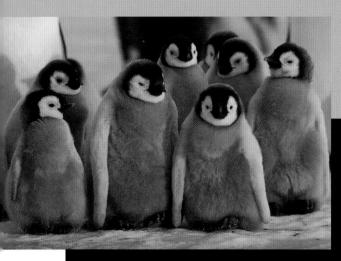

normally in extreme cold I have my motor drive set to a slow advance mode, but if you do not have this facility, it may be worth having your motor drive set to single shot mode.

For the duration of my time in Antarctica, I kept my gear in a photo backpack, which was both well insulated and sealed from the snow. The backpack was kept outside the tent, which meant I never had to worry about condensation. Only my batteries were kept warm, stored in my

75mph (120kph) bringing a wind chill temperature of -00°F (-55°C), an incredible experience. In these temperatures film becomes very brittle, and a couple of leaders snapped on loading. Another problem is reloading the camera. With blowing snow and the extreme cold it is imperative not to have your gloves off for more than a few seconds and the roll must be changed with the camera inside your jacket.

Along with brittle film, extreme cold can create static electricity, particularly when the air is dry. A motor drive for advancing film is normally the culprit, the fast movement creating a spark, that can leave a mark on your film. I have only ever had this happen once, as

Below **Adverse weather can create unrepeatable opportunities. This group of Emperor Penguins was huddled together during a storm, with winds exceeding 50mph and a windchill temperature of 31°F (-35°C). This was one of the most challenging photographic situations of my career, but manageable due to being fully protected against the cold. A balaclava and goggles were needed to protect my face from frostbite, and blowing ice and grit created by the penguins' frozen guano. Few photographers have had an opportunity to photograph Emperors in such conditions, so it was important to maximize the opportunity.**

Nikon F5 with 24mm lens, exposure details not recorded, Fuji Velvia 50 pushed 1 stop

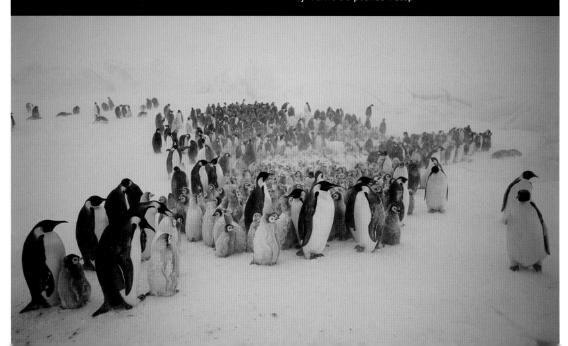

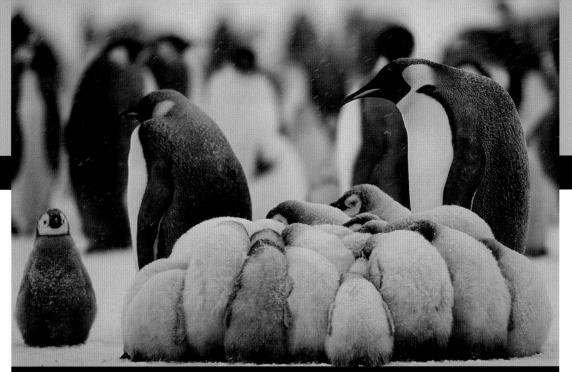

Above **Another endearing image, an Emperor chick has been left out in the cold, while the others huddle together in a creche to keep warm.**

Nikon F5 with 300mm lens, 1/125sec at f/8, Fuji Velvia 50 pushed 1 stop

jacket. The clothing I wore was that which was described earlier in the chapter with the addition of a down jacket, rather than my normal lined jacket. We slept in down sleeping bags, which kept us warm in temperatures of –40°F (–40°C).

The daily routine of checking satellite images for the weather was finally broken late on the afternoon of the 8 November, and by early evening we were on our way. The 930 miles(1500km) to our destination rookery took six hours, including a stop en route at a fuel cache that we had to dig out of the snow. The first major drama occurred here; the starter in one of the Twin Otter's engines failed, so the flight engineer had to repair the fault as best he could. Thankfully we were soon airborne again, flying over a breathtaking landscape of crevasse fields and glaciated valleys.

The Dawson-Lambton Glacier came into view at 1.40am. It enters the south-western part of the Weddell Sea, west of the Brunt ice shelf, and was discovered in 1915 by Ernest Shackleton. By 2am we had landed safely on the sea ice, with the sun low on the horizon, casting a beautiful light across the ice. We hurried towards the colony. Once the colony came into view we were all speechless, it is impossible to do justice in words to the spectacle of thousands of penguins standing against a backdrop of towering ice cliffs

and shimmering blue pressure ridges. For the next six days we had almost unbroken sunshine. My film stock was Fuji Velvia 50, and I tended to shoot from 6pm through to 8am. There were two reasons for this, the sun being at it's lowest gave a beautiful quality of light as opposed to the harsh daytime light when the sun was overhead, and it was far more comfortable to sleep in the tent during the day, as the sun warmed it. There was no need for long lenses as when working in the colony you could get relatively close to the penguins, although I almost exclusively used my 300mm lens, as the shallow depth of field that it gave proved helpful in blurring the often cluttered backgrounds that could otherwise have distracted viewers from the main subject of the image.

Temperatures often hovered around the freezing mark during the middle of the day, at night once the sun was low, the temperature would typically drop to between 23°F to 5°F (–5°C to –15°C) – comfortable conditions for picture taking. On our

In the Field

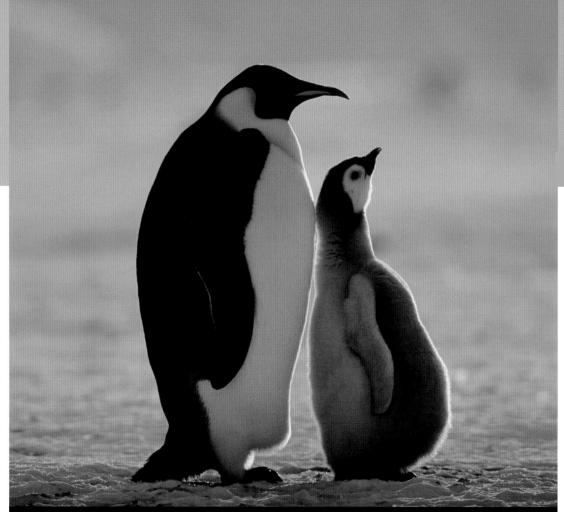

Above **If you sell your work, then images that mirror human emotions are generally the most commercial. This image conveys feelings of contentment, reliance and calm amongst others, all good ingredients for a successful selling image. I took the image of this adult Emperor with chick at around 2am, at which time the sun was at its lowest.**

Nikon F5 with 300mm lens, 1/60sec at f/2.8, Fuji Velvia 50

seventh day a storm hit. Temperatures dropped and the wind howled. We experienced complete white-out conditions, confining us to our tents for almost two days. During the storm we managed to reach the colony, just over 1.2miles (2km) away, on two occasions. It was difficult to reach, as disorientation in the blowing snow caused us to retrace our steps and start again. When we did eventually reach the penguins, we were faced with huge creches of young, huddled together in the driving snow, scenes that made some memorable images. The intense cold, and the grit and snow in the air made reloading the camera difficult, and possible only by kneeling with my back to the wind and reloading inside a half-open coat. Lenses soon became coated in snow and the fine grit created by the frozen penguin guano. It was during this storm that one of my cameras failed. The other struggled with failing power, but although sluggish the electronics

continued to operate, and I was able to make pictures. My journey to the Emperors ended in drama, as on the tenth day the ice on which we were camping started to crack. It was time to leave. We had to take off in very poor weather, and because of a low fuel load, needed to refuel at a nearby fuel dump on the Antarctic Plateau. As we circled over the fuel, it was clear that the weather was too bad to attempt a landing, however the pilot spotted a hole in the clouds, which he managed

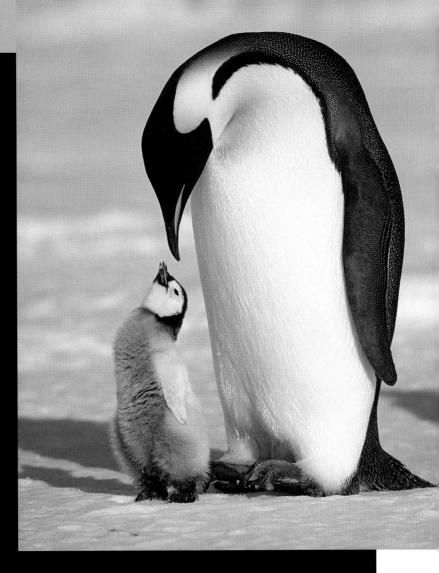

to navigate the plane through. We were some way from the fuel, but the hole was drifting in the right direction, after a wait of fifteen minutes we took off again, but again we were forced to land short of the fuel. The pilot then decided it might be worth attempting to taxi to the fuel. This we did, and eventually we arrived back at Patriot Hills at 4am tired and hungry, but with a satisfied feeling that we had managed to capture during our ten days some unique images of a bird that lives in the harshest environment on the planet. A further wait of five days was experienced, until the weather allowed the Hercules to come in and fly us back out to Chile.

This was a remarkable journey that was a test not only to my physical capabilities but to those of my equipment. It is one of the shooting situations that even now, with robust digital cameras, may still favour using film.

In the Field

Beating the heat – health matters

For me staying focused on photography in the heat is harder than dealing with the cold. Extreme heat and high humidity can be debilitating. Some of the world's outstanding sites for bird photography lie in such areas. Unlike cold climates where insects are few, health matters come more to the fore in the tropics, where both insect and waterborne disease are a real possibility. Listed below are a few measures you can take to minimize your exposure to health risks when travelling in the tropics.

On any trip to a developing country or remote region it is worth packing a medical kit, with dressings and bandages for minor cuts and scrapes, antiseptic and a pack of disposable syringes. I always take plenty of packets of rehydration mixture after experiencing a particularly bad bout of food poisoning in Peru. While on the subject of tummy trouble, take a good supply of Immodium, or similar medication, so as to avoid getting caught short. If you can, obtain a prescription for antibiotics from your GP to help prevent more serious diarrhoea.

Most importantly, you should ensure before you leave that you are up to date with the required vaccinations for the countries you are visiting. When entering some countries, border guards may insist on seeing certificated evidence of cholera and yellow fever vaccinations, particularly if you are leaving a zone where the diseases are prevalent.

Taking care of your gear

The photographer has two big enemies in hot climates: dust and humidity. Many parks in India, Africa and South America are notorious for having very dusty tracks and roads, and it soon coats your gear if not protected. If travelling along dusty roads on long journeys I may put my camera bag inside a large plastic bag. In open-topped jeeps, where constant use of the gear is required, I wrap the camera and lens in a towel or jacket, giving protection, as this gives the ability to fling the cover off the lens, if a subject suddenly presents itself. I pack a make-up blusher brush for cleaning the dust off equipment. These work really well and are ideal for cleaning the inside back of film cameras too.

Dust is one of the digital photographer's big enemies. The sensors in digital cameras can easily accumulate dust, and this will then show on your resulting pictures, leading to some time-consuming work on the images once they have been downloaded.

These basic rules have helped me to enjoy the vast majority of my journeys in good health.

○ The best way to avoid contracting malaria or other insect-borne diseases is to avoid getting bitten in the first place. Applying insect repellent and wearing long sleeves, long trousers and decent footwear are all advisable. Sleeping under a mosquito net is a good idea. It is worth packing one as even if they are available at your destination, they are sometimes in a poor state of repair with holes and rips.

○ If you are entering a malarial zone, then instructions for taking anti-malarial medication should be followed.

○ Ice cubes in drinks, tap water, ice cream and ice lollies should all be avoided in developing countries. Use bottled water for cleaning your teeth, and check the seal is intact. In some countries unscrupulous sellers collect discarded bottles and fill them up from the tap or worse!

○ Any raw or uncooked food such as salads should be avoided. Fruit should only be eaten if you can wash or peel it yourself.

○ Be aware of the strength of the sun, a large-brimmed hat and sunscreen may save you from heat stroke or sore skin. If you travel regularly in the tropics, or where there is bright sunlight and glare, for example in polar regions, then wearing sunglasses will prevent damage that may cause cataracts later in life.

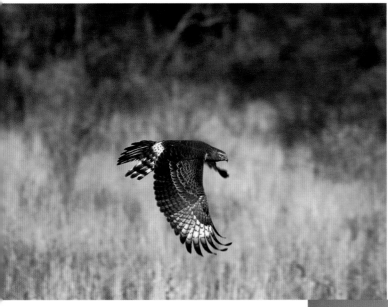

Left **I had my camera under a jacket to protect it from the dust while travelling along a very dusty road in Namibia but, by reacting quickly, I caught this image of an immature Pale Chanting Goshawk as it swooped by my vehicle. It is a good idea to have your gear set up in your vehicle, as you never know what might appear along the roadside.**

Nikon F5 with 500mm lens, 1/1000sec at f/5.6, Fuji Velvia 100

Below **Photographing birds in rainforests such as the Amazon is a big challenge. Not only are many of the birds elusive, but the high humidity can be hard on your gear.**

Nikon F5 with 300mm lens, 1/125sec at f/4, Fuji Velvia

Clean your sensor on a regular basis. I would suggest you never touch your sensor, but instead use a powerful air blower – the type you squeeze with your hand. Never use a can of compressed air as this can spray moisture over it. Camera manufacturers offer a cleaning service and it is likely that once in a while you will be resigned to sending it back to them for a decent clean. We can only hope that camera manufacturers will find technology to solve this problem in the not too distant future.

Humidity can be a problem, if you are travelling or staying in an air-conditioned environment. A sudden temperature change from cold to hot will cause condensation, something you should attempt to avoid. One way is to put your gear in a plastic bag or other reasonably airtight container and allow the temperature to slowly reach the outside temperature, and vice versa if taking your gear inside. Ziploc bags are a good solution to this.

Storing gear in very humid countries can, over time, lead to mould and fungal growth on lenses. Many photographers who live in the tropics get round this by storing their gear in 'dry cabinets' that have an in-built electrical de-humidifier. Such measures are not needed for the travelling photographer, however a good way of keeping humidity down in your camera bag, if staying in a rainforest or similar environment, is to use silica gel, a desiccant that absorbs moisture. You need to buy the indicating type, which is blue and then turns white when it becomes saturated and is no longer effective. It is easily re-used by sticking it in the oven for around 10 minutes at 300°F (150°C), or a couple of minutes in a microwave should do the trick. It can be kept in a sock with the top tied and placed in your camera bag. In normal humidity, silica gel has an effectiveness of roughly three weeks.

In the Field

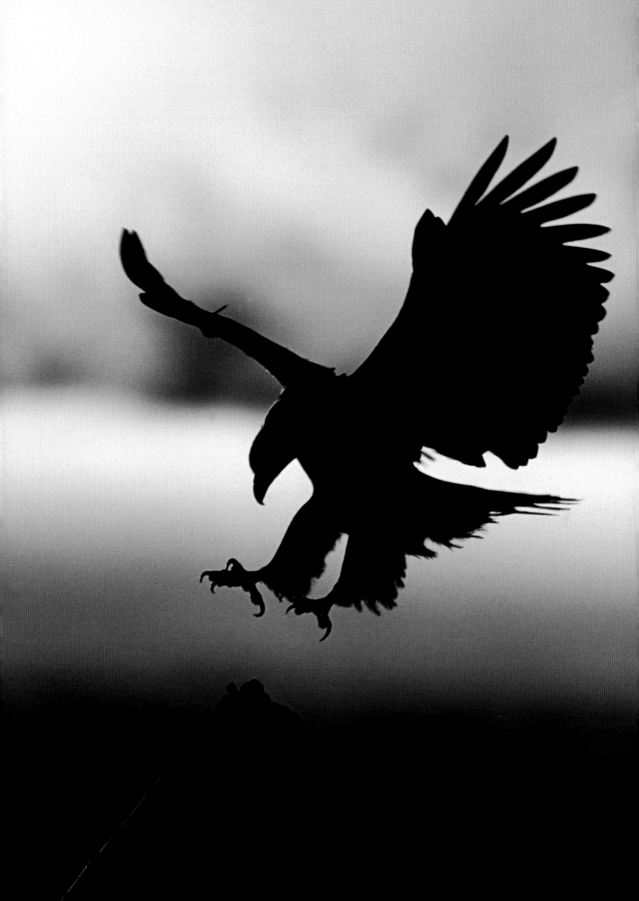

Chapter 5 The opportunities available to bird photographers around the globe have never been better than they are now. If your aim is to photograph a particular species, or visit a region or country, chances are there will be someone somewhere who can help you.

Planning and Travelling

With any trip visiting at the right time of year is paramount, so plenty of research before you go will pay dividends. If you have an interest in a region or country and want to visit in order to photograph as diverse an array of species as possible, then one of the best places to start looking for ideas on where to go, and when, is to peruse the many brochures that birdwatching holiday companies produce. Of course such holidays are not designed for photographers, but the brochures often go into a lot of detail and so can give a good feel for a place.

In recent years more and more travel guides have been published that specialise in destinations rich in wildlife, so these too are worth looking at. The drawback to these is that often the popular general travel guides have wildlife sections written by travel experts rather than informed writers on wildlife, and this is often particularly true when chapters are written on birdlife.

The most complete resource is the internet, which has a mass of information awaiting discovery. In searching here, you are also likely to uncover leads for ground agents and locals who will be able to help with advice and logistics for your trip.

Above **There are some destinations, such as this vast King Penguin colony at St Andrew's Bay on South Georgia, where the only way of travelling is with a group. But with trips such as this, once you are there you can still go off on your own. South Georgia is a good example of a destination that is offered by many cruise boat tour operators, yet time ashore varies from just an hour or two with some companies to a whole day at each location with others. So wherever you decide to go, investigate thoroughly what is being offered and try to speak to photographers who have taken the tour in the past.**

Hasselblad Xpan with 45mm lens, 1/60sec at f/8, Fuji Velvia 50

Opposite **One of my favourite Bald Eagle shots. I waited for over an hour for this bird to land on this piece of driftwood, on a beach in Alaska.**

Nikon F5 with Nikon 500mm lens, exposure details not recorded, Fuji Velvia 50

Finally the most important resource is talking to other photographers who have visited the places you intend to visit. There is no substitute for first hand experience and knowledge, and the vast majority of bird photographers will be only too happy to pass on information.

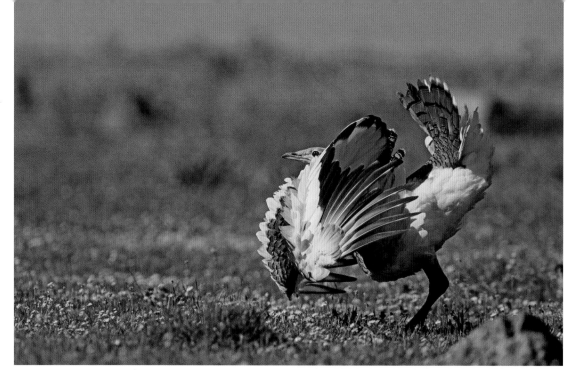

Above **Tailored opportunities now exist for species that most photographers could once only dream about photographing. For example in Spain you can now join an organized tour to photograph Great Bustards. Of course, these opportunities do not guarantee success. I had a bit of luck with this species, as this young male started to display to a female that happened to walk close to my hide.**

Nikon F5 with 500mm lens, 1/500sec at f/5.6, Fuji Velvia 100

Joining a group

Bird photography lends itself to being a lone pursuit, but many of us enjoy following our interests with like-minded others. Another, perhaps more compelling, reason for joining a group for a bird photography trip is that of logistics: costs come down, it can be physically safer, and if you are going on an organised trip with an experienced leader, time can be saved and opportunities maximized.

When I first got into photography, wildlife photography tour operators were as rare as the dodo. Today, this part of the eco-tourism market is one of the fastest growing and many trips offered by specialist operators are sold out even before they reach the brochure.

Destinations offered by these companies tend to be those sites that provide almost guaranteed opportunities. Locations such as Florida, Africa, India and Antarctica are places where the birds are so approachable that you cannot go far wrong. If your desire is to photograph birds in more off-beat destinations, perhaps those only offered by a few of the bird tour operators, then this might be the only route.

However, while companies may insist good photographic opportunities are possible, you could find that the pace and the way the tour is set up causes frustration. Other tour participants once they have seen a bird will want to move on and

a schedule will need to be kept to. Of course you cannot move in on your subject until everyone has stopped watching it with their telescopes, and by this time the pressure is on you as you stalk the bird, while other tour participants climb aboard the minibus keen to move on.

So try to avoid birdwatching tours if photography is your main interest. If planning to go on an organised photo tour, you are likely to be parting with a considerable amount of money. So before you sign up contact the leader and ask plenty of questions; in short, satisfy yourself that the trip is likely to produce the kind of opportunities you want.

There will always have to be compromises made with group travel but at least with a photo tour the whole group is there to take pictures. Photo tours are great fun, they are normally relaxed rewarding holidays, and with a good leader should be instructional, so that opportunities to develop your photography are created.

Going it alone

Individual travel is easily arranged to the majority of key bird photography areas around the world. Careful planning is of course crucial and, as discussed above, the internet offers plentiful information and further leads on your chosen destination.

Some countries now have local bird photographers and tour operators who are offering tailored opportunities for desirable target species. For example in Spain there is a specialist operator offering Great and Little Bustard photography. In Finland opportunities exist at specially designed sites to photograph in the wild, Golden Eagles, Capercaillies and Black Grouse at leks, fishing Ospreys and, in good winters for them, even hunting owls. Such trips are not cheap, but remember, setting up such opportunities in many cases may have taken years, and considerable work by the locals to keep them viable. Imagine transporting a dead cow two miles through a forest in the depths of a Finnish winter in order to keep the eagles happy. So, if you are planning to visit a country with a specific target bird in mind, it is worth investigating whether there is a local who can help.

Travelling abroad

It is every photographer's nightmare to have their precious photo gear transported in the aircraft hold. Security and restrictions are increasing all the time for flying passengers. As airlines continue to tighten their rules and security at airports evolves, the difficulties of travelling with lots of photographic gear increase. I am continually adapting how I travel with my gear. It pays to have a flexible approach, and a helpful attitude.

In more recent years I have run into difficulties with my carry-on bag. Although I use a bag that fits the size rule of airlines, it normally weighs in at around 33lb (15kg), nearly three times the usual acceptable weight limit when flying in economy. On one occasion I was asked to hand it over so that it could be placed in the hold. It took a lot of gentle persuasion to keep my gear with me, but probably saved it from being thrown around and damaged.

This experience made me reassess and I purchased a Pelican™ case. These cases will withstand any treatment, are hard and rubber sealed. However, they are heavy. This meant that my hold luggage with the Pelican™ case would tip the scales at over 77lb (35kg). Furthermore the case shouts 'steal me' – that is, before the potential thief realises its weight! – particularly as it is wise to lock it with two heavy-duty padlocks. Some photographers put their cases in duffel bags or similar as a disguise. On my second outing with this case, it got off-loaded on a flight I was on, and so when I arrived at my destination I had no photo gear and had to wait three days for it to arrive.

Apart from the security and potential damage implications of putting your gear in the hold, if you do decide to do this, make sure your photographic insurance covers damage or theft whilst in the custody of an airline, as many policies have an exemption clause. Airlines and airports are not insured for such losses, and may well pay out a maximum that is far short of the value of your gear. If your equipment is stolen or damaged in transit on your outward journey, an eagerly anticipated holiday could be ruined.

I have gone back to transporting all my essential photo gear as carry-on baggage. Extra items such as spare camera bodies and my tripod and head, are packed in bubble wrap and placed in a hard-cased suitcase.

A number of airlines only allow one item of carry-on baggage. An increasing number allow a main bag and a smaller item such as a laptop or briefcase. I always take film as carry-on luggage. This is a must as the X-ray machines used for screening hold baggage will ruin your film stock, never ever put film in your hold baggage. Before turning digital I used to put my film, an average of 100-plus rolls, in a duty-free plastic bag and was never challenged. If you are hoping to take additional weight in luggage on to a flight, it is best to avoid the cheaper low-cost airlines who will often charge you for overweight hold baggage. They usually weigh and inspect hand baggage and place a tag on it, to confirm checking.

Airline staff these days have the right to stop you from flying. If challenged about a heavy bag politely explain what is in it. If your powers of persuasion are failing point out that your insurance will not cover the gear in the hold and nor will the airline take responsibility. This last line of defence normally works.

Finally it is a good idea to try to be one of the first on to the plane, so there is plenty of room in the overhead lockers. If you arrive late and get on last, if all the space is full, and your bag fails to fit under a seat, you could find it being taken off you and put in the hold.

North America Pribilof Islands Homer, Alaska Anhinga Trail, Florida Sanibel Island, Florida Venice Rookery, Florida Bo
Antarctic Peninsula, South Shetland Islands and Weddell Sea Ross Sea **Australasia** Lamington National Park, Australia

Antarctic Islands **Asia** Beidaihe/Happy Island, China Bharatpur, India Khichan, India **Europe** Lesvos, Greece Varanger, A
Scotland Hermaness, Scotland Mousa, Scotland Fair Isle, Scotland Caerlaverock, Scotland Pembrokeshire Islands, Wa

Site Guide

Many of the world's great wildlife spectacles involve birds, whether it be a pink mass of flamingos on one of Africa's Rift Valley Lakes or an Osprey plunging into the water to emerge with a writhing trout. I have selected in the following guide some of the most popular subjects and locations for bird photography. I have had to be highly selective in my choice. Much of my selection is personal and based on experience.



, Florida Churchill, Canada **South America** Galapagos Islands Manu, Peru Falkland Islands **Antarctica** South Georgia Australia Kakadu National Park, Australia Steward Island, New Zealand South Island, New Zealand New Zealand Sub-

ngasala, Finland South West Archipelago Kuusamo, Finland Hornborga Lake, Sweden Farne Islands, Scotland Bass Rock, Wales Slimbridge, England Welney, England **Africa and the Middle East** Eilat, Israel East Africa Southern Africa

North America Pribilof Islands; Homer, Alaska; Anhinga Trail, Florida; Sanibel Island, Florida; Venice Rookery, Florida; E
Rookery, Florida; Bosque del Apache, New Mexico; Churchill, Canada; Pribilof Islands; Homer, Alaska; Anhinga Trail, Flor

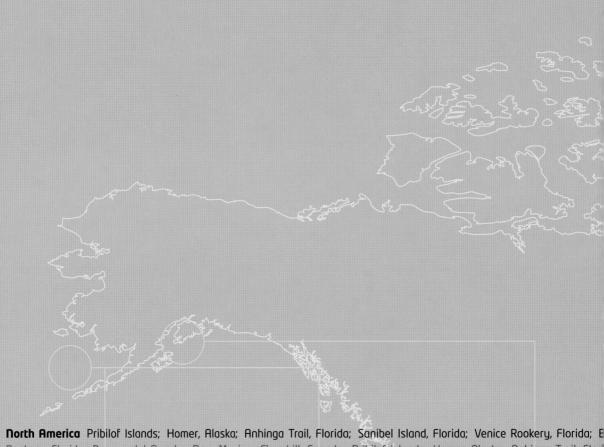

Anhinga Trail, Florida; Sanibel Island, Florida; Venice Rookery, Florida; Bosque del Apache, New Mexico; Churchill, Canada
Churchill, Canada; Pribilof Islands; Homer, Alaska; Anhinga Trail, Florida; Sanibel Island, New Mexico; Venice Rookery, Florid

North America

Early conservationists such as John Muir (America's most famous and influential conservationist), laid the foundations for a network of national parks and wildlife reserves that can be matched by no other continent in the world. Several books could be written on the fantastic bird sites to be found across America and Canada, therefore those listed here are just a representation of some of the most popular sites visited by bird photographers living outside of the North American continent.

If planning a trip to North America, the temptation is often to try and cram too much in. Distances between your desired places to visit might be huge. Luckily internal flights are frequent and reasonably priced, car hire is relatively cheap too.

The sunshine state of Florida is one of the easiest places on the planet to photograph birds. Great light and often very confiding birds is a recipe for great images. Because of these two factors creative bird photography is easier here than anywhere else I have been.

Bird photographers are also plentiful in North America. If you visit any of the popular bird photography sites you may well find like-minded souls offering good information on local opportunities.

ne, New Mexico; Churchill, Canada Pribilof Islands; Homer, Alaska; Anhinga Trail, Florida; Sanibel Island, Florida; Venice
d, Florida; Venice Rookery, Florida; Bosque del Apache, New Mexico; Churchill, Canada; Pribilof Islands; Homer, Alaska;

Homer, Alaska; Anhinga Trail, Florida; Sanibel Island, Florida; Venice Rookery, Florida; Bosque del Apache, New Mexico;
ache, New Mexico; Churchill, Canada; Pribilof Islands; Homer, Alaska; Anhinga Trail, Florida; Sanibel Island, Florida; Venice

Key Birds All the breeding seabirds are accessible for photography and include Northern Fulmar, Pelagic Cormorant, Red-faced Cormorant, Glaucous-winged Gull, Black-legged Kittiwake, Red-legged Kittiwake, Guillemot, Brunnich's Guillemot, Parakeet Auklet, Least Auklet, Crested Auklet, Tufted Puffin and Horned Puffin.

Pribilof Islands

They have been described as the Galapagos Islands of the north, the Pribilof Islands may well be one of the foggiest places on earth, yet they really do live up to their billing. The island teems with life in summer, with over two million seabirds crowding the cliffs, whilst the beaches attract more than 900,000 Northern fur seals to pup.

The small archipelago lies 200 miles (320km) north of the Aleutian islands, a chain of over 150 volcanic islands off Alaska's coast. There are two main seabird islands, St Paul and St George, lying 40 miles (64km) apart. St George has historically been more difficult to reach due to frequent flight delays and cancellations as a result of poor weather. However this is no longer the problem it once was. St Paul is easier to reach and has a more developed infrastructure for visitors. Although the cliffs and seabird colonies are not as spectacular as those on St George, they are arguably more accessible for photography and all the same species are present. The island of St Paul stretches for 14 miles (22.5km), with the main town (also called St

Paul) the base for a stay. During summer the island's tundra interior puts on a colourful display of wildflowers, in amongst which nest Lapland Buntings and Rock Sandpipers, both of which can be photographed with a little effort. However it is the cliffs that are the main attraction, with a host of seabirds on offer, and the majority tame enough for frame-filling portraits.

There are four main stretches of cliff on St Paul suitable for photography. Close to the town and within easy walking distance is Reef, where the cliffs are low, and species such as Crested Auklet breed in reasonably accessible locations. Zapadni Cliffs require extreme care, as there are partly concealed volcanic lava tubes just inland of the cliff ledges, whilst the latter are quite crumbly. These cliffs are good for photographing Black-legged Kittiwakes, but not great for the auks. Ridgewall is my favourite spot for photography, with some good opportunities for most species. Most spectacular are the South West Cliffs, and here too photography is good for a range of species.

Below Tufted Puffins are one of the most photogenic seabirds nesting on the Pribilof Islands. I photographed this individual on the West Cliffs. Although these cliffs are high and on first glance do not appear great for photography. Closer inspection will reveal a few points from which pleasing images can be taken.

Nikon F4 with 600mm lens, 1/250sec at f/5.6, Fuji Velvia 50

Above **Numbering in their millions, the Least Auklet is the most abundant seabird of the North Pacific, and the smallest, being the size of a sparrow. It nests in large numbers on the Pribilof islands, favouring boulder beaches as well as crevices in cliffs. The best way to photograph them is to sit quietly on the edge of a colony. During the afternoon they come ashore in large numbers. This image was taken at Zapadni Cliffs. I continually panned my 600mm lens, as birds came in. It was hit and miss as I focused manually, however a strong wind slowed them a little. I shot a lot of film and this was the most successful image.**

Nikon F4 with 600mm lens, 1/250 sec at f/5.6, Fuji Sensia 100, fill-in flash

Opposite left **Sunshine is a rare commodity for the photographer on the Pribilofs. Colourful houses adorn the few roads through the town of St Paul on St Paul Island. It is the cliffs though that will attract most of your attention.**

Nikon F4 with 24mm lens, 1/250 sec at f/5.6, Fuji Velvia 50

Opposite right **It was impossible to find an angle on the cliff top to photograph this Red-faced Cormorant, so I made a squeaking noise to get it to peer over the top of the cliff at me. Red-faced Cormorants are dotted about the island, and make an attractive subject. This image was taken on a typically dull, slightly foggy day so I used a bit of fill-in flash to give the image that extra 'pop' and bring out the colour on the bird's face.**

Nikon F4 with 600mm lens, 1/250 sec at f/5.6, Fuji Velvia 50, fill-in flash

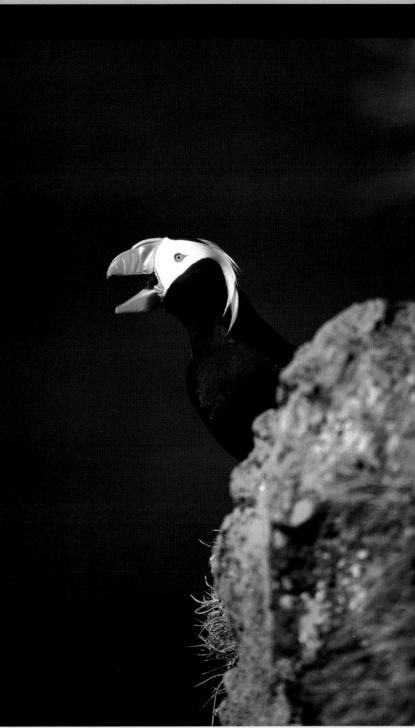

Below A sought-after subject for many photographers, the Pribilofs offer the best opportunity for photographing the endangered Red-legged Kittiwake. I stalked this bird out on the salt lagoon. With care they allow a close approach. It can take a lot of searching to find a pair that can be photographed on St Paul's cliffs, so the lagoon is probably the best option.

Nikon F4 with 600mm lens, exposure details not recorded, Fuji Sensia 100

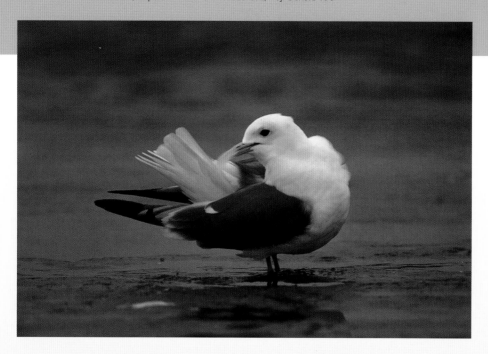

Red-legged Kittiwake, one of the Pribilofs' specialities, are far more numerous on St George than St Paul. But on St Paul, one of the easiest places to obtain pictures is at the salt lagoon close to town. They come to bathe here and congregate in small flocks.

When To Go

Weather on the Pribilofs can be poor, with rain, wind and fog commonly experienced. The later you go during the breeding season, the better your chances of some fine weather. Mid July to early August is, in my opinion, the peak time for a visit, but note that the Least Auklets are normally the first seabirds to leave and these can often be gone by the second week in August.

Travel / Accommodation

A visit to the Pribilofs is not cheap. Flights depart from Anchorage, with an almost daily service to St Paul, and a three times a week service to St George. St George Tanaq Corporation owns and maintains

a recently renovated ten-room hotel, details of which can be obtained from their website.

On St Paul, St Paul Island Tours operate package tours of a minimum of three days / two nights. They transport you around the island with guides and you stay in the King Eider Hotel, the only accommodation on the island. Of course being in a tour group is not conducive to photographing birds, so they will normally drop you off at a cliff and pick you up later at a pre-arranged point. Various websites exist with further information on booking.

Some North American bird photographers run photography tours and workshops on the Pribilofs, and at least one tour company runs occasional photo tours to the islands. These opportunities are often advertised in the American birding press.

Key Bird Bald Eagle

Homer, Alaska

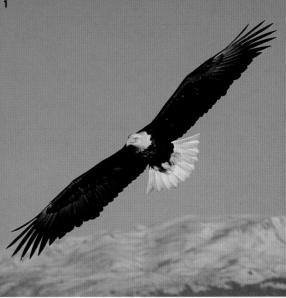

1

Both Homer and Haines (see additional sites) in Alaska are well known for attracting concentrations of Bald Eagles in winter.

At the end of Homer Spit, a strip of land jutting five miles (8km) out into Kachemak Bay, in excess of 300 bald eagles often congregate. They come here to feast on fish fed to them by Alaska's Eagle Lady, Jean Keene. Jean lives at the end of the spit on the edge of the campground. You can shoot from a vehicle in the parking lot next to her living accommodation. Under no circumstances should you get out of your vehicle, as this will scare the birds and ruin the session.

One of the big attractions of Homer are the wonderful snow-covered mountains that make a spectacular backdrop to your pictures. During late winter it can be extremely cold, and you should be prepared for temperatures as low as -4°F (-20°C), on occasions falling to -40°F (-40°C). There is often a great deal of snow too, with more than 15 feet (4.5km) falling in some years.

Above left **Jean Keene's home on Homer Spit complete with eagles and the photographers who make a pilgrimage here from all over the world.**

Nikon F5 with 17-35mm lens, exposure details not recorded, Fuji Velvia 100

Above and over **These three images are typical of what can be achieved during an average visit to Homer in winter. During the afternoons many photographers feed the eagles on the beach below the Landsend Hotel. Here you can get great action images of birds swooping in to fish. The silhouetted shot (over) was taken at dusk. I lay down on the beach, and tempted an eagle to within range of my wideangle lens by offering fish.**

1 Nikon F5 with 70-100mm lens, 1/80sec at f/8, Fuji Velvia 50
2 (page 74) Nikon F5 with 17-35mm lens, 1/60sec at f/11, Fuji Velvia 50
3 (page 74) Nikon F5 with 500mm lens, 1/500sec at f/4, Fuji Velvia 50

When To Go

Jean feeds the eagles from late December to early April. A visit between mid February and mid March is probably best. Feeding time starts at 9.30am and may last up to two hours.

Site Guide

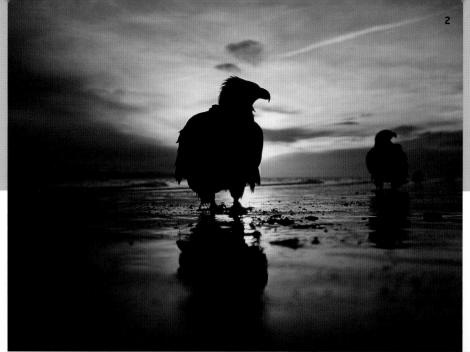

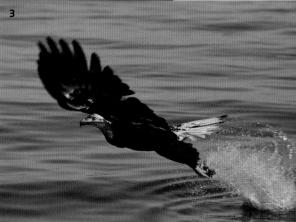

Jean Keene

Jean Keene has been feeding the eagles for more than 20 years. The vast majority of Bald Eagle photographs published annually around the world are shot from Jean's backyard.

As a young lady she worked as a trick rider in a travelling rodeo until having a serious accident that forced her to give up her performing. She later became a long distance truck driver, among many other vocations, before settling in Homer in the 1970s. Her camper van on Homer Spit has been her home ever since.

If you do get to shoot in Jean's backyard, then offer a donation, as it can be an expensive business keeping the eagles fed during the winter.

Travel / Accommodation

From Anchorage you can either fly to Homer or drive. In my opinion it is best to make the four-hour drive from Anchorage rather than fly, as car hire is cheaper in Anchorage than Homer. During periods of high snowfall the road to Homer can be temporarily blocked, but this doesn't normally last for long.

There is plentiful accommodation in Homer during winter. It is worth shopping around for a good deal as there are normally few people staying in the town at this time of year. There is a motel at the end of Homer Spit, called Landsend. It is not cheap to stay here, however it is well placed, being at the heart of the action for the eagles. They do give discounts for eagle photographers.

Bird Photography

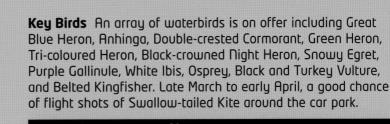

Key Birds An array of waterbirds is on offer including Great Blue Heron, Anhinga, Double-crested Cormorant, Green Heron, Tri-coloured Heron, Black-crowned Night Heron, Snowy Egret, Purple Gallinule, White Ibis, Osprey, Black and Turkey Vulture, and Belted Kingfisher. Late March to early April, a good chance of flight shots of Swallow-tailed Kite around the car park.

Anhinga Trail – Everglades National Park, Florida

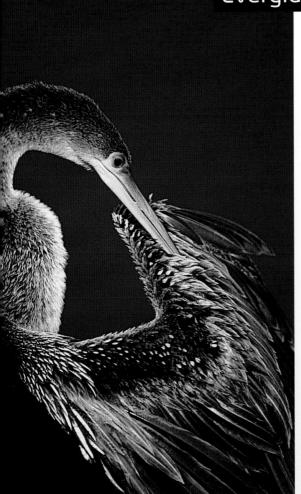

My first visit here blew me away: a host of tame birds was gathered alongside a path plus a sprinkling of photogenic alligators too. The trail is aptly named, as Anhingas nest and perch within touching distance of the trail allowing easy photography.

When To Go
December through to April is the time to visit with February to April being the peak months.

Travel / Accommodation
The trail is inside the Everglades National Park, which in turn is reached from the town of Homestead. The town offers motel accommodation. Alternatively there are three campgrounds inside the park.

Above **Anhingas are easily approached along the aptly named Anhinga Trail in the Florida Everglades. This bird showed no concern for my presence as it preened in the early morning light.**

Nikon F4 with 300mm lens, 1/125sec at f/8, Fuji Velvia 50

Key Birds Most of Florida's large wading birds can be seen. In addition to those listed for the Anhinga trail, subjects include Roseate Spoonbill, Great White Egret, Wood Stork, Little Blue Heron, Reddish Egret, Mottled Duck, Blue-winged Teal and Willet. On the Sanibel beaches Brown Pelican, Black Skimmer, Forster's, Sandwich and Royal Tern, Knot and Grey Plover.

Sanibel Island, Florida

Right **Birds share Florida's sun-drenched beaches with hordes of sun seekers. But such are the tameness of the birds here, that it seems not to make much impact. Knot are difficult if not impossible to approach in Europe, yet in America they present no such problems. This image was taken to illustrate both bird and man using the beach.**

Nikon F4 with 300mm lens, exposure details not recorded, Fuji Velvia 50

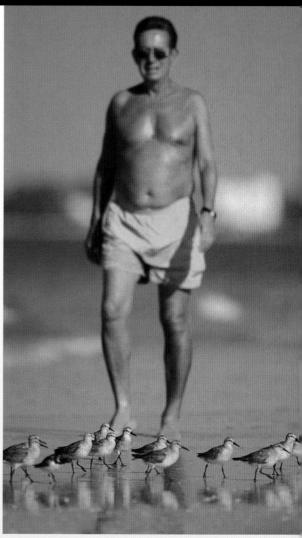

There are many locations on Sanibel, but the jewel in the island's crown is Ding Darling National Wildlife Refuge. This site can be outstanding for wading birds. Dawn and dusk visits offer excellent opportunities. Feeding frenzies often occur at which hundreds of birds gather to fish in a productive lagoon, an excellent photo opportunity if you are lucky enough to catch one. Roseate Spoonbills are one of the prime photographic attractions and are often found roosting close to the road in the early morning before they depart to nearby feeding areas.

The beaches on the island can be productive for photographing roosting Sandwich, Royal and Forster's Terns. I have also done well with Black Skimmers here. One of the best locations is found by leaving Ding Darling and turning right before proceeding to the bridge at Blind Pass. The beaches here frequently provide opportunities. Another favourite place for photographers is the fishing pier near the old lighthouse at the eastern end of Sanibel. Very tame Brown Pelicans and egrets pose here. Whilst on the island look out for osprey nests, as this is one of the better locations for photographing this species too.

When To Go
December to the beginning of April is the best time to visit.

Travel / Accommodation
Accommodation on the island is often at a premium. It is easier and cheaper to find accommodation on the mainland nearby, where there are plenty of motels to choose from.

Bird Photography

Venice Rookery, Florida

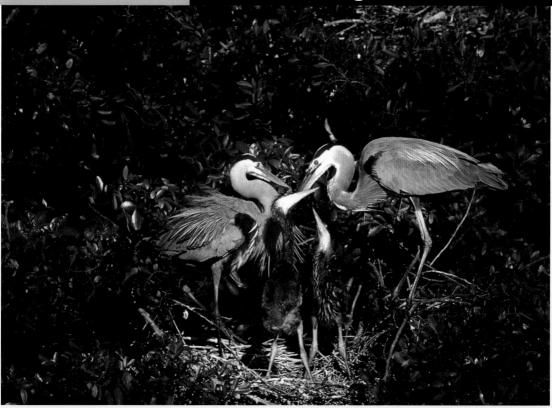

Above **Taken at the Venice Rookery, Great Blue Herons at the nest are an easy subject. This image was taken with a 600mm lens, the addition of a 1.4x teleconverter would be useful at the rookery for tight shots depicting behaviour. This is a popular site, on some mornings I have seen more photographers than birds at the rookery!**

Nikon F5 with 600mm lens and 1.4x teleconverter, 1/250sec at f/5.6, Fuji Sensia 100

Located in South Venice, this well known spot is just a small lake with an island in the middle. On some days there can be as many bird photographers as birds here, as few locations allow such good opportunities for photographing nesting Great White Egrets and Great Blue Herons. Lots of different images can be made, from displaying pairs, feeding young and flight shots.

When To Go
November through to April. February and March are perhaps the peak months for photographing a variety of behaviours.

Travel / Accommodation
From Interstate 75 turn off at exit 35, which is Jacaranda Boulevard. From here proceed southwest for a few miles until you reach the traffic lights at US 41. Turn right here, then take the first left at the Florida Highway Patrol station. The lake is further along here on the right. This area has numerous motels so finding accommodation should not be a problem.

Site Guide

Bosque del Apache, New Mexico

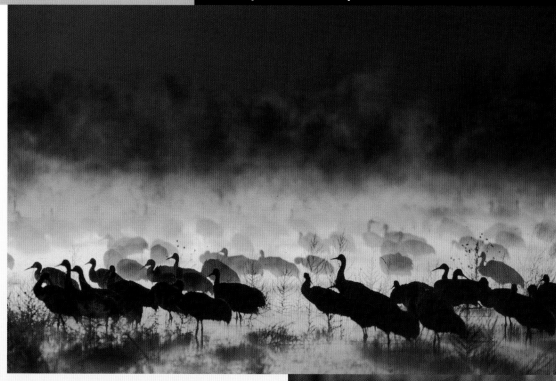

This National Wildlife Refuge in the heart of New Mexico straddles the banks of the Rio Grande and is considered to be one of the best bird photography locations on the planet. Around 40,000 Snow and Ross's Geese, and in excess of 15,000 Sandhill Cranes in winter, attracted by fields of crops grown just for the birds.

With spectacular mountain backdrops, and sunrises and sunsets that have to be seen to be believed, Bosque in winter is a bird photographer's heaven. Creative possibilities are endless, and great photography can be enjoyed from before dawn until after dusk. Apart from the geese and cranes a host of other species are likely to present themselves to your lens. Greater Roadrunners are relatively common, and can be photographed from the tracks on the reserve. However a reliable site is the sandy

Bird Photography

90

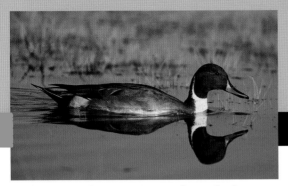

Above **Bosque offers a good range of waterfowl to photograph in winter, and really it is down to luck as to what you come across that is close enough to your vehicle. This drake Pintail was on a small roadside pool.**

Nikon F5 with 500mm lens, 1/160sec at f/8, Fuji Velvia 50

Opposite **Sandhill Cranes just before sunrise at Bosque. This scene lasted just a couple of minutes, before the sun peeped over the distant mountains. These are the types of image I am always striving to create - pictures that transcend from simply a record of a species, to a piece of art. Bosque offers such opportunities in abundance.**

Nikon F5 with 500mm lens, exposure details not recorded, Fuji Velvia 50

Opposite, below **Greater Roadrunners can be photographed from the car at Bosque. This individual was sunning itself in the early morning along the edge of the track. The bird's black down helps to soak up the sun's heat. Once the air temperature has warmed roadrunners become active, searching out prey.**

Nikon F5 with 500mm lens, exposure details not recorded, Fuji Velvia 50

tamarisk-covered bank opposite the reserve entrance, where often during the early morning a roadrunner may be found sunning itself or feeding.

Around the visitor centre various passerine species can be tempted by putting down seed, and this is a good spot to photograph Gambell's Quail. As winter progresses raptor numbers build, with photographic possibilities of perched birds from a vehicle on the reserve loop roads.

A typical day for me at Bosque will start by leaving the motel in Socorro around an hour before dawn. Driving along the approach road to the reserve there are pools on the right and left where Sandhill Cranes roost. Those on the left face the sunrise and if it has been a very cold night with a frost it might be worth stopping here to shoot the cranes against the glow of the rising sun as, if conditions are right, the cold air and warmer water temperature creates a mist that turns red just

before the sun peeps over the distant mountains. Alternatively I continue on, and on entering the reserve turn left to the first deck on the right overlooking a lagoon. Here there may be thousands of Snow and Ross's Geese plus a few cranes that will have roosted, and again great sunrise silhouettes can be shot here. The birds leave at around sunrise to feed in the fields. For much of the day you can cruise around the reserve using your vehicle as a hide, looking for subjects. The geese and cranes are likely to grab your attention frequently throughout the day.

At sunset there are various options. You can stand on the farm loop close to the farm deck for flight shots, or alternatively return to the crane roosting lagoons on the road approaching the reserve to shoot the cranes against a sunset, or frontlit as they come in over your head.

When To Go

The Snow Geese and Sandhill Cranes start arriving in late October. Early November can be good for obtaining those red mist shots, due to the onset of cold nights while the days are still warm. Many photographers visit in January when there are good numbers of raptors, which in early November there are generally not. A visit anytime from November to early March will prove very successful.

Travel / Accommodation

Bosque lies 20 miles (32km) south of Socorro which is 90 miles (145km) south of Albuquerque. The best option is to fly into Albuquerque, and hire a car for the short journey south. Most visitors stay in Socorro with Motel 8 at the northern end of the town being favourite. Note there is a crane festival at Bosque each November, when thousands of visitors descend. It is worth avoiding this as the reserve will be crowded and accommodation at a premium. Dates of the festival can easily be found on the internet, or by contacting the reserve centre.

Key Birds Pacific Loon, Common Eider, Long-tailed Duck, Greater and Lesser Scaup, Willow Ptarmigan, Spruce Grouse, Arctic Skua, Bonaparte's Gull, Ross's Gull in some years, Hudsonian Godwit, American Golden Plover, Whimbrel, Stilt Sandpiper, Short-billed Dowitcher, Lesser Yellowlegs, Dunlin, Least Sandpiper, Redpoll, Blackpoll Warbler, Lapland Bunting.

Churchill, Canada

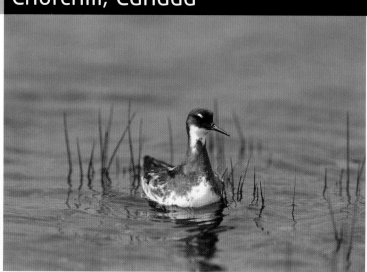

Right **Excellent images of Red-necked Phalaropes can be bagged in Churchill in summer. They are very confiding so you can often use a short lens.**

Nikon F5 with 300mm lens, 1/250sec at f/5.6, Fuji Velvia 50

This small town in Manitoba, on the shores of Hudson Bay, is the place to photograph Polar Bears in early winter. In June however it is the domain of the bird photographer, with a plentiful variety of Arctic species on offer. Often poor weather and sometimes plagues of mosquitos can be off putting, however the opportunities should certainly outweigh the discomforts.

The delicate Ross's Gull is not guaranteed but may be photographed in some years, whilst Pacific Diver, Bonaparte's Gull, Stilt Sandpiper, Hudsonian Godwit and American Golden Plover are just a few of the species likely to be on offer during a typical visit.

Care should be taken when photographing birds at this location as most will be nesting, so any undue disturbance should be avoided. It is worth taking a hide. The tundra with numerous bogs can be very wet, and for this reason thigh or chest waders are not a bad idea if you intend stalking birds in the wetter areas of the tundra, though you should take extreme care as some areas are exceptionally boggy. When the cold northerly wind is not blowing, mosquitos, as in most sub-arctic destinations, can be a nuisance, so mosquito hats and gloves and plenty of repellant will help keep them at bay.

There are a number of particularly good sites around Churchill for photography, they include the Granary Ponds a short way from town, the Red-necked Phalarope is a potential subject here. The Launch Road provides access to a number of tundra loving waders and opportunities for photography from a vehicle, while at the Landing Lake a tree-nesting Bonaparte's Gull colony can be found.

When To Go
Any time from late May when the breeding birds start to arrive will be productive. A visit in late June or July will encounter mosquitos but offer a good cross-section of breeding species for photography.

Travel / Accommodation
There are no roads leading to Churchill, so the options are either to take the train or fly, both leave from Winnipeg. The train takes 38 hours and is a great experience. The Rail Canada service leaves Winnipeg at 10pm on Sundays, Tuesdays and Thursdays. Air Canada fly return flights from Winnipeg to Churchill daily except at weekends when there is a restricted service.

Churchill is a small town, so accommodation needs to be booked in advance.

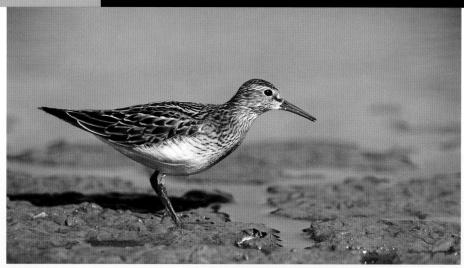

Above **Pectoral Sandpiper is just one of a number of species of shorebird on offer at New York's Jamaica Bay in autumn, all can be stalked, often to within very close range.**

Nikon F5 with 500mm lens, 1/350sec at f/8, Fuji Velvia 100

Dry Tortugas, Florida

Perched 70 (112.5km) miles west of Florida's Key West, these seven keys are a magnet for birds. Landing is only allowed on two of the keys. The main attraction, Garden Key, can be outstanding for passerine migrants in April and May. A water fountain inside Fort Jefferson attracts birds to drink.

Most photographers who visit regularly set up a drip for the birds inside the campground. This comprises a suspended bottle or other receptacle holding water, which can be punctured so that it drips onto a receptacle or piece of pond liner. This technique proves instantly attractive to migrants such as Catbirds and an abundance of warblers, dazzling in their spring dress. They include Magnolia, Hooded, Cape May, Black-throated Blue – the list is endless. Orioles, vireos, grosbeaks, thrushes and Yellow-billed Cuckoos can all be expected. Along the shoreline, waders and various seabirds are further photographic possibilities.

You can take either a seaplane or daily boat to Garden Key from Key West. Overnight camping is allowed on Garden Key, but you need to pre-book. Alternatively you might consider joining a birding tour which will enable access to Loggerhead Key.

Jamaica Bay Wildlife Refuge, New York

On the outskirts of New York City, this reserve is just a few minutes from John F Kennedy Airport. A big attraction in late August are the waders that stop off here on their southward migration. Both juveniles and moulting adults can be photographed on their favoured location, the East Pond. Greater and Lesser Yellowlegs, Semipalmated and Least Sandpipers, Semipalmated Plover and the scarcer White-rumped, Baird's, Pectoral and Stilt Sandpipers are all likely photographic subjects at this time. There is a hide (blind) on Big John's Pond that can be productive for photography throughout the year.

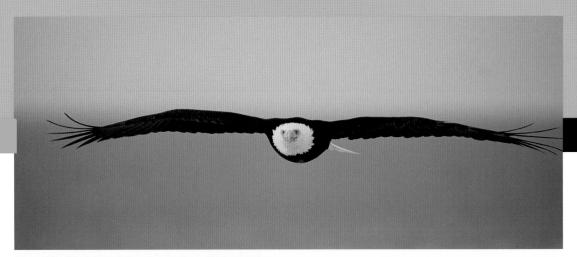

Above **For this image I placed a perch on the beach in front of me then stood upwind of it throwing fish. The Bald Eagles liked using the perch before jumping down on to the fish and because I was upwind, they flew straight at me before landing.**

Nikon F5 with 500mm lens, 1/1250sec at f/5.6, Fuji Velvia 50

Haines, Alaska

Haines is a small town in South East Alaska, close to the Chilkat River. Drawn by Alaska's last salmon run of the year, in excess of 4,000 Bald Eagles can be found on the Chilkat in early winter, spread along a 30 mile (50km) stretch of river. The largest concentrations can be found where the Tsirku River joins the Chilkat, here shallow channels twist through broad gravel bars, against a backdrop of black cottonwood trees and mountains. Mid November sees peak numbers of birds, the weather at this time can be snowy, it can rain, and it can be mild and sunny, so you need to be prepared for all eventualities.

Eagles can come to within 30ft (10m) of the road bordering the river. Eagle activity peaks during early morning and late afternoon. The easiest way to reach Haines is to fly in, however the planes that serve the town from Juneau are small so weather delays do occur. If travelling by road, Anchorage to Haines is 800 miles (1,300km). Ferry services run from Skagway and Juneau, and this may be a more attractive option.

Midway Atoll, Hawaii

A speck in the Pacific Ocean, Midway is one of the world's remotest islands, best known for its strategic importance in the Second World War, placed as it is midway across the North Pacific between North America and Japan.

Nearly two million birds of 15 species nest on the Midway Atoll annually. This total comprises nearly 300,000 pairs of Laysan Albatross, an astonishing sight. Among the Laysan and Black-footed Albatross colony you may be lucky enough to run into a Short-tailed Albatross, one of the world's most endangered birds. Photography of the albatrosses is outstanding, as is photography of species such as Red-tailed Tropicbird, Black Noddy, White Tern and various others. Bristle-thighed Curlews can be found in winter and are another much sought-after subject.

Flights depart from Honolulu airport in Hawaii. Visits have to be pre-booked and facilities are excellent for visitors. December through March is a good period in which to visit to photograph a diverse range of seabirds. More information can be obtained from the island's website at www.midwayisland.com

Below **The White-crowned Sparrow is a widespread North American species. This bird was baited by sprinkling seed at the edge of a car park.**

Nikon F5 with 500mm lens, 1/125sec at f/5.6, Fuji Velvia 50

Point Pelee, Canada

A finger of land jutting out of the northern shore of Lake Eyrie, Point Pelee is famous as one of North America's finest migration watchpoints. Warblers, thrushes, sparrows, tanagers, vireos, grosbeaks and orioles, all migrating north in spring make landfall here after crossing the lake. In autumn birds congregate before departing south across the lake.

Late April to mid May is the time to visit in spring, when on some days the point can be alive with birds. The low trees, bushes and beach are ideal for photography. The peninsula is south of the town of Leamington, which in turn is south of Detroit, gateway to the area.

Site Guide

South America Galapagos Islands; Manu, Peru; Pantanal, Brazil; Llanos, Venezuala/Columbia Galapagos Islands; Man
Galapagos Islands, Manu, Peru, Pantanal, Brazil, Llanos, Venezuala/Columbia Galapagos Islands, Manu, Peru,

Galapagos Islands; Manu, Peru; Pantanal, Brazil; Llanos, Venezuala/Columbia; Galapagos Islands; Manu, Peru; Pantanal, B
Peru; Pantanal, Brazil; Llanos, Venezuala/Columbia; Galapagos Islands; Manu, Peru; Pantanal, Brazil; Llanos, Venezuala/Colu

South America

South America is known as 'The Bird Continent', Peru alone boasts an impressive bird list of 1700 species. There are numerous localities the length and breadth of the country, with no doubt many more awaiting discovery.

The majestic Andes, South America's backbone, stretch for thousands of miles starting in the northern end of the continent, which is dominated by the Amazon rainforest, home to a more diverse array of life than anywhere else on earth. Off the coast of Ecuador lies the wildlife photographers nirvana; Galapagos. While the far south, realm of the Andean Condor and gateway to the Antarctic, is a windswept place of stark beauty.

Ease of travel in Latin America varies from country to country, if going it alone then being able to speak some Spanish will help enormously. The use of guides is recommended for many locations. Group travel makes more sense in South America than in many other places, purely because of the logistics and costs of reaching some of the continent's far flung sites.

al, Brazil; Llanos, Venezuala/Columbia; Galapagos Islands; Manu, Peru; Pantanal, Brazil; Llanos, Venezuala/Columbia; il, Llanos, Venezuala/Columbia Galapagos Islands, Manu, Peru, Pantanal, Brazil, Llanos, Venezuala/Columbia

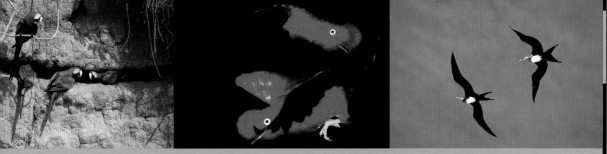

ezuala/Columbia; Galapagos Islands; Manu, Peru; Pantanal, Brazil; Llanos, Venezuala/Columbia; Galapagos Islands; Manu, Islands; Manu, Peru; Pantanal, Brazil; Llanos, Venezuala/Columbia; Galapagos Islands; Manu, Peru; Pantanal, Brazil; Llanos

The Galapagos Islands

Straddling the equator, 600 miles (965.5km) west of the Ecuador mainland, the islands lie at the meeting point of ocean currents, this position means they swarm with life. Almost half of the 61 resident species of bird are endemic. There is much to attract the bird photographer. It is the remarkable tameness of just about all the species encountered that surprises and delights first time visitors. Short zoom lenses are adequate for many subjects.

Nesting seabirds are one of the big attractions, they include the Waved Albatross, Flightless Cormorant, Galapagos Penguin and Swallow-tailed Gull. Because of a large number of visitors, the islands are heavily regulated. Landing on the various islands is permitted in small groups accompanied by a Galapagos guide.

The setup can be a little frustrating, particularly if you are the only keen photographer in a group, as groups have to stay together. Therefore I would advise joining a photography tour to the islands. A number are run annually, and by joining one of these you will have more chance of being on the islands during the early morning and late afternoon. Due to being on the equator, the light is particularly harsh during the middle of the day. The other main consideration is to examine the itinerary of whatever tour you decide to join, as many species such as Waved Albatross have a restricted distribution.

A few islands stand out, Tower Island is one where large numbers of seabirds nest, highlights here include Lava and Swallow-tailed Gulls, the latter nest on the landing beach at Darwin Bay, and allow very close approach, other easy subjects here are Red-footed and Masked Boobies and Great Frigate Birds. There is a route over a very irregular lava field, so care is needed. This takes you to a cliff where flight photography can be very good. Another popular landing place on Tower is Prince Phillips Steps. The dwarf forest here contains nesting Red-footed Boobies and Great Frigate Birds.

Waved Albatross breeds only on Hood, while the Galapagos Penguin is localised but more widespread, though the population varies

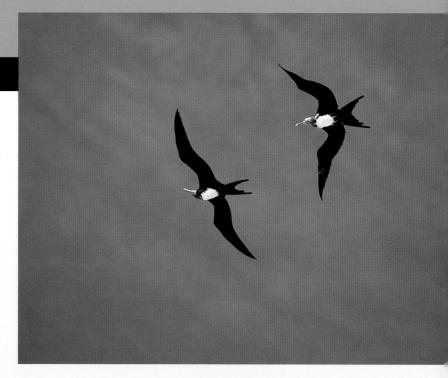

Far Left **A visit to Tower Island in the Galapagos archipelago is a highlight for bird photographers, with species such as Swallow-tailed Gull allowing approach to within a few feet.**

Nikon F5 with 135mm lens, exposure details not recorded, Fuji Velvia 50

Left **A Blue-footed Booby incubates it's egg, just inches from a path. Wide angle lenses allow pictures of birds within their habitat in Galapagos.**

Nikon F5 with 24mm lens, 1/60sec f/11, Fuji Velvia 50

Right **The Galapagos is a good destination for flight shots. Great Frigatebirds are regularly encountered in the islands. They sometimes drift along in groups alongside boats, and on islands where they nest provide plenty of opportunities.**

Nikon F5 with 300mm lens, 1/320sec at f/5.6, Fuji Velvia 50

dramatically, declining markedly after El Nino years. Another attraction for many are Darwin's finches, it was this group of birds that were a cornerstone of Darwin's theory of evolution. They are spread around the islands, and most are very approachable. Creating a small pool of fresh water will often have instant results in attracting some of these.

When To Go

A visit at any time of year will be fruitful. Galapagos is at its best for breeding seabirds in April and May. July and August is the high season, and the weather is often not so good. It may also be worth avoiding El Nino years.

Travel / Accommodation

The islands are reached via Ecuador, with regular flights from Guyaquil. I suggest booking a specialist tour, ideally with a company offering photography, otherwise with a specialist natural history tour. The islands are reached by boat, with the smaller groups normally chartering yachts or catamarans. Living accommodation can be a bit cramped, but such discomforts are soon forgotten. The drawback is that such a holiday is not cheap, but it is worth shopping around, prices vary considerably.

If you don't mind risking leaving it to the very last minute and you are flexible, then it may be possible to join one of the bigger boats at short notice from Santa Cruz, where all boats depart. At Puerto Ayora, berths are regularly advertised at heavily discounted rates.

Key Birds Hoatzin, macaws, parrots, Andean Cock-of-the-Rock, plus a multitude of other rainforest species.

Manu, Peru

Above **This is an image of two male Andean Cock-of-the-rocks lekking in Manu's dark cloud forest. It gets so dark under the canopy that it can be like night time. This is an original image, which on slide looks acceptable, however the black background causes the bird's black wings to be lost, and on the whole left me feeling it was unsatisfactory. So to make it a more interesting picture, I scanned the transparency, and then in levels in photoshop simply darkened the whole picture, making the birds eyes and vivid plumage glow in the dark. I feel it works well, but of course it would not be to everyone's taste. When it comes to manipulation I just about draw the line here, for example if the original picture had just one bird in the frame, then I would not have added a second as that, in my eyes, would have been to distort the truth of the image. In my view, pictures that are manipulated in that way lose their wow factor. With this picture I feel I have created an image that accurately reflects not only the behaviour of the birds, but the feel of the gloomy under-storey of the cloud forest.**

Nikon F5 with 300mm lens, exposure details not recorded, Fuji Velvia 50, fill-in flash

The Manu Biosphere Reserve contains the highest diversity of life on earth. From cloud forest cloaking the slopes of the Andes, to the lowland rainforest in the Amazon Basin, over 1,000 species of bird have been recorded here. To visit Manu you need a spirit of adventure, there are still Indian tribes deep in the rainforest that have never come into contact with the outside world.

Despite this profusion of birds, bird photography is not easy. Many species stay high in the rainforest canopy, out of range, while others skulk on the forest floor. Ingenuity and hard work is needed. Having said that, there are a handful of species that do provide good opportunities.

The cloud forest in the reserve lies on the eastern slope of the Andes. Tumbling streams rush

Above left **Bird photography in rain forests is hard work. Fruit put out on a makeshift bird table can lure species that creep about in the undergrowth or flit about in the canopy to within range. This Versicolored Barbet was tempted into a forest clearing in the Manu cloud forest, with an offering of bananas.**

Nikon F5 with 500mm lens and 1.4x teleconverter, 1/180sec at f/5.6, Fuji Velvia 50

Above right and over **Photographing macaws at a clay lick has to be one of the photographic highlights of a visit to the Amazon. These Red and Green Macaws were photographed at the lick on the river close to Manu Wildlife Centre.**

Nikon F5 with 600mm lens, exposure details not recorded, Fuji Sensia 100

through luxuriant forest. This is home to the Andean Cock-of-the-Rock, striking in colour the males gather at traditional lekking arenas in the forest, from where they call and display to visiting females. Purpose built viewing platforms overlooking one of these leks allow great photo opportunities. A flutter of wings signals the first arrivals to the lek at dawn. Piercing shrieks then break the silence as the show begins. The bright orange males, bow and bill snap, and make spine chilling shrieks, as they attempt to attract a chocolate brown female over to their perch to mate. When a female does arrive, the males start

bouncing up and down while extending their wings in a bow. Birds approach to within a few feet of the platform. Flash is a necessity here.

Lodges in the cloud forest are good places at which to entice birds down with food. Fruit such as bananas are ideal and may attract the striking Versicoloured Barbet, and perhaps tanagers too, whilst most lodges have hummingbird feeders allowing veranda-based photography.

The other big bird photography attraction in Manu are the macaws that gather at clay licks. One of the best is situated close to the Manu Wildlife Centre, a lodge on the Alto Madre Dios River. Macaws eat the clay to absorb toxins that they ingest from the seeds they feed on. Of the handful of known clay licks in South America this is one of the best for lighting, as early in the morning the sun will be behind you illuminating the bank perfectly. You arrive at a floating hide just prior to dawn. As the sun starts to rise, hundreds of Blue-cheeked and Orange-cheeked Parrots arrive, creating a sea of green, and a good entree to the main dish!

Slowly the macaws gather in the trees along the riverbank, most numerous are Red and Green Macaws, but a few Scarlet Macaws join the noisy flocks. As if stage managed, the smaller parrots wheel excitedly away into the forest, leaving the riverbank to the macaws that alight in raucous groups. Just occasionally the whole flock may explode from the riverbank in a sea of colour.

Because of the sheer number of birds in Manu, unexpected photo opportunities are likely.

One of the most photographed species, is the Hoatzin, a prehistoric-looking bird, that can often be stalked successfully from a raft or boat. Amazonia Lodge is a particularly good site for photographing this species, as they feed on arum leaves on a small marsh close to the lodge, and can be photographed both perched and in flight.

When To Go
Best time to visit for both the lekking cock-of-the-rocks and macaws in the same trip is September to early October. This is the tail-end of the dry season, the wet season starts around mid-October and lasts through to March. Therefore many birds are starting to breed so there is a lot of activity. Dry and wet seasons in these rain and cloud forest environments do not mean as much as in other parts of the world, however in the dry season you are less likely to experience prolonged bouts of rain that could disrupt. An umbrella is a great accessory, particularly in the cloud forest where it rains daily. Try wearing wet weather gear, and the humidity and heat will soon create your own mobile sauna.

Insects are not too much of a problem in the dry season, however some biting insects can be persistent unless you have adequate protection. A deet-based repellant is the ideal. Many bird photographers who regularly work in rainforests wear rubber boots as protection against biting ants and potential snake bites. Alternatively a lightweight pair of hiking boots that stretch well above the ankle are a good idea, this is my preferred option.

Travel / Accommodation
Any trip to Manu starts with an internal flight from Peru's capital Lima, to the Andean town of Cusco. From Cusco there are two options, to either fly down into the Amazon to the Boca Manu airstrip in the rainforest, or take a spectacular road journey up over the Andes and down to the small settlement of Atalaya. This could be described as one of the great road journeys on earth as you climb up and over the Andes and then down through cloud forest to the vast Amazon below.

There are a couple of lodges along this road, within the cloud forest, at an altitude of around 5000ft (1524m), where the star attraction is the Andean Cock-of-the-Rock leks. Down at Atalaya, across the river lies Amazonia Lodge, good for

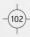

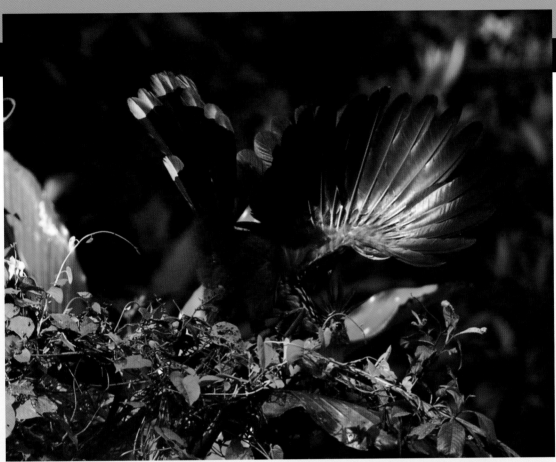

Above **The prehistoric looking Hoatzin can be photographed at numerous wetland sites across much of South America. This individual was feeding on aurum leaves at Amazonia Lodge in Peru.**

Nikon F5 with 500mm lens, 1/250sec at f/5.6, Fuji Sensia 100

photographing Hoatzins and a wealth of other rainforest species. From here Manu Wildlife Centre and various other lodges are reached by motorized canoe. There is much information online on the various lodge options available. Ideally joining a tour or bringing together a small like-minded group, then contacting one of the Peruvian nature tour companies, to deal with ground arrangements is the best way to help keep costs down.

Finally if visiting this part of Peru, don't miss out on the magnificent Inca ruins of Machu-Pichu. Aguas Calientes, the town below the ruins, is easily reached by train from Cusco, reckoned in itself to be one of the world's great train journeys and good for spotting Torrent Ducks on the river close to the tracks.

Pantanal, Brazil

Western Brazil's Pantanal region is the world's largest freshwater wetland. Extraordinary numbers of waterbirds swarm across these vast seasonal floods. Indeed the Pantanal can make the Florida Everglades seem mediocre in comparison. Access to the area is along the two-lane Transpantaneira Highway, which starts from Pocone.

The highway crosses numerous creeks, and from its banks excellent photographic opportunities of the waterbirds can be had. Particularly as the dry season kicks in and pools start to shrink, then birds can become concentrated along deeper roadside pools, created from the building of the road. Species likely to be encountered include Jabiru Storks, various herons, egrets, ibis and spoonbills. Landbirds include Toco Toucans and one of the most photographed birds of the Pantanal, the Hyacinth Macaw, the world's largest parrot.

Further exploration can be made by boat, and apart from the waterbirds, other photographic opportunities are likely to include Caimans and Capybaras. Accommodation can be found in the region's ranches. Cuiaba is 60 miles (96.5km) north of Pocone and acts as a gateway to the Pantanal. It is served by flights from South American cities. The wet season lasts from October to March and by February water levels can be high enough to prevent access to some areas. Better to visit from May through to September when birds are concentrated in fast-drying pools and in the roadside canals. There are a number of inns along the highway offering accommodation.

Llanos, Venezuala/Columbia

Shared by Venezuala and Columbia, this bird-rich wetland is seasonal, created by rivers flooding during the wet season. Sunbittern, Hoatzin, Sungrebe, Agami Heron; these are just some of the sought after waterbirds on offer. The Llanos is ranching country, with a number of ranches offering accommodation and photographic opportunities on their land. The area can be explored by both vehicle and boat, and many species are approachable for photography.

The dry season running from October to April gives better photo opportunities as birds are more concentrated, and the light may be better. Cloudy skies can plague the wet season. True cowboys can be seen on the Llanos, they are known as Llaneros (plains cowboys). San Fernando do Apure has an airport with flights to and from Caracas.

Right Roseate Spoonbills are a feature of many South American wetlands.

Nikon F4 with 600mm lens, exposure details not recorded, Fuji Velvia 50

Bird Photography

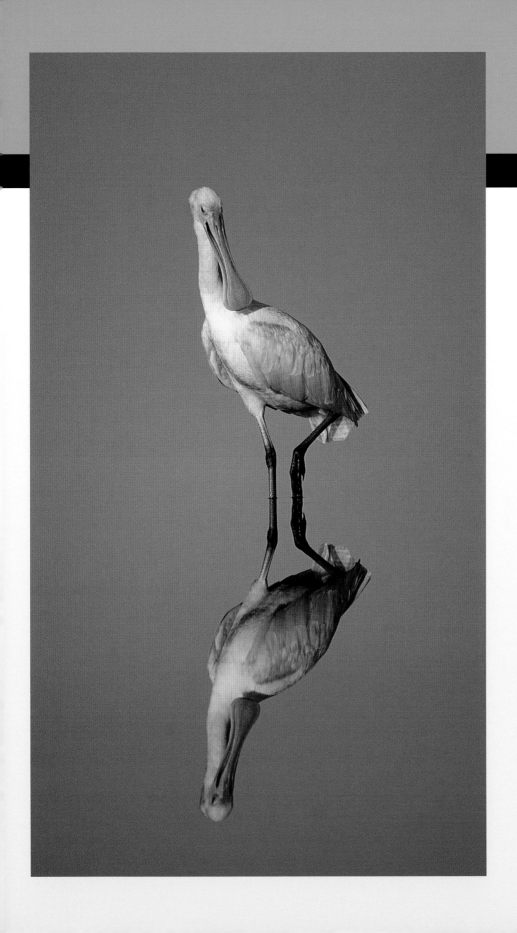

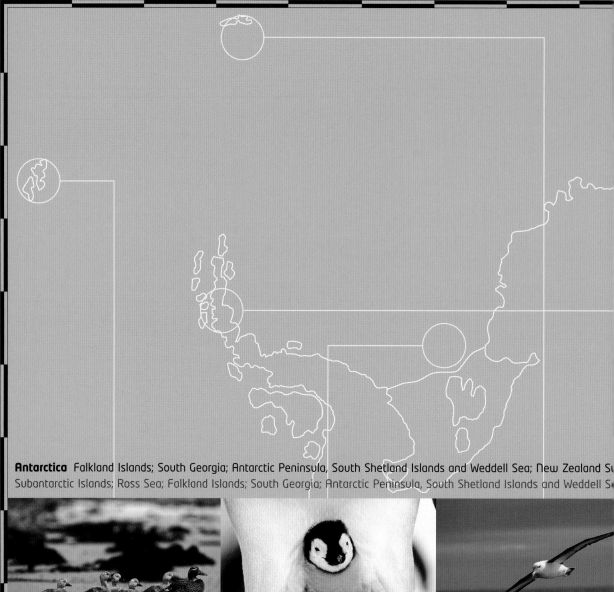

Antarctica Falkland Islands; South Georgia; Antarctic Peninsula, South Shetland Islands and Weddell Sea; New Zealand Su
Subantarctic Islands; Ross Sea; Falkland Islands; South Georgia; Antarctic Peninsula, South Shetland Islands and Weddell Se

Sea; New Zealand Subantarctic Islands; Ross Sea; Falkland Islands; South Georgia; Antarctic Peninsula, South Shetland Isle
Islands and Weddell Sea; New Zealand Subantarctic Islands; Ross Sea; Falkland Islands; South Georgia; Antarctic Peninsula,

Antarctica and Subantarctic

Few other destinations allow the bird photographer so many creative possibilities as the far south. Vast penguin rookeries stand against a backdrop of snow-capped mountains, albatrosses skim low over storm-tossed seas, great opportunities abound. It is easy to run out of superlatives when attempting to describe the potential for photography and the incredible experiences visitors enjoy on journeys to this region. Such adventure, however, comes at a cost. Few other destinations are so expensive to visit, with the only way of reaching the area being by ship or, for the intrepid, by yacht.

ds; Ross Sea Falkland Islands; South Georgia; Antarctic Peninsula, South Shetland Islands and Weddell Sea; New Zealand Subantarctic Islands; Ross Sea; Falkland Islands; South Georgia; Antarctic Peninsula, South Shetland Islands and Weddell

l Sea; New Zealand Subantarctic Islands; Ross Sea; Falkland Islands; South Georgia; Antarctic Peninsula, South Shetland slands and Weddell Sea; New Zealand Subantarctic Islands; Ross Sea; Falkland Islands; South Georgia; Antarctic Peninsula

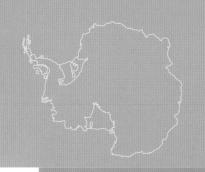

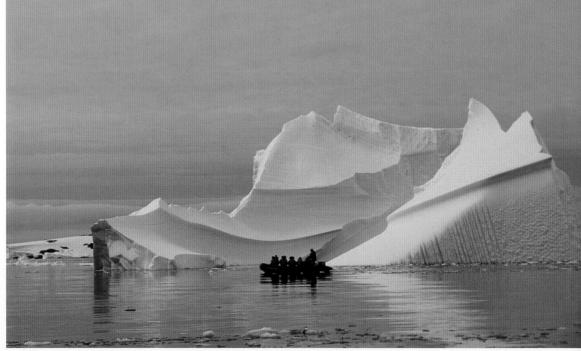

Antarctic tourism is booming, attracting thousands of visitors annually. As a result there is plenty of choice when booking a trip. The average voyage lasts between two and three weeks and normally includes visits to a number of subantarctic islands, before cruising the wildlife-rich waters of the Antarctic peninsula.

Most cruises depart from South America, from either Punta Arenas in Chile or Ushuaia in Argentina. Alternatively a voyage from New Zealand calling in on various subantarctic islands, before cruising across the Southern Ocean to the 'ice' is another possibility. Trips departing from this side of the continent normally visit the Ross Sea, home to many of the expeditionary huts such as Scott's hut at Cape Evans. Tempting for the bird photographer are the many Emperor Penguin colonies found in this part of the continent.

When making crossings there are often good opportunities for photographing seabirds that are following the ship, particularly albatrosses and petrels. For sheer spectacle the immense penguin colonies along the Antarctic peninsula are magnificent. For many, South Georgia is a highlight. Close encounters with Wandering Albatrosses, and immense penguin colonies nestled below snow-capped mountains and glaciers are images that will live long in the memory.

An important consideration when choosing a cruise is the time you are given ashore. Big boats and lots of people usually mean short landings. Some may allow just one hour, useless for photography, yet a small icebreaker with no more than 100 passengers may allow a whole day. Talk to people who have taken the tours you are interested in, and try to quiz expedition staff

Left **Zodiacs are everyday transport on an Antarctic trip.
An anti-vibration medium-length zoom is a useful lens to
have at the ready when zodiac cruising, both for birds
and other marine life such as seals and whales.**

Nikon F5 with 70-200mm lens, exposure details not recorded,
Fuji Velvia 100

or tour leaders beforehand. This is important as it
may be the most expensive photographic trip you
ever take. Also prices can vary dramatically for the
same itinerary, so shop around. The internet is a
great way to seek out the various options on offer,
and if you are European, take a look at what the
American tour companies are offering; you can
save a considerable amount of money if the
exchange rate is favourable.

If you have a large bank balance then you can
embark on the greatest adventure open to wildlife
photographers in Antarctica, to camp next to an
Emperor Penguin colony on the sea ice. It is
possible to fly to Antarctica in a Hercules aircraft,
then transfer to a Twin Otter for a flight to one
of the colonies.

One final point should be made of the wet weather
gear you should prepare yourself with, if joining
a cruise to the region. Landings are made via
Zodiacs and, due to the often ferocious weather in
the Southern Ocean, waterproof overtrousers are
a necessity, as are rubber boots. For protecting
camera gear I would strongly recommend taking
a dry bag. This is a bag you can purchase from
outdoors stores, in which you can place your
camera bag. It will seal and be completely
watertight. It is not uncommon for waves to break
over zodiacs when leaving or arriving at a beach
landing, and such an event could ruin your gear.

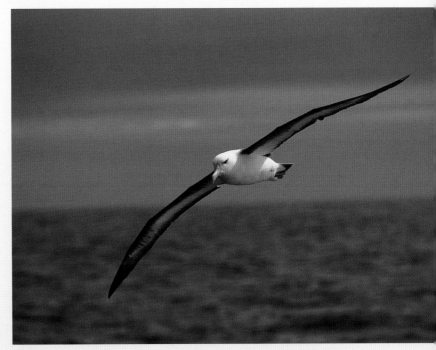

Right **Spending as much time as
possible out on deck when steaming
through the Southern Ocean should
bring good opportunities for flight
shots. Black-browed Albatross is one
of a number of species of seabird
that often follow ships. Ships with
a low rear deck work well, allowing
some intimate shots of flying birds.
The ship's wake can often give some
reflected light, as in the case of this
bird where the underwing has been
nicely illuminated. This was taken
by hand holding my 500mm lens.**

Nikon F5 with 500mm lens, 1/500sec at
f/4, Fuji Velvia 50 film

Key Birds Spectacular Black-browed Albatross colonies, Rockhopper, Gentoo and Magellanic Penguins, and Striated Caracara's are some of the highlights.

Falkland Islands

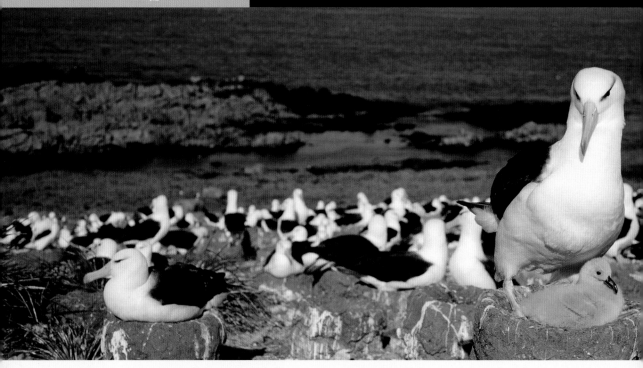

The Falklands are included in the majority of Antarctic cruises departing from Ushuaia or Punta Arenas, and are worth an individual visit in their own right. Common with just about all subantarctic islands, the birds on the Falklands are very approachable, allowing great photo opportunities.

The island's seabirds provide most interest, whether it be groups of Rockhopper Penguins exploding out of the surf, or the sometimes vast colonies of Black-browed Albatrosses. Around 60 species of bird breed annually. The islands are windswept, with sheep grazing being the dominant land use.

Stanley is the capital of the islands, but for the bird photographer there is not too much of interest here other than good opportunities with photographing some of the archipelago's landbirds. Volunteer Point, reached by a four-hour overland

journey by Landrover, gives good chances to photograph various species that include a small colony of King Penguins.

Away from Stanley I have listed below islands that are, in my opinion, most productive for photography. The majority of these are visited by cruise trips. Most are reasonably accessible to the independent traveller too.

Kidney Island is close to Stanley. Permission needs to be gained from the Environmental Planning Office to visit this National Nature Reserve. Magellanic and Rockhopper Penguins are found here, and there is a large colony of Sooty Shearwaters.

Pebble Island lies north of West Falkland, and can be reached by light aircraft from Stanley. An excellent selection of birds on offer, the island provides the photographer with plenty of potential

Left **Few of the world's seabird colonies can rival the Black-browed Albatross colony on Steeple Jason Island, for sheer spectacle. It is the largest albatross colony in the world.**

Hasselblad Xpan with 45mm lens, 1/60sec at f/11, Fuji Velvia 50

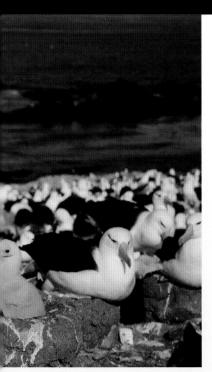

Middle right **The Falklands' deserted sandy beaches are often full of birds. These Magellanic Penguins were photographed on Carcass Island. I used a shallow depth of field to render the tourist behind the birds slightly out of focus. Images such as this that illustrate eco-tourism are much in demand for travel brochures, so if you sell your work, always be on the look out for images that are ignored by most people.**

Nikon F5 with 500mm lens, 1/250sec at f/4, Fuji Velvia 100

Bottom right **A flightless Falkland Steamer Duck leads her chicks down the beach to the sea. As with most species on the Falklands, Steamer Ducks are very confiding subjects. I spent most of a day along a 90 metre (100 yard) stretch of beach where this picture was taken. There were just so many birds to photograph, all of which were extremely tame.**

Nikon F5 with 500mm lens, 1//250sec at f/8, Fuji Velvia 100

for capturing many of the waterfowl and shorebirds found on the Falklands. Other highlights include Striated Caracaras and Pale-faced Sheathbills.

Sea Lion Island is 10 miles (16km) south of East Falkland and is often visited by tour groups. An excellent selection of birds, including Rockhopper Penguins and Black-browed Albatrosses, can be photographed here and are all easily accessible. As well as birds, non-avian highlights are the Southern Elephant Seals and a chance of encountering both Killer Whales and Peale's Dolphins.

Carcass Island offers the biggest variety of birds. This would be my number one choice for an extended stay. You can spend half a day moving just a few hundred yards due to the myriad opportunities. From Gentoo and Magellanic

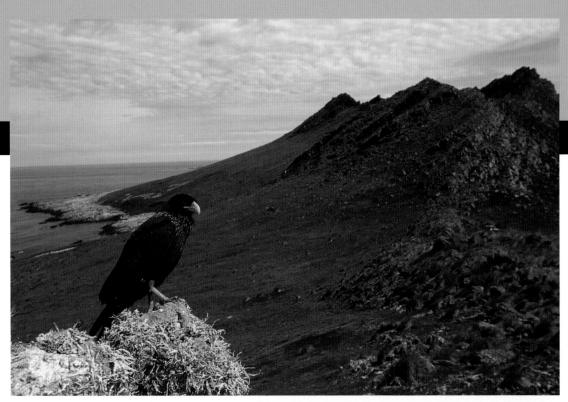

Above **The Striated Caracara, locally known as Johnny Rook, is the villain of the bird world in the Falklands. They will often vandalize or steal property left unattended. They are fearless – I was able to approach this bird on Steeple Jason Island and photograph it with my wideangle zoom lens. I used fill-in flash to give a catch light in the eye.**

Nikon F5 with 17–35mm lens, 1/60sec at f/11, Fuji Velvia 50

Penguins, Flightless Steamer Ducks and Kelp Geese on the beaches to Striated Caracaras, various passerine species and waterfowl inland, the numbers of birds are impressive when compared to some other islands. Landing here is often on the itinerary of Antarctic cruise ships.

West Point Island is a regular stop for cruise boats. My only visit came on New Year's Day 2003 and this timing meant that a hangover prevented me from exploring too much of the island! I did note that the clifftop at Devil's Nose is a good place for photographing Rockhopper Penguins as they make their way through the tussocks to their nest sites. A Black-browed Albatross colony adds further interest, but is not the best of colonies for photography.

New Island has a landing beach near a settlement, where Kelp Geese can be located, and from here there is a short walk across the island to a line of cliffs. Here Black-browed Albatross and Rockhopper Penguin colonies are of most interest. The cliffs allow good opportunities for flight shots of Albatrosses along with Imperial Shags. A route can be taken down on to the boulder beach below where groups of Rockhopper Penguins explode out

of the surf, then march up the beach and climb to the colony. Some good action photography can be enjoyed, although the action is so fast that it is advisable to shoot as many frames as you can.

Along the path Ruddy-headed Geese may be approached, and at night thousands of Slender-billed Prions come ashore to their burrows.

Steeple Jason Island is home to the largest albatross colony in the world. More than 150,000 pairs stretch along three miles (4.8km) of the island. This is one of the most scenic islands, comprising a central spine dotted with peaks, the tops of which give great views and are easily scaled. The albatross colony can be reached through tussock grass that is so tall it is impossible to see where you are going, so the sound of the birds helps navigation. Every lens from wideangle to long telephoto is useful at this

colony, there is much scope. Visit in January when most cruise ships do, and the birds will have young chicks in the nest. The island has many Striated Caracaras, known as Johnny Rooks, and the young birds move in gangs terrorizing the Gentoo Penguins that nest there. Leave anything unattended, and you will either lose it or have it damaged, as they are notorious thieves and vandals.

The eastern end of Steeple Jason has a Southern Giant Petrel colony. This species is very susceptible to disturbance, so should be avoided. An Antarctic cruise offers the best chance of a landing here, as permissions for disembarkation are strictly regulated.

When To Go

Breeding season in the Falklands is the austral summer from November through to March. The ideal time to visit would be December or January for the height of the breeding season, but these can also be the wettest months of the year.

Travel / Accommodation

Unlike most subantarctic islands, the Falklands are ideal for solo travel. A regular air service to the archipelago makes reaching the Falklands straightforward, albeit a little expensive. Twice-weekly civilian flights depart from RAF Brize Norton in the UK, and there are weekly flights from Punta Arenas and Santiago in Chile. Mount Pleasant airport is 35 miles (56km) west of Stanley. There are plentiful internal flights making island hopping relatively easy.

Accommodation can be found on many of the islands. For up-to-date information on this and further ideas on islands worth visiting, Falkland Islands Tourism can provide all the help you need. Tourist lodges exist at Port Howard, San Carlos, Sea Lion Island and Pebble Island, and there are a couple of hotels in Stanley.

If joining a cruise, the limited time ashore you often get at most locations means finding more detailed information on what is on offer is worthwhile before you visit in order to maximize your time.

Left **These Rockhopper Penguins were photographed on West Point Island, a popular stopping off point for cruise boats.**

Hasselblad Xpan with 45mm lens, exposure details not recorded, Fuji Velvia 50

Site Guide

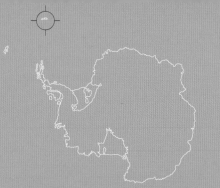

Key Birds Vast King Penguin colonies, Macaroni Penguins, Wandering Albatrosses at their nest sites, display flights of Light-mantled Sooty Albatrosses.

South Georgia

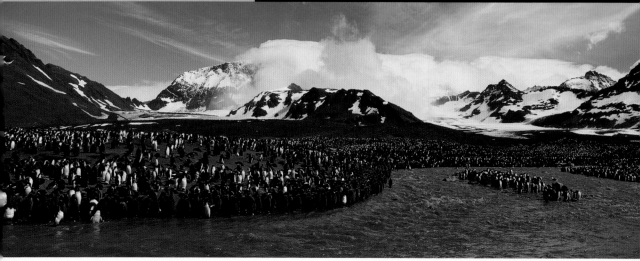

Remote, breathtaking scenery and wildlife spectacles that rank with the very best on earth are some of the ingredients that make South Georgia unforgettable for many wildlife photographers who are lucky enough to visit.

King Penguin colonies such as those at Salisbury Plain and at St Andrew's Bay are vast, the latter may contain in excess of 100,000 pairs, nestled at the base of glaciers and snow-capped peaks. When visiting these colonies for the first time, it is easy to become a little punch drunk with the photo opportunities on offer, and return to your ship at the end of the day not sure what you have taken! While it is tempting to concentrate on photographing the colonies at such sites, don't ignore the beaches where penguins are constantly on the move.

All the main wildlife sites are located down the western shore of the 105 mile (170km) long island. In the north lies the Bay of Isles, and this is where a handful of islands host nesting Wandering Albatrosses. Photographing these ocean wanderers at their nest site is one of the highlights of a visit to South Georgia. There are tight landing

restrictions, however the birds are hand tame and you may get opportunities to photograph birds displaying. The South Georgia Pipit, not the most exciting bird but endemic here, may pose for the camera too. Other species of albatross nest on South Georgia. Light-mantled Sooty Albatross can be found on the cliffs above Gold Harbour. This landing offers some great photography with King Penguins set against the backdrop of the hanging Bertrab Glacier.

Most, if not all, visiting ships stop at the old whaling settlement of Grytviken. Historically interesting, this is also one of the best spots at which to photograph another South Georgia endemic, the South Georgia Pintail. Other photo highlights include the derelict whaling station and Shackleton's grave.

When To Go
December and January are the ideal months. South Georgia is a windy place and the weather very changeable. My last visit to South Georgia coincided with high winds on a couple of days, making the zodiac rides from ship to shore very wet.

Bird Photography

Left South Georgia offers a heady mix of vast penguin colonies and spectacular scenery. Over 100,000 pairs of King Penguins crowd the gravel plain nestled beneath jagged snow-capped peaks and glaciers. I took this shot from the beach at St Andrew's Bay, where the glacial melt stream enters the ocean.

Hasselblad Xpan with 45mm lens, 1/125sec at f/8, Fuji Velvia 50

Top right **A Wandering Albatross incubates its egg on Albatross Island in the Bay of Isles, South Georgia. Our ship is moored below.**

Hasselblad Xpan with 45mm lens, 1/60sec at f/11, Fuji Velvia 100

Below right **A young King Penguin passes the time of day with a tourist. I am always on the lookout for images such as this which engage people with wildlife. As mentioned previously they are useful for travel brochures, books and magazine articles where eco-tourism needs to be illustrated. This was taken at South Georgia's Gold Harbour.**

Nikon F5 with 300mm lens, 1/125sec at f/8, Fuji Velvia 50

Travel / Accommodation
As South Georgia is the highlight for many when visiting this region, it is worth looking around for trips that spend a few days here, giving plentiful time ashore. It is possible to reach South Georgia by yacht, giving a more flexible approach, however good sea legs are needed for the crossing, which in itself can be very exciting!

Site Guide

Key Birds Penguin colonies against impressive backdrops, and penguins on bergs at Paulet Island are the highlights. The peninsula is an excellent place for close encounters with whales, particularly Humpbacks.

Antarctic Peninsula, South Shetland Islands & Weddell Sea

As the most accessible part of Antarctica it follows that the peninsula is the most visited too. Some popular stops for ships, such as Port Lockroy, welcome tourists on an almost daily basis during the high season. If you have visited South Georgia before reaching the peninsula you might find some of the bird spectacles a little tame in comparison.

This is a land of ice, rock, water and sky, ingredients that make it one of the most beautiful places on earth, and although many of the colonies you will visit on the peninsula are small, they do enjoy some spectacular backdrops. Few seabirds are seen from the ship down here, other than Snow Petrels and skuas. This is the realm of the penguin, with huge numbers of Adelie and Chinstrap Penguins. My favourite spot on the peninsula is Petermann Island. Normally snow covered this

small island at one end of the Lemaire Channel (known as Kodak Alley for its scenic splendour) has breeding Adelie and Gentoo Penguins on rocky outcrops. Photography here can be excellent particularly towards sunset, as this is a good site for silhouettes.

The South Shetland Islands are separated from the Antarctic Peninsula by the Bransfield Strait. They consist of 11 major islands, many of which are rich in birdlife, some with huge penguin colonies, one of the most impressive being on Deception Island at Baily Head. Zodiac landings are notoriously difficult here due to a steeply shelving beach, however the effort of reaching the black volcanic beach is worth the soaking you might receive, as walking into the caldera surrounded by penguins is awesome. The beach provides great

Bird Photography

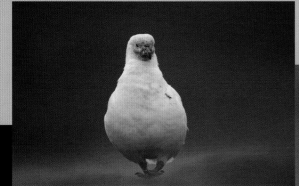

Above **To photograph this Pale-faced Sheathbill on the Antarctic Peninsula, I lay flat on my stomach and used a waist-level viewfinder. To throw the background out of focus I used a shallow depth of field.**

Nikon F5 with 500mm lens, 1/125sec at f/4, Fuji Velvia 100

Right **Gentoo Penguin calling, Port Lockroy on the Antarctic Peninsula. I shot this in the vertical format for extra impact.**

Nikon F5 with 500mm lens, 1/500sec at f/5.6, Fuji Velvia 100

Left **A late evening landing on the Antarctic Peninsula gave the opportunity to silhouette an Adelie Penguin and chick. Such opportunities will not be available on all cruise ships, so it is worth trying to ascertain how flexible the expedition leader is on your chosen cruise.**

Nikon F5 with 500mm lens, 1/1000sec at f/8, Fuji Velvia 50

photography as hundreds of penguins come and go. Hannah Point at the south-west end of Livingston Island is regularly visited. You can see Antarctica in miniature as nearly all the peninsula's breeding birds can be found here in close association.

There are numerous other landing sites in these islands and on the peninsula, and all will provide birds that will pose just a few feet away.

East of the Antarctic Peninsula lies the ice-choked Weddell Sea. A few icebreakers venture into this area annually. One of the Weddell's jewels, is Paulet Island. This is the place to photograph Adelie Penguins on icebergs and to get that classic shot of a group of birds tumbling off a berg into the ocean. The island is surrounded in late summer by hundreds of small bergs many of which will have penguins on them. My advice here would be to do as many zodiac trips as possible as this is the best opportunity for getting these shots. My last visit produced an amazing encounter with a Leopard Seal that caught and devoured no fewer than five Adelie Penguins.

When To Go
Ships visit the region from November to late February. December and January are best.

Travel / Accommodation
Numerous ships visit the peninsula, and relatively cheap trips can be taken for a duration normally of around ten days. Otherwise the peninsula is always included on longer cruises out of South America. For Paulet Island it is often necessary to be in an icebreaker and even then, depending on ice conditions, it may not be possible to reach the island.

Key Birds Various species of albatross and the Royal Penguins on Macquarie are high spots for photography. The islands are often visited en route to the Ross Sea, and photography of seabirds from the ship at sea in this region can be very good.

Right **Macquarie Island is host to a huge King Penguin colony.**

Nikon F5 with 70-200mm lens, 1/125sec at f5.6, Fuji Velvia 50

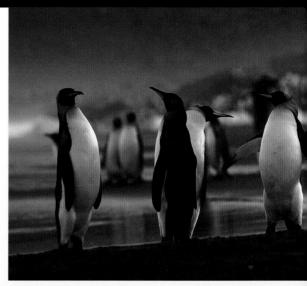

Including the Chathams and the Australian territory of Macquarie Island, these islands are outstanding for birds. However, strict limitations are put on visits, landing is prohibited on most islands in the group, and so visits are dominated by zodiac cruising along the shore. This of course makes photography very frustrating.

The Auckland Island archipelago is regularly visited by ships, with Auckland Island itself offering various species of albatross and Yellow-eyed Penguins, plus Auckland Shag, an endemic. A strict code has to be adhered to on Auckland as with visits to other New Zealand administered islands. Carnley Harbour in the south of the island can be full of Sooty Shearwaters, and Yellow-eyed Penguins are likely here too. One of the best landings is at South West Cape where a colony of White-capped and a few Gibson's Albatrosses can be photographed.

At the northern end of Auckland Island is the small Enderby Island. Photography is productive here with Southern Royal Albatross available to photograph. Both New Zealand Snipe and the rare Auckland Teal are further possibilities.

Campbell Island, the southernmost of New Zealand's subantarctic islands, is one of the few where landings are permitted. If landing at Perseverance Harbour, a walk up to Col Peak via a boardwalk is well worthwhile as the world's largest Southern Royal Albatross colony can be enjoyed. The birds nest amongst the megaherb fields. These impressive plants flower in January.

Macquarie Island boasts an impressive avifauna with close to a million pairs of Royal Penguins and over 150,000 pairs of King Penguins. Other highlights include Wandering, Grey-headed, Black-browed and Light-mantled Sooty Albatrosses, plus a host of breeding petrels and the endemic Macquarie Shag. Strict visitor guidelines operate, meaning many locations are off limits and others only viewable from zodiacs. However the research station at the southern end of the island offers photography of the four breeding species of penguin plus Giant Petrels.

When To Go
Most ships visit the island between December and February.

Travel / Accommodation
Ships leave from Tasmania and New Zealand, usually visiting these islands before travelling on to the Antarctic. As with other cruises, size of ship, itinerary and length of time ashore are the vital considerations.

Bird Photography

Key Birds The Emperor Penguin is the star bird. Other avian photo highlights in this region include Snow Petrels and Antarctic Petrels that breed here in their millions.

Ross Sea

Right **Snow Petrels occasionally present themselves around ships in Antarctica, but are best photographed close to their nest sites. This image was taken on the Weddell Sea, just as birds were returning to their colonies.**

Nikon F5 with 300mm lens, 1/500sec at f/4, Fuji Velvia 50

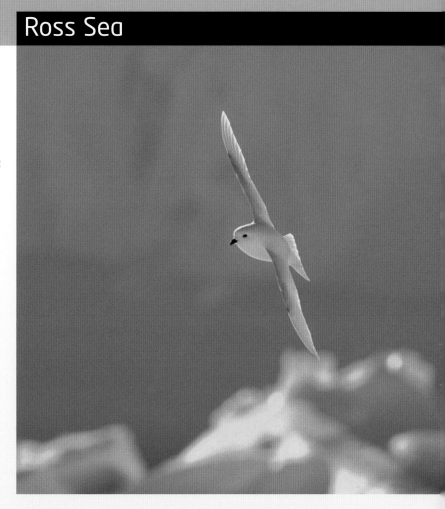

The Ross Sea is a large bay on the Pacific Ocean side of Antarctica. On one side is the huge Ross ice shelf, the size of France, from where huge icebergs float out into the ocean. The Ross Sea region is best known as the site of expeditionary huts, namely Scott's and Shackleton's, and is the most accessible area for Emperor Penguins.

When To Go
A number of Emperor colonies can be visited with special voyages departing in November from New Zealand or Tasmania. Otherwise cruises visit from December through to February. For much of the year the bay is covered in pack ice. Emperors can often have left their colonies by mid to late December, so if this species is a prime photographic subject, I would suggest a November departure is essential.

Travel / Accommodation
Many of the voyages that visit the Ross Sea also visit some of the New Zealand subantarctic islands. Most voyages are for three to four weeks, and usually cost more than trips to the peninsula. A good ice-breaker is essential, and a ship with a helicopter gives more flexibility, both for reaching colonies and the chance of seeing the Dry Valleys.

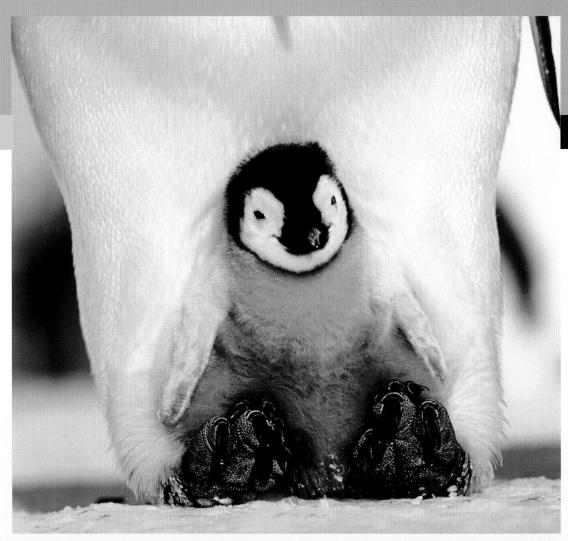

Above **To be in with the best chance of capturing a young Emperor still being brooded on their parent's feet, a fly-in trip in early November is the only viable option. For this image I lay on the ground with a waist-level viewfinder.**

Nikon F4 with 300mm lens, 1/250sec at f/4, Fuji Velvia 50

Emperor Penguin fly-in expeditions

Dependent on demand, Adventure Network International run expeditionary style trips to one of the Weddell Sea Emperor Penguin colonies, usually the Dawson-Lambton Glacier. In recent years these trips have departed in mid November, a little late to make them attractive to photographers.

However, ANI are flexible and you can arrange to go at the beginning of the month if you have enough like-minded people. I joined an expedition in 1998 (an account of which you can find in Chapter 3). We negotiated ten days, camping on the sea ice next to the colony. For the cost, which currently is around US $20,000, it is a gamble. Weather delays are frequent, and three-week delays in Punta Arenas before flights can get in are not unheard of.

Additional Sites

As already mentioned there are numerous landing sites on the Antarctic Peninsula and on the islands off the peninsula. Below I have listed some of the most popular and their main attractions to the photographer.

Hannah Point
Located at the southwest end of Livingston Island, the island supports Chinstrap and Gentoo Penguin colonies and a few Macaroni's. There are Southern Giant Petrels nesting and Cape Petrels too, and you may see Wilson's Storm Petrels flying around during evening landings. Southern Elephant Seals are an added photo attraction here.

Deception Island
This large volcanic island in the South Shetlands has a number of landing sites. Whaler's Bay is a popular landing site, of most interest for it's history and landscape photo opportunities than wildlife. Baily Head can provide difficult landing conditions due to a steeply shelving beach, however the huge colony of Chinstrap Penguins is quite spectacular, and the site offers up a photographic feast

Cuverville
This rocky island in the Errera Channel offers up an impressive Gentoo Penguin colony along with a good range of other peninsula species. The scenery here is dramatic offering some impressive backdrops.

Torgerson Island
Close to Anvers Island site of the US Palmer research base, this popular cruise ship landing has a Gentoo colony, along with Antarctic Shag and Kelp Gull.

Port Lockroy
Perhaps the most visited site on the continent by tourists, a Gentoo Penguin colony is once again the main attraction, although there is historical interest with the restored British huts that were first built in 1944 establishing a British base here.

Petermann Island
Adelie, Gentoo Penguins, Antarctic Shags, and South Polar Skua all vie for attention here. The island is partly snow covered in summer. I have found this island to be one of the best for creating images showing the birds within the vast Antarctic landscape. An evening visit here is as already mentioned great for silhouette and backlit shooting.

Paulet Island
Within the northwest part of the Weddell Sea lies Paulet Island. A huge colony of Adelie Penguins cover the 3.5km long beach and low hillside. Usually surrounded by small grounded icebergs this is the place to shoot penguins on bergs and jumping off them. Zodiac cruising is usually best for this. Leopard Seals often cruise the beach, and on my last visit here I was able to photograph a seal catching penguins as they made the dash to the sea.

Site Guide

121

Australasia Lamington National Park, Australia; South Island, New Zealand; Michaelmas Cay, Queensland Australia; Kakad◆
Michaelmas Cay, Queensland, Australia; Kakadu National Park, Northern Territory, Australia; Stewart Island, New Zealand;

Territory, Australia; Stewart Island, New Zealand; Lamington National Park, Australia; South Island, New Zealand; Michaelm◆
Australia; South Island, New Zealand; Michaelmas Cay, Queensland, Australia; Kakadu National Park, Northern Territory, Aus◆

Australasia

The vast and scarcely populated landscapes of Australia and
New Zealand are home to an incredible array of wildlife. Here there
are plants and animals that have evolved over millions of years in
isolation, producing some of our planet's most bizarre and
colourful creatures and providing a wealth of sites at which to
photograph birds.

When visiting either Australia or New Zealand, do not be tempted
to crowd too much in and end up spending much of your time
travelling as a result. Furthermore, ensure that you plan your trip
carefully as much of the land is extremely remote.

Northern Territory, Australia; Stewart Island, New Zealand Lamington National Park, Australia; South Island, New Zealand;
onal Park, Australia; South Island, New Zealand; Michaelmas Cay, Queensland, Australia; Kakadu National Park, Northern

and, Australia; Kakadu National Park, Northern Territory, Australia; Stewart Island, New Zealand; Lamington National Park,
sland, New Zealand; Lamington National Park, Australia; South Island, New Zealand; Michaelmas Cay, Queensland, Australia

Australia's climate varies considerably, from the temperate south to the steamy tropics of the north. In its 'red centre' as it is known, in Uluru-Kata Tjuta National Park, lies Australia's best known natural wonder, Uluru or Ayers Rock. The climate here is dry and hot, but even so a good variety of birds can be found.

Local knowledge is a big plus when photographing birds in Australia, and it is worth seeking out local guides for assistance. The northern state of Queensland is hard to beat for variety of species and photographic opportunities. Here there are lush rainforests, wetlands teeming with life and spectacular mountain gorges. Offshore lies the world-famous Great Barrier Reef, where islands such as Michaelmas Cay offer great photo opportunities for tropical seabirds.

Australia is obviously a long flight from the northern hemisphere, and many flights offer stopovers in places such as Bangkok, Singapore or Hong Kong. A visit to the northern territory is best between May and October. The monsoon arrives between November and March, bringing with it high humidity. The beauty of Australia is the provision of excellent accommodation, good roads, magnificent scenery, some spectacular-looking birds and of course decent wine too.

Unfortunately humans have had a devastating effect on the birds of New Zealand. Due to a lack of land predators, many species evolved to be flightless. Then 900 years ago the Maori came, followed by Europeans around 200 years ago. With them came rats, cats, pigs and various other threats. Some species have been lost, others have been saved in the nick of time, so that wildlife conservation has today become a high priority. This is good for the birds, but not so good for photographers, as many sites are off limits and others require permits and are difficult to reach.

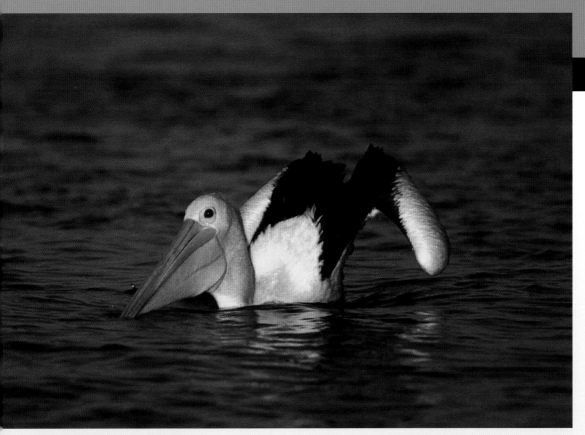

Left **I stalked this Beach Thick-knee on Great Keppell Island. Although Australia's barrier islands may have few species, those they do have are well worth photographing.**

Nikon FE2 with 600mm lens, 1/125sec at f/5.6, Fuji Sensia 100

Above **Australian Pelicans are one of Australia's more approachable species, and can be encountered at numerous localities.**

Nikon FE2 with 600mm lens, 1/125sec at f/5.6, Kodachrome 64

Over 50 endemic species of bird occur on the mainland of New Zealand, a number of which are relatively easy to track down and photograph. They include the Kea, Yellow-eyed Penguin and the wonderfully named Tui. A popular way of seeing New Zealand is to hire a motor home or to camp. There is plentiful guesthouse and hotel accommodation, and other options are cheap cabins and holiday parks. Advance booking might be sensible in the busy holiday months of January and February.

Planning a trip is relatively straightforward as much information already exists on where many of the most sought-after birds can be found. A highlight is a visit to Kaikoura, from where a boat can take you into waters rich in seabirds. There are few better places to photograph the Great Albatrosses, petrels and shearwaters.

Key Birds Birds that are relatively easy to photograph include Brush Turkey, Regent and Satin Bowerbirds, Green Catbird, Common Rosella, King Parrot, Lewin's Honeyeater, Eastern Spinebill and Superb Fairy Wren. Rainforest skulkers such as Albert's Lyrebird pose far more of a challenge.

Lamington National Park, Queensland, Australia

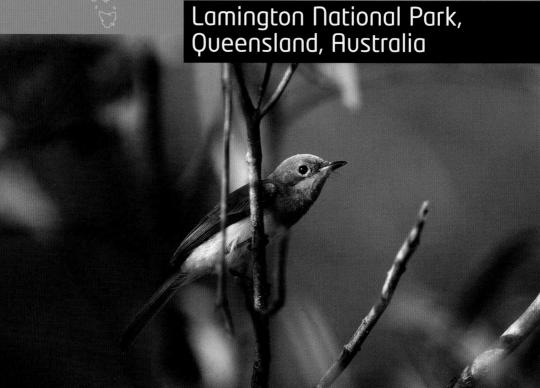

Above **This Leaden Flycatcher was taken on one of the Barrier Islands off Australia's east coast.**

Nikon F4 with 600mm lens, exposure details not recorded, Kodachrome 64

Perched above Brisbane, the World Heritage listed rainforest of Lamington National Park is home to some of Australia's most sought-after subjects for bird photographers. For photography a stay at the O'Reilly's Guesthouse is a must. Here there is rainforest just a few metres from your room, while a multitude of species are attracted by the provision of food. These include various species of bowerbird, and hand-tame King Parrots and Crimson Rosellas.

Within the rainforest bird photography is much more difficult, so it is worth concentrating most effort around the guesthouse. The staff will be able to help out with locations for other photo opportunities.

When To Go
May to October is the dry season, and the ideal period for a visit. I have visited in January and experienced heavy rain daily, which greatly hampered photography. However different seasons here will throw up different opportunities.

Travel / Accommodation
The city of Brisbane is the obvious gateway to Lamington, where there is an international airport. O'Reilly's is a two-hour drive (www.oreillys.com).

Bird Photography

Key Birds Seabirds are a big attraction, plus Yellow-eyed Penguins, kiwis and the many other endemics.

South Island, New Zealand

Right **The Cape Petrel is just one of many species of seabird found off New Zealand's Kaikoura. There are few more productive sites in the world for photographing such a range of seabirds as Kaikoura.**

Nikon F5 with 500mm lens, 1/1500sec at f/5.6, Fuji Velvia 50

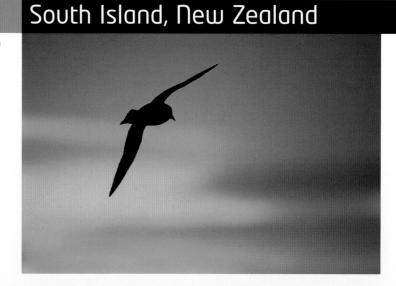

One of the easiest photographic subjects on South Island is the Kea, a green parrot that is famous for being destructive with anything that is left lying around. They can be found around the car parks to the Fox and Franz Josef Glaciers. Here they attack parked cars, destroying windscreen wipers and anything else they can get their beak into.

Undoubtedly the star site for photography on South Island is Kaikoura. World famous as a whale watching resort, it is however the seabirds and the photographic possibilities on offer that make this the premier site for capturing images of albatrosses, petrels and shearwaters at sea.

The greatest variety of seabirds gathers offshore between April and November, although many species are present throughout the year, so it is not imperative that you visit during the winter.

What makes Kaikoura so special is its location. It is situated on a peninsula jutting out into the Pacific Ocean with a deep water canyon just offshore. This canyon is the meeting point of warm and cold currents, the basis for a food chain attracting large numbers of birds. Wandering, Royal, Shy, Salvin's and Black-browed Albatrosses can be seen and often photographed at close range throughout the year. Different shearwaters

and petrels are seen at varying times during the year depending on the species.

Kaikoura offers plentiful accommodation. Various boat operators run daily trips out to the canyon. Most are preoccupied with whales. One specialist for birds is Albatross Encounters (www.oceanwings.co.nz), and this is your best bet for photography, as they chum (put out chopped fish and oils), which brings many species, particularly albatrosses, very close.

During winter (May to September) the company runs twice-daily trips and during summer there are three trips a day. Advance booking is recommended. For further information on Kaikoura itself go to www.kaikoura.co.nz.

When To Go
The southern hemisphere spring is as good a time as any to visit for most of the specialities.

Travel / Accomodation
Travel is easy around the country on good roads. Accommodation is plentiful, ranging from guest houses to cabins and plenty of campsites. A popular way of seeing the country is to rent a motor home.

Site Guide

Michaelmas Cay, Queensland, Australia

This sandy island on the outer part of the Great Barrier Reef has breeding Brown Noddy, Sooty, Bridled and Crested Terns, and the chance of photographing Great and Lesser Frigatebirds too. The diving and snorkelling here is not to be missed. Boats depart daily from Cairns, however they all visit the cay during the middle of the day, usually for a period of around two hours, so fill-in flash is a useful technique to soften the often harsh light at this time of day (see page 30).

Kakadu National Park, Northern Territory, Australia

Covering 7,722 square miles (20,000 square kilometres), this park is not only immense but very remote too. There are numerous aboriginal rock art sites reflecting its cultural as well as natural importance. The park encompasses an entire river system, and habitats that range from mangrove to rocky escarpment, and includes beautiful waterfalls and wetland plains, the latter often covered in waterbirds, notably Magpie Geese.

There are a number of camps and lodges in the region at which you can stay, along with quite a few airstrips, allowing arrival by air from Darwin or Katherine. A monsoon-type climate lasts from November to April, when roads can sometimes be closed. The build-up to the rains in October and early November can lead to some oppressive temperatures. A visit between May and October is best.

Stewart Island, New Zealand

Located off the southern tip of South Island, this destination is a must. Ulva Island off Stewart Island (reached easily by water taxi) has extremely tame Wekas. Kiwis are high on everyone's list to photograph. They are nocturnal so these flightless balls of feathers are often difficult to find. However Ocean Bay offers a good chance of Brown Kiwi that readily come to the beach to feed. There are a number of other endemic species on the island that give photographic possibilities. The island can be reached by ferry from Bluff.

Left **Bronze-wing Pigeon is a forest species, that typically may need flash to photograph.**

Nikon F5 with 300 mm lens, exposure details not recorded, Fuji Velvia 100, flash

Right **Black Swans are a native to Australia and were introduced to New Zealand. Here I have moved in close for a head shot. It was a dull cloudy day and a whole image of the swan may have looked a bit lifeless in the poor light. But by picking out the detail of the head, an attractive picture could still be made.**

Kodak DCS Pro 14n with 500mm lens, 1/60sec at f/4, ISO 160

Asia Beidaihe/Happy Island, China; Bharatpur, India; Khichan, India; Japan Beidaihe/Happy Island, China; Bharatpur, India; Khichan, India; Japan Beidaihe/Happy Island, China, Bharatpur, India, Khichan, India, Japan Beidaihe/Happy Island, China,

Bharatpur, India; Khichan, India; Japan; Beidaihe/Happy Island, China; Bharatpur, India; Khichan, India; Japan; Beidaihe/Happy Island, China; Bharatpur, India; Khichan, India; Japan; Beidaihe/Happy Island, China; Bharatpur, India; Khichan, India; Japan;

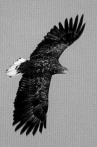
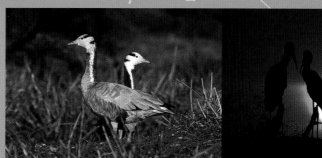

Asia

Ever since Marco Polo returned to Italy from his travels in Asia with fascinating tales of the exotic, Asia has beckoned. Today those of us with an interest in wildlife are drawn to the region's natural riches. Birds abound, with numerous photography hotspots stretching from the high Himalayas to the rainforests of Indonesia. There is a marked contrast to the approachability of birds in various countries. For example in China where persecution, and most notably trapping, has been part of the culture for centuries, most birds are notoriously shy of human approach, making photography a big challenge. Contrast this with the Indian subcontinent, where birds are on the whole left alone and so are far more tolerant of approach. I have selected four locations that, for me, stand out as photographic experiences. All four are very different in what they have to offer.

Beidaihe and Happy Island, China

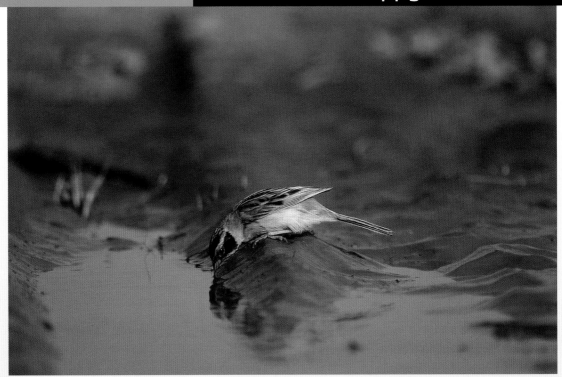

Bird Photography

Lying on a migration flyway, both Beidaihe (pronounced bay-die-her) and Happy Island (proper name Shijiutuo Dao) have in the past decade become a mecca for Western birders. For bird photographers this part of China has become the most accessible location to photograph Siberian migrants.

Beidaihe is a seaside town on the shores of the Gulf of Bohai. It is a popular resort for workers from Beijing being just 170 miles (280km) east of the capital and served by a good rail link. The town and its environs have changed much since my first visit in 1992. Then there were a number of wooded gullies leading to the sea, some orchards and numerous areas of scrub in and around the town. All acted as refuge points for the tired migrants passing through on their way north to Siberia each

April and May, and on their return journey in the autumn. Many of these localities have been built on, as the town has grown in size. However enough habitat still remains to make a visit worthwhile.

Photography is not easy, with perseverance and a long telephoto lens being the key ingredients to success. In quieter spots and in the Lotus Hills, it is possible to construct small drinking pools and erect hides, a technique that will greatly increase your success rate.

Happy Island lies 50 miles (80km) to the south of Beidaihe and is easily reached by road. It lies just offshore, surrounded by wide tidal mudflats that in spring and autumn are thronged with migrant waders. At high tide they gather at the south western corner of the island, and on spring

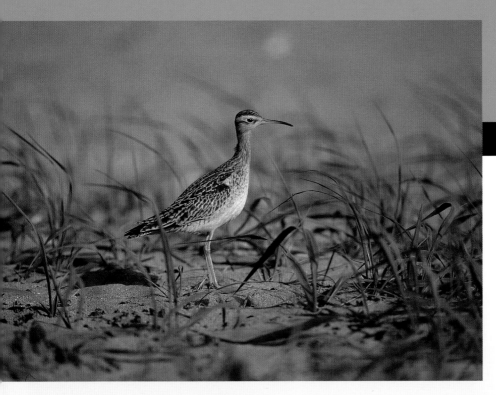

Above **A prime find on the beach in Beidaihe one morning was this Little Whimbrel. Normally on migration, this species is difficult to approach so finding a tame individual was a real bonus. This is one of the world's great travellers, wintering in Australia they migrate north to Siberia to breed.**

Nikon FE2 with 600mm lens, 1/125sec at f/5.6, Kodachrome 64

Left **Japanese Reed Bunting is one of around 250 species of migrant birds that pass through Beidaihe in spring.**

Nikon FE2 with 600mm lens, 1/250sec at f/5.6, Fuji Sensia 100

tides they can be photographed. It is however the passerine migrants that are the biggest lure. Incoming birds are often exhausted, and can arrive in spectacular numbers. I will never forget my first visit; the island was simply buzzing with birds.

There is a limited amount of fresh water on the island, and these are excellent spots at which to place hides. Thrushes, buntings, chats and warblers will all come down to drink and bathe. I have managed plenty of good pictures on the island by not using a hide, often just by sitting quietly at the edge of a clump of bushes, or by careful stalking. The beauty of the island is that every day is very different, and you never know what will appear next.

When To Go
The first two weeks in May are best for variety and numbers. Autumn can be good, however photography is far harder as there is much more vegetation due to summer growth, and as many of the birds are of a skulking nature, it can be frustrating.

Travel / Accommodation
Beidaihe is easily reached by train from Beijing. Tickets can be bought at the 'foreigners' desk' inside the main railway station. Alternatively they can be arranged in advance. Beidaihe, being a popular holiday town, has a couple of good hotels where Westerners are permitted to stay. The Jin Shan has traditionally been the popular choice for birders as it is close to a number of good locations within the town, and offers excellent food.

On Happy Island it is possible to stay in very basic accommodation, which needs to be arranged in advance, either by contacting a ground agent or the hotel at Beidaihe in which you plan to stay.

Site Guide

Bharatpur, India

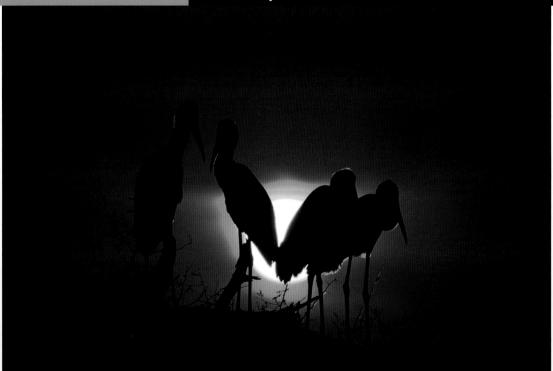

Just inside the state of Rajasthan, and just 33 miles (52km) west of Agra (home to the Taj Mahal), is Bharatpur. Keoladeo Ghana National Park, as it is also known, is one of the world's finest wetlands, and for bird photographers the most popular destination on the continent. Covering 11 square miles (17 square kilometres), the reserve was once a duck-hunting preserve of the maharajas.

After the monsoon (July-September) the shallow marshes provide a rich hunting ground for nesting storks, ibis, herons, egrets, darters and a host of other species. During winter the breeding bird population is augmented by visitors that have migrated south, and include ducks, geese such as the Bar-headed Goose, cranes, waders and a variety of eagles. Eagles are more approachable here than just about anywhere else in Asia, with

the Greater Spotted Eagle being one of the more numerous. Surrounding the wetland are grassland, thorn scrub and deciduous woodland. These habitats provide further picture possibilities. Some of the most photographed species other than waterbirds include Large-tailed Nightjar, Spotted Owlet and Collared Scops Owl, and Hoopoe around the temple area.

Tree-lined bunds crisscross the wet areas. It is most productive to take a flat-bottomed punt out on to what is known as the boating lake. These can be booked at the barrier.

Your boatman will be able to manoeuvre you close to many species of waterbird, and during the breeding season in late summer/early autumn, Painted Storks and Spoonbills can be approached at the nest.

eagles and Marsh Harriers, the former may include Great Spotted, Steppe, Tawny and Crested Serpent Eagle. In some years Painted Snipe are present, and with perseverance skulking over-wintering species such as Siberian Rubythroat and Orange-headed Ground Thrush. Annual stake-outs include Collared Scops Owl, Spotted Owlets, Large-tailed Nightjar and often Jungle Nightjar. In some years nesting Dusky-horned Owls can be photographed too.

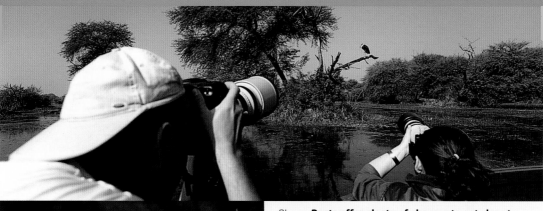

Above **Boats offer plenty of chances to get close to waterbirds, such as this Woolly-necked Stork at Bharatpur.**

Hasselblad Xpan with 45mm lens, exposure details not recorded, Fuji Velvia 50

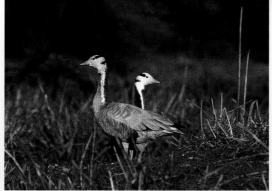

Left **Bar-headed Geese can be approached by boat. To keep both of these birds in focus I had to use a large depth of field.**

Nikon F5 with 500mm lens, 1/60sec at f/11, Fuji Velvia 50

Left **Painted Storks silhouetted against the sinking sun at Bharatpur. I severely underexposed this image, using the reading my centre-weighted meter gave me as an exposure value.**

Nikon F5 with 500mm lens, 1/2000sec at f/8, Fuji Velvia 50

Travel / Accommodation

Bharatpur is a four-hour drive from Delhi, and just over one hour from Agra. Travelling on Indian roads can be stressful at times. It is cheap enough to be able to hire a vehicle with a driver for any road journeys you make. I normally go through a ground agent (Exotic Journeys) for my visits to the subcontinent. They meet me at the airport and take care of all transportation.

There is a lodge within the park offering comfortable accommodation. The advantage of staying here is its convenience, as you are right on the edge of the wetland area. Numerous other guest houses and hotels are located outside the park gates, and offer a cheaper but less convenient alternative. Bicycle and rickshaw hire is readily available. Many of the rickshaw wallahs have a good knowledge of birds and know where various nightjars and owls roost, so they are worth hiring.

Bharatpur is particularly good for flight shots. From a boat and from Python Point (near the Temple) are two suggestions.

When To Go

The most popular period to visit is between late November and late February. Water levels should still be high, and there should be good numbers of birds in the park. Temperatures at this time of year are very pleasant, early mornings can be chilly.

Occasionally the monsoon fails. In such years, far fewer birds are likely to visit and many species may not breed. For breeding behaviour, a visit during late August and early September is recommended, however it will be hot and it may still be a little wet at times.

Site Guide

135

Khichan, India

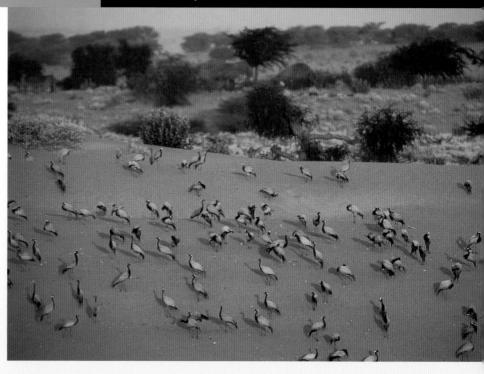

During the winter months the village of Khichan, in the Thar Desert of Rajasthan, hosts a gathering of over 10,000 Demoiselle Cranes. From October to March the village offers a photographic feast; with the combination of the landscape, sheer numbers of birds, and superb light, there is much potential.

The whole area between here and Jodphur is inhabited by the Vishnoi people - a community of strict vegetarians who value all forms of life highly and have developed a remarkable affinity with nature. This protection has given the wildlife in this region a far more confiding nature than in the rest of India, hence the quite outstanding opportunities on offer.

The cranes winter in the vicinity of the village and are fed twice a day by a local voluntary organisation, which puts food down in a walled enclosure roughly the size of a football pitch.

The birds get through an amazing ten sacks of grain per day.

As dawn approaches, the cranes gather on the large sand dunes bordering the village, the noisy flocks make a stirring sight as the sun rises. Slowly the restless flocks creep closer to the enclosure which is right on the edge of the village. Eventually, cautiously, one crane hops over the fence, followed by a few more, then hundreds. Thousands linger on the dunes and for around three hours after dawn there is an endless procession of birds coming and going.

I have visited in November and was invited on to the roof of a house overlooking the enclosure and dunes. This enabled me to photograph the cranes at eye-level as they flew in. In the mid-afternoon I would go over to the nadis - rainwater reservoirs on the other side of the village.

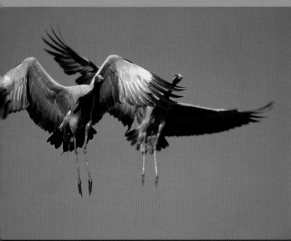

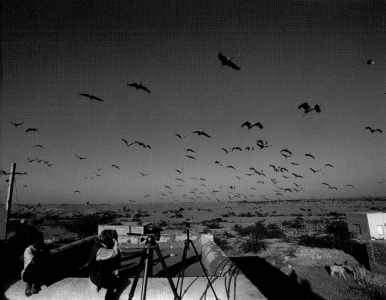

Far Left **Demoiselle Cranes gather on the dunes surrounding Khichan at daybreak. It is worth getting into position well before sunrise.**

Nikon F5 with 300mm lens, 1/125sec at f/8, Fuji Velvia 50

Top **On occasions cranes comes so close overhead, they appear as if they are about to land on the rooftops! This pair were photographed from the roof of a villagers house overlooking the feeding site.**

Nikon F5 with 80-200mm lens, 1/250sec at f/5.6, Fuji Velvia 50

Left **The sight and sound of thousands of cranes as they arrive at the feeding compound, makes this one of the world's great bird spectacles. These shots were taken with a 24mm lens, but just occasionally its nice to put the camera down for a couple of minutes and soak up the atmosphere**

Nikon F5 with 24mm lens, exposure details not recorded, Fuji Velvia 50

Here the cranes arrive to drink, bathe and rest, showing little concern for passing camel carts and local people. The second feeding session of the day normally takes place in the late afternoon, but the cranes can fail to return then. However, photography can still be good as flocks fly over the dunes to their roosting site, often silhouetted against the setting sun.

When To Go
Any time between mid October and late February.

Travel / Accommodation
Khichan lies just off the main route between Jodphur and Jaisalmer, near the market town of Phalodi. It is not really a tourist area, and accommodation is not plentiful, however there are a couple of comfortable lodges not too far from the area. The best option is to arrange your accommodation and transport before leaving for India. Exotic Journeys can do this for you and may be able to arrange access to rooftops overlooking the feeding area.

Site Guide

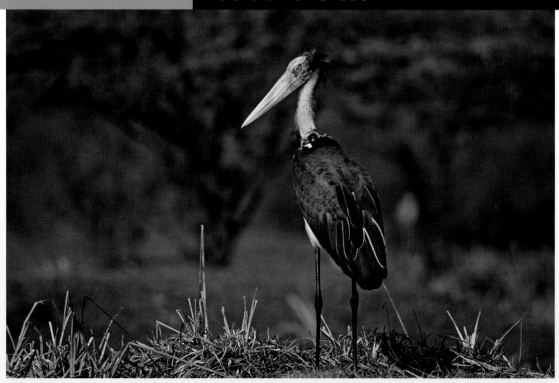

Japan

Japan has become popular with wildlife photographers for the subjects that are on offer during the often harsh Japanese winter. They include the famous Snow Monkeys that bathe in hot thermal springs, and the other star attractions are birds. They include cranes, particularly Japanese Cranes, Whooper Swans and Steller's Eagles. White-tailed Eagles are easier to photograph at many winter sites in Japan, than they are in northern Europe.

Japan is not the easiest of countries to make a solo trip to. Navigation can be difficult on Japan's roads, and English is not spoken by as many people as in many other Far Eastern countries. The vast majority of photographers join groups specializing in photography, of which there are a few each year.

Korea

South Korea offers some of the best birding in Asia, and for photographers can offer some exceptional opportunities. It is a safe destination and the people friendly. Some of the best periods for a visit are mid winter, spring (April, May) and also September and October for autumn migrants including the chance of Spoon-billed Sandpiper.

Other potential photographic subjects may include vast flocks of Baikal Teal, and the chance of Black-faced Spoonbill among others. For more information visit www.birdskorea.org.

Above **A White-tailed Eagle circles overhead. Japan offers excellent opportunities in winter for photographing this species as well as the much sought after Steller's Eagle.**

Nikon F5 with 500mm lens, exposure details not recorded, Fuji Velvia 50

Right **A Japanese Crane struts its stuff across the snows of a Japanese winter. Beautiful images can be captured of this species in winter, just one of a number of prized birds on offer to the photographer in Japan.**

Picture by Eric McCabe (courtesy of Windrush Photos)

Opposite **Lesser Adjutant Storks are a scarce species occurring in Indonesia and South East Asia. This was a chance encounter with a wandering bird in India. I have knelt on the ground to get a low angle on the bird.**

Nikon F5 with 500mm lens, 1/250sec at f/8, Fuji Sensia 100

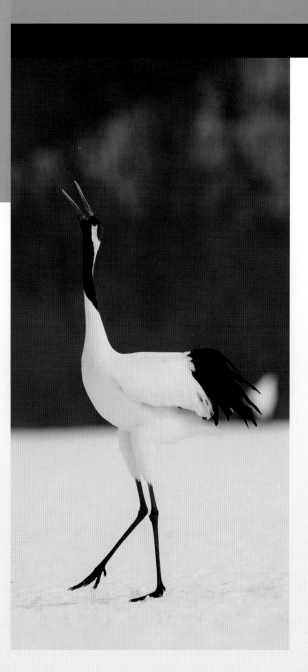

Europe Lesvos, Greece; Varanger, Arctic Norway; Owls, Finland; Kangasala, Finland; South West Archipelago; Kuusamo, Fi◼
Isle, Scotland; Handa, Scotland; Caerlaverock, Scotland; Pembrokeshire Islands, Wales; Gigrin Farm, Wales; Slimbridge, Englan◼

Grouse, Finland; Hornborga Lake, Sweden; Farne Islands, Scotland; Bass Rock, Scotland; Hermaness, Scotland; Mousa, Scotlan◼
England; Lesvos, Greece; Varanger, Arctic Norway; Owls, Finland; Kangasala, Finland; South West Archipelago; Kuusamo, ◼

Europe

Variety of landscape, climate and culture are some of the joys of travel in Europe. The continent's birdlife is varied, ranging from the typical Mediterranean species of the south to the Arctic specialists of the far north.

Population pressures and some persecution in a few parts of Europe has meant bird photography is far from easy in many countries. Despite this Europe has much to offer, from spectacular winter flocks of geese to seabird cities where birds such as Puffins are so tame they can be photographed with a wideangle lens. For many European bird photographers, migrants are a big lure. There are few better places to photograph these than the Greek island of Lesvos.

There are some European countries, such as Spain and Poland, where excellent prospects for the bird photographer await. However, many opportunities in such countries require careful planning and research before visiting. For this reason I have refrained from covering such places in great detail, as a whole volume could be written on Spain alone. Instead are featured destinations where you can turn up and be almost guaranteed good photography.

...land; Hornborga Lake, Sweden; Farne Islands, Scotland; Bass Rock, Scotland; Hermaness, Scotland; Mousa, Scotland; Fair ...nd Lesvos, Greece; Varanger, Arctic Norway; Owls, Finland; Kangasala, Finland; South West Archipelago; Kuusamo, Finland;

...n;, Handa, Scotland; Caerlaverock, Scotland; Pembrokeshire Islands, Wales; Gigrin Farm, Wales; Slimbridge, England; Welney, ...finland; Hornborga Lake, Sweden; Farne Islands, Scotland; Bass Rock, Scotland; Hermaness, Scotland; Mousa, Scotland

Key birds Resident species include Middle-spotted Woodpecker, Sombre Tit and Cinereous Bunting. Migrants include Squacco Heron, Little Bittern, Wood Sandpiper, Red-footed Falcon, Bee-eater, Red-throated Pipit, Whiskered and White-winged Black Terns. Migrants such as Black-headed Bunting and Rufous Bush Chat are relatively easy targets.

Lesvos, Greece

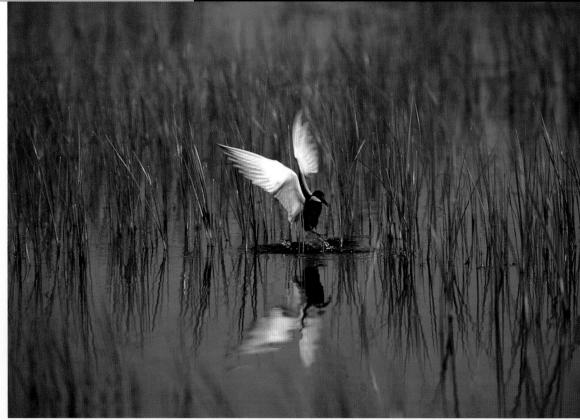

Greece has a number of excellent sites for bird photography, however the island of Lesvos in the Aegean stands out. Indeed it would be difficult to find a better locality to photograph Mediterranean species. A visit in April through to the middle of May is likely to bag a good selection of images. The island is perfect for photography. It is quite compact with good accommodation and lots of quiet roads and tracks on which a car can be used as a hide.

Migration starts in late March/early April, but for numbers and variety of species, a visit in the last two weeks of April and the first week of May is ideal. Herons, crakes, bitterns, waders and a good

variety of passerines are all on offer. Some of the fords on the island such as at Faneromeni near Sigri, are particularly good for photography. Depending on water levels, small pools full of tadpoles attract Little, Baillon's and sometimes Spotted Crakes, and Little Bitterns.

Other photographic hotspots include the East River and nearby tracks at Skala Kalloni. Quite close are the saltpans, and an area of rough grazing land attractive to wagtails, pipits and waders such as the Collared Pratincole. Bee-eaters and often Red-footed Falcons are further target species here, while the water-filled dyke separating the salt pans from the road is often

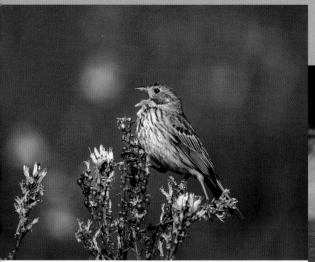

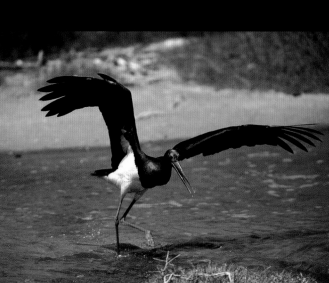

Above **Corn Buntings are numerous on Lesvos and easily photographed from a vehicle in spring, when they perch low down on roadside vegetation emitting their distinctive 'jangling keys' song.**

Nikon F5 with 600mm lens, 1/500sec at f/4, Fuji Velvia 50

Left **Whiskered Terns are passage migrants on Lesvos, never lingering for long. This individual was feeding on the Kalloni Pool in Skala Kalloni. The pool is often a meeting point for bird watchers and photographers on the island and so is a good place to exchange information.**

Nikon F5 with 500mm lens, 1/500sec at f/4, Fuji Velvia 50

Above right **Black Storks show up regularly each spring and may allow approach in a vehicle. This bird was too preoccupied chasing fish to worry about my presence.**

Nikon F5 with 500mm lens, 1/500sec at f/4, Fuji Velvia 50

a productive site for photographing Squacco Heron, and in some years lingering Black Storks. In short there are numerous great localities on the island for photography. To get a better insight on where to go, Birding on the Greek Island of Lesvos by Richard Brooks is an indispensable aid.

When To Go
Mid April to mid May is the most productive period. The advantage of going in May is that it is then possible to book a package with a charter flight, thus having a direct flight.

Travel / Accommodation
Charter flights from Europe normally start during the first few days of May. By joining a charter and buying a package, money can be saved and the aggravation of changing planes en route avoided. However this does restrict when you can go.

Otherwise, flying to Lesvos requires arriving at Athens and then transferring to the domestic airport for an internal flight to Mytilini, the capital of the island. The flight times are such that an overnight stay in Athens is usually required.

Car hire is cheap and there are all the normal car rental firms operating on the island. Most birders and photographers stay at one of a number of hotels in Skala Kalloni, in the centre of the island. This is an ideal location, situated close to a number of the best spots for photography.

Site Guide

Key Birds In winter Steller's, King and Common Eiders, Long-tailed Duck, Kittiwake, Glaucous and possibly Iceland Gulls. You may get a chance of a roadside Gyr Falcon. In summer Long-tailed Skua, Red-necked Phalarope, Temminck's Stint, Ruff, Ringed Plover, Turnstone, Whimbrel, Arctic Tern, Shore Lark, Snow and Lapland Buntings, Red-throated Pipit and Bluethroat.

Varanger, Arctic Norway

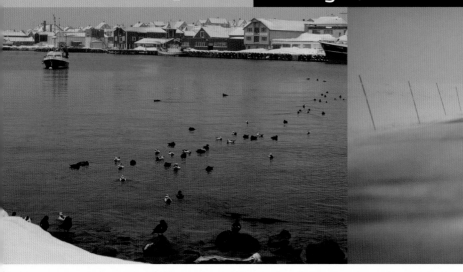

Varanger ranks as one of my favourite places to shoot birds. Wild and remote, the region offers up exciting photography of sought-after species. Winter highlights include rafts of Steller's Eiders and, if you are lucky, a roadside Gyr Falcon. While in the short Arctic summer nesting birds include Red-necked Phalarope, Dotterel, Shore Lark and often Long-tailed Skua, to name but a few.

Winter trips produce few species but those that are on offer are some of the most difficult to photograph in Europe. Nowhere else are Steller's and King Eiders so easy to photograph. The harbours attract flotillas of ducks that number in their hundreds, sometimes thousands. Excellent places for photography, it is the harbours that have working fish factories that are best. Here you can photograph Steller's Eiders at eye level and often very close to the shore. At the entrance to some of the harbours are piers from which excellent flight shot opportunities can be had, not just of Steller's but of King and Common Eider, and Long-tailed Ducks too. Winter is extremely cold however, so

decent clothing is a necessity for standing around over long periods. White-winged Gulls are possible, with Glaucous Gulls likely in at least Vardo Harbour. Summer at this latitude means 24 hours of daylight. To make the most of the best light it is worth considering reversing your clock so that you sleep in the day and take pictures at night. Apart from a short spell during the middle of the night when the sun is at its lowest and many species rest, there is plenty of activity. There is likely to be less wind, and with no people around it's an ideal time to be out and about. Breeding waders, terns and passerines such as the Snow Bunting and Shorelark can be located on the tundra.

In the town of Vardo, Kittiwakes nest on some of the buildings, making for some attractive-looking images. Offshore, the island of Hornoya has impressive seabird cliffs. Shag, Brunnich's Guillemot along with Black Guillemot, Guillemot, Puffin and Razorbills all nest there. Boat trips can be taken out to the cliffs, and you can land on the island, which is worthwhile for Puffin photography.

Bird Photography

Right This group of Steller's Eiders were photographed from a vehicle parked on the harbour wall in Vadso.

Nikon F5 with 500mm lens, 1/500sec at f/4, Fuji Sensia 100

Far left Steller's Eiders in Vardo Harbour. This image was taken from my hotel bedroom window with a wideangle lens. Bleak and cold in winter it might be, but for the committed bird photographer there are some outstanding opportunities on offer.

Nikon F5 with 24mm lens, 1/60sec at f/8, Fuji Sensia 50

Left Varanger is a bleak place in winter. I took this picture en route to Vadso one March.

Nikon F5 with 24mm lens, 1/60sec at f/8, Fuji Sensia 50

Bottom right Bluethroats sing from the vegetated areas in spring. With patience good images can be had of this species. This bird was photographed in northern Lapland in June.

Nikon F5 with 300mm lens, 1/500sec at f/4, Fuji Sensia 100

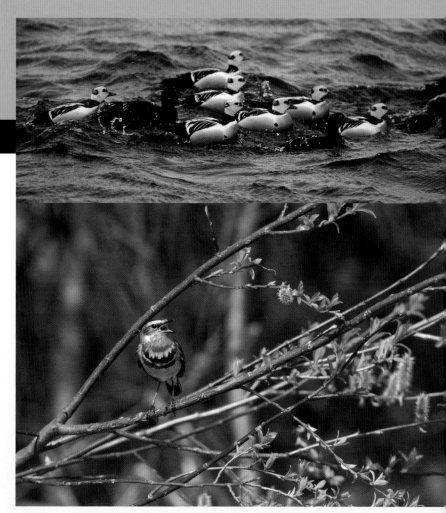

When To Go

For winter photography, a trip in March is best. The days are lengthening by now, and there are still large flocks of ducks. At this lattitude winter still has its icy grip, so you should be well prepared for temperatures that, when wind chill is taken into account, will be well below freezing.

For the summer breeding species, a visit from mid June would be ideal. It is worth noting that even in summer the weather up here can be harsh, sometimes even snowing.

Travel / Accommodation

Roads lead from Norway, Sweden and Finland to Varanger. Perhaps the most straightforward route is to fly to Ivalo in northern Finland, and then drive the 190 miles (300km) north to Varanger. In winter studded tyres are compulsory, and a four-wheel-drive vehicle would give peace of mind. The roads up around Varanger can become blocked with drifting snow, so you should be prepared for disruption. To take the aggravation away from driving yourself, you might consider hiring a Finnish guide (check www.finnature.com).

Accommodation in winter is limited to hotels and some cabins. There is a good hotel overlooking the harbour in Vardo, from where I have enjoyed Steller's Eiders from my bedroom! In summer it is worth camping or driving a camper van up from Finland. Alternatively there is cabin and hotel accommodation. Norway is an expensive destination; with food, fuel and accommodation a trip up here can soon become costly. Therefore if you are driving up from Finland, it is worth bringing as much food with you as possible.

Species available in good years are Great Grey Owl, Ural Owl, Hawk Owl, Pygmy Owl, Tengmalm's Owl.

Owls, Finland

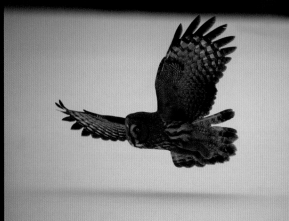

Above left While the owls and the grouse are the big draw in Finland, there are plenty of other species on offer. This Grey-headed Woodpecker was an unexpected bonus as I waited deep in the Finnish forest for a Goshawk to appear. It was lured to this tree stump by fat smeared into the bark.

Nikon F5 with 500mm lens, 1/60sec at f/5.6, Fuji Velvia 50

Above right A Great Grey Owl glides low over the snowfields of northern Finland. In good owl years and when food is in short supply, Great Greys are forced out of the forest to hunt the fields; an ideal opportunity for photography.

Nikon F5 with 500mm lens, 1/320sec at f/5.6, Fuji Velvia 100

In theory photographing birds in Finland, with its vast, often seemingly empty stretches of forest, impenetrable bogs and endless lakes, should be quite a difficult prospect. In reality it is one of the most productive European countries for hard-to-photograph species. This is all because Finnish wildflife photographers have had the foresight to offer certain opportunities to visiting photographers, from photographing Golden Eagles at bait in winter, to Black Grouse and Capercaillie leks in spring, and fishing Ospreys in summer, to name just a few.

Perhaps Finland's biggest attraction, however, is its owls. Numbers fluctuate depending on vole populations. These vary from one area to the next, so although in one year it may be poor for owls in, say, Kuusamo, just 124 miles (200km) to the south in Oulu, there may be many birds. Therefore, before deciding on a trip it is worth checking to see whether it is a good or bad owl year.

One of the big draws are the opportunities in winter for flight shots of both Hawk Owl and Great Grey Owl. They tend to hunt at the edge of the forest in winter, looking for movement beneath the snow in bordering fields. Various techniques can be employed to enable flight photography.

In summer local Finns will know where owls are nesting, and photography can be made at nest boxes and more rarely at natural holes. Great Grey Owls nest in stick nests, and can sometimes be photographed on these. However they are often perched in poorly lit sites in thick forest.

When To Go
February and March are best for winter owls. May and June are good for nesting birds.

Travel / Accommodation
The Oulu region is one of the best for staked out species. Local guides here are vital (Contact Finnature at www.finnature.com).

Bird Photography

Kangasala, Finland

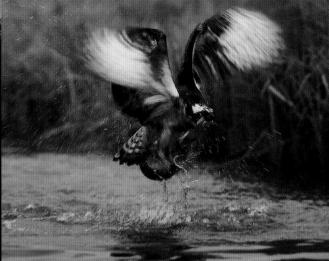

Left **Kangasala is the premier site for photographing fishing Ospreys. The pond and hides are shown here**

Right **The kind of result that is possible from a few sessions in the hides at Kangasala. The wind has to be in the right direction for the birds to fly at the hides, and you have to be quick, the action is over within a few seconds.**

Nikon F5 with 300mm lens, 1/125sec at f/2.8, Fuji Velvia 50

I have visited Finland more than a dozen times on bird photography trips, and undoubtedly one of the highlights was the first week I spent at Kangasala back in 1998. Kangasala is a small town that has become the place to photograph fishing Ospreys. A small pool has been excavated on the edge of the fish farm in which hundreds, if not thousands, of fish are placed each summer. There are three photographic hides around the pool.

The photography can be truly spectacular. On my first visit Ospreys were diving to within feet of the hide before exploding out of the water and flying straight at me over the roof of the hide. Conditions were perfect and I shot over 80 rolls of film in four days. On occasion I witnessed more than 100 dives in a day.

When To Go

July and early August is when adult birds are busy catching fish to feed hungry mouths, so plenty of birds will be fishing at the farm during this period.

Travel / Accommodation

Kangasala is just over two hours' drive north of Helsinki. There is cabin accommodation close to the fish farm and guesthouse and hotel accommodation nearby. The photographic hides at Kangasala can be rented on a daily basis. Contact Finnature for bookings.

Site Guide

South West Archipelago, Finland

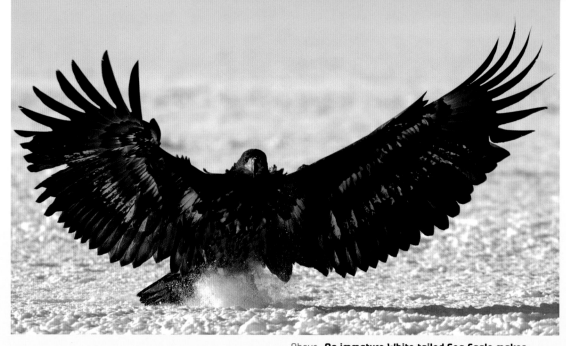

Above **An immature White-tailed Sea Eagle makes a spectacular landing at one of the feeding sites on the sea ice.**

(Photo courtesy of Jari Peltomaki)

The cluster of islands off the south west coast of Finland, attracts White-tailed Sea Eagles each winter. The eagles tend to winter on the edge of the Baltic sea ice, which in mid winter will be a fair way south. However in late winter as the sea ice slowly retreats, so the eagles move north in readiness to depart for their breeding grounds.

Come February there may be around 20 to 30 eagles attracted to food put out at two different feeding stations. Sitting in hides in winter for many hours can be quite arduous. Thankfully the Finns are masters at building very comfortable, well-insulated hides, and the provision of heaters too means the experience is bearable. Long periods waiting for something to happen is typical of eagle photography however, so patience is a necessity. When birds do arrive, extreme care is needed when moving a lens on to the subject. If an eagle detects movement and identifies it as danger, it is likely to depart and may not return for days or even weeks.

When To Go
February and March are good months to visit, both for day length and during late winter there are likely to be more eagles around.

Travel / Accommodation
The islands are easily reached by car from Helsinki. Guesthouse accommodation can be found in winter. Finnature (www.finnature.com) makes bookings for the eagle hides and can also escort you to the sites and arrange accommodation.

Bird Photography

Key Birds Grouse, Siberian Jay, Siberian Tit, Hazelhen and Red-flanked Bluetail.

Kuusamo, Finland

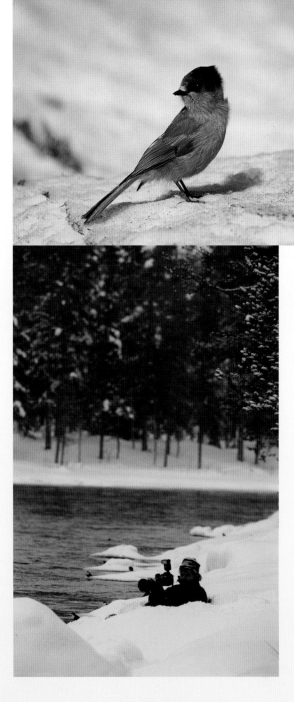

The Kuusamo region of Finland straddles the Arctic Circle, and is home to a range of highly sought-after northern species. These include the Siberian Jay, Siberian Tit, Hazelhen and Red-flanked Bluetail. Siberian Jays and Tits are very tame and relatively easy to photograph when coming to a feeding station in winter. Kuusamo is good for grouse, with Capercaillie, Hazelhen, Willow Grouse and Black Grouse all possible targets. The best way of finding these is to cruise around the tracks in and around Oulanka National Park in late winter, when they come to the gravel roads to ingest grit.

In the northern part of Kuusamo a stretch of shallow river running between two lakes, known as Kiveskoski, attracts an amazing gathering of dippers. Few stretches of water remain open in winter this far north, and as this stretch also provides ideal feeding you may find 50 or more birds present in a very small area. East of the road bridge is normally the best spot and a hide can be erected adjacent to a suitable looking rock – it won't be long before it is occupied by a dipper.

When to go
February and March are best for dippers. Late April to early June is a good time for other species.

Travel / Accommodation
Kuusamo is served by a regional airport, with frequent flights from Helsinki. There is cabin and hotel accommodation in and around the town.

Top **Siberian Jays are often hand tame, and will readily come to food thrown to them. This bird was photographed in a roadside lay-by in Kuusamo in spring.**

Nikon F5 with 300mm lens, exposure details not recorded, Fuji Velvia 50

Bottom **In this picture I am lying among dippers at Kiveskoski in Kuusamo.**

(Picture courtesy of Jari Peltomaki)

Site Guide

Grouse, Finland

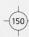
Bird Photography

Some north European countries, such as the UK, have experienced a serious decline in grouse populations, leading to added protection and extra difficulties for photography. Grouse have been declining in Finland too; however the populations of Capercaillie and Black Grouse, the two species that have communal leks, are still healthy. Therefore Finland is a good destination for photographing these two at their leks.

In some years, particularly in well-watched Kuusamo, rogue male Capercaillies will appear. Rogues are males that take up a territorial lekking site, and chase anything except female Capercaillies away. They can be extremely aggressive, readily attacking humans, dogs and sometimes even vehicles. Some years ago I was photographing a rogue Caper in heather when I lost my footing. As I fell back the bird grabbed my

trousers and tore them at the knee, leaving me with a scar that I still have to this day.

With care, effective images can be secured of these birds, particularly as they can be skilfully tempted to stand and display on suitable perches. Nothing, however, can beat photographing a proper Capercaillie lek. You need to be inside your hide the evening before as they tend to roost in close proximity to their lekking area, and arrive well before dawn to start their display ritual. Often leks are over by the time the sun is spilling through the forest.

Black Grouse gather in more open areas, often on frozen bogs, or in large woodland clearings, and they lek throughout much of the day. However the peak of activity is often soon after dawn. Once again it is necessary to be within your hide before daybreak. Black Grouse emit a wonderful range

Opposite **Black Grouse leks offer a special experience. Tricky to expose for, you should take care not to overexpose the white in the tail. This was a lek on a frozen Finnish bog. It was bitterly cold sitting in the hide at dawn, but worth the pain for the experience alone.**

Nikon F5 with 300mm lens,
Fuji Velvia 50

Left **Displaying Capercaillies make such good subjects, it is difficult to stop taking more and more pictures. I got completely carried away with this bird, taking more than 40 rolls of film. I'm sure the bird was flattered!**

Nikon F5 with 70-200mm lens,
Fuji Velvia 100

Below **Few birds are more entertaining than a rogue male Capercaillie. Here a nervous photographer cautiously approaches with his camera.**

of bubbling calls, and fights between males are not uncommon. In winter they can often be seen high up in trees browsing on buds. I have successfully photographed females feeding on sallow buds in spring, by using a car as a hide.

Willow Grouse can be photographed from a vehicle along forest tracks, and they come readily to a tape being played. The most difficult grouse is the Hazelhen. They pair in October, and this is when they are at their most responsive to tapes or imitation hunters' whistles. In spring they may often be encountered along the roadside, and some individuals will respond to a tape being played. I have had moderate success photographing this species in April, by using a tape and photographing from a car.

When To Go
Capercaillie lek from around the second week in April to early May, with the third week in April being best. Black Grouse are lekking from early March and continue on into May at least.

Travel / Accommodation
Finnature can arrange photography at Capercaillie and Black Grouse leks.

Site Guide

Hornborga Lake, Sweden

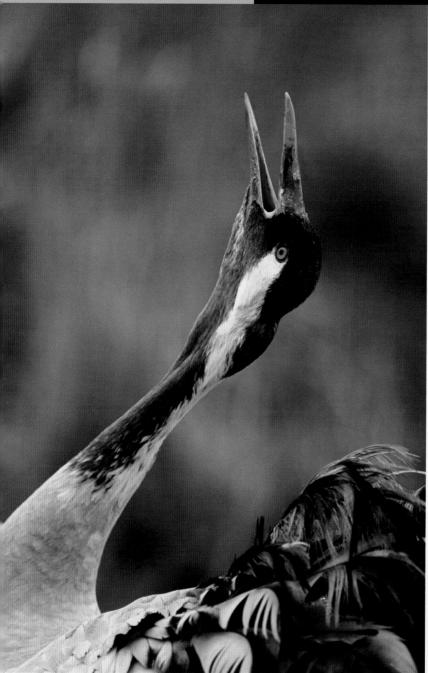

Left and right **Common Cranes come incredibly close to Hornborga's photo hides. Various aspects of crane behaviour can be captured during a session in one of the hides. Here a bird bugles and a pair mate.**

Nikon F5 with 500mm lens, 1/500sec at f/4, Fuji Velvia 50

Far right **A group of cranes lifts off at dusk to go to roost. I was ready for this shot as I had watched this small group walk to the top of the ridge as it was dusk and I was sure they would use the ridge to take flight. Learning to anticipate behaviour or action is something that comes with experience, but can be vital in capturing interesting images.**

Nikon F5 with 500mm lens, 1/500sec at f/4, Fuji Velvia 50

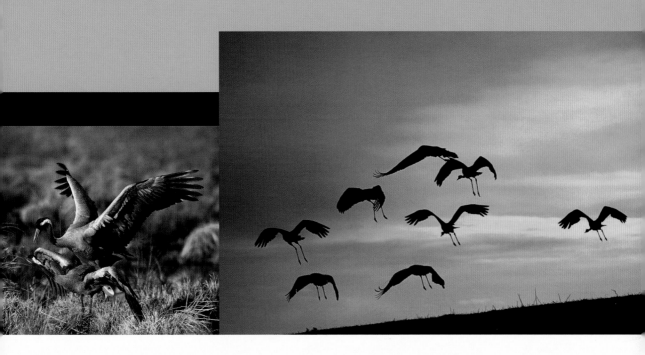

North-east of Gothenburg, in southern Sweden, lies the vast Hornborga Lake. In summer the lake is outstanding for its breeding wetland birds, but it is spring when bird photographers flock here from all over Europe, to photograph one of the finest assemblies of Common Cranes on the continent. The majority of the 20,000 or so that pass through Hornborga come from their wintering grounds in Extramedura in Spain.

The cranes congregate in a marshy area of fields bordering the lake, and they do so because grain is put out for them daily. They linger here for just a few days, before migrating on north to their breeding grounds in northern Scandinavia. An information centre on a rise overlooking the fields is a good location for flight photography, whilst various vantage points will give you good opportunities for images of the feeding flocks.

To get up close and personal with the cranes, hiring one of the photographic hides on the lake shore is the way to go. You need to be in situ either the night before or an hour before sunrise. You are given a bucket of grain and can sprinkle the food in the spots to which you want the birds to go. The cranes come incredibly close, sometimes even peering in at you. For what is normally such a shy bird, a session in one of these hides

is a wonderful experience, and it goes without saying that the photography is quite outstanding. Hides need to be booked well in advance (details from www.hornborga.com).

When To Go
Timing is imperative, as Hornborga is a staging site for birds on their way north. If the weather is good to the north, the cranes may not stay long; conversely in bad weather they may linger. Peak daily counts can exceed 10,000 birds. The peak time is between 10 and 20 April.

Travel / Accommodation
Hornborga is a four-and-a-half-hour drive from Stockholm, or around two hours from Gothenburg where there is a ferry terminal. An amazing 150,000 people visit Hornborga during April to see the cranes, so finding accommodation can prove problematic. It can be worth booking in advance. The nearest main town to the lake is Falkoping.

Key Birds Species easy to photograph include Fulmar, Shag, Eider, Kittiwake, Common and Arctic Terns, Guillemot, Razorbill, Puffin. Species present (depending on your luck) include Cormorant, Ringed Plover, Oystercatcher, Black-headed, Herring and Lesser Black-backed Gulls, Sandwich and Roseate Terns, (the latter breeds most years) and Rock Pipit.

Farne Islands, England

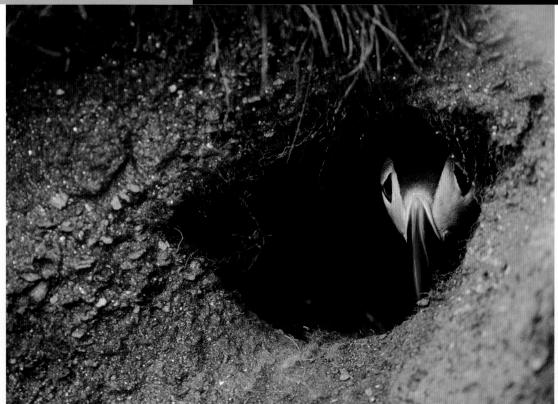

Thousands of seabirds breed on these low-lying islands situated just off the Northumberland coast. No other seabird sites in Britain offer such intimate encounters with their birds as here – they are a bird photographer's paradise. Shag, Arctic Tern, Puffin and Eider sit within touching distance. A full day trip, which will encompass a landing on Staple Island during the morning and Inner Farne in the afternoon, is recommended. The other islands in the group are off limits to visitors.

Staple Island has a large Puffin colony, with much of the grassy inner island riddled with burrows. One of the best points to get close to Puffins is around the landing stage on the northern side. There is a boardwalk overlooking nesting

Guillemots, Razorbills, Shags and Kittiwakes. Inner Farne has the same species as found on Staple Island plus a large colony of mainly Arctic Terns, with a smaller colony of Sandwich Terns that, depending on where they decide to nest annually, can be good for photography. The one frustration with photography on the Farnes is the limited landing time you get on each island, along with the inability to be on the islands at the start and end of the day when the light is at its best.

When To Go
A visit from mid May to late July is best, as before May the terns will not have arrived. However April is a good time to photograph Eiders on Inner Farne.

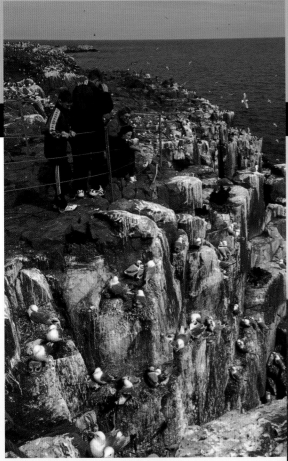

Left **Puffins are a favourite subject of mine, and this bird peers from its burrow on Inner Farne. Staple Island offers great opportunities for this species too.**

Nikon F5 with 500mm lens, 1/45sec at f/4, Fuji Velvia 50

Above **Observation points overlooking the cliffs allow access to species such as Kittiwakes. Getting close is not a worry here, however one of the skills is to be able to isolate subjects from cluttered backgrounds teeming with birds.**

Right **A hat is useful when visiting the Farnes. Arctic Terns nest almost on the paths on Inner Farne and are not slow to attack when you walk past their nests.**

Travel / Accommodation

Boats run from Seahouses. This stretch of coast is popular with day trippers and holiday makers in summer, and so there is plentiful accommodation, and a campsite on the edge of Seahouses. Boats run daily from April to September, weather permitting. Departing from 10am. The islands are very popular at weekends and during the summer. As mentioned it is best to take an all-day excursion, landing on both islands. Apart from the fee for the boat trip, there are also National Trust landing fees for each island, unless you are a National Trust member.

Bass Rock, Scotland

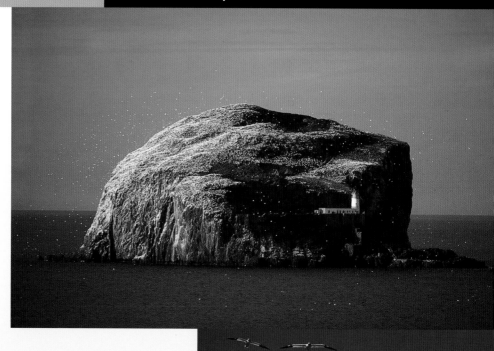

Just inside Scotland this impressive lump of rock in the Firth of Forth appears covered in whitewash from a distance, until closer inspection reveals a living mass of Gannets. It is one of the most spectacular Gannet colonies in the world, and a visit landing on the rock comes highly recommended. In recent years the birds have started to build their nests across the path, inhibiting visitors' progress, and currently only a little distance up the rock can be made. This does not matter too much, as some fantastic photography can be enjoyed.

When To Go
July is a good month to visit as many of the birds will have reasonable sized chicks.

Travel / Accommodation
A boat trip runs twice a day from North Berwick, taking you around the rock. Sadly they no longer hold the landing rights, and so to land the Scottish Seabird Centre at North Berwick has to be contacted. They run trips for photographers that give a landing time of around three and a half hours, though the fee is rather hefty.

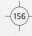

Top Left **I try to visit the Bass Rock at least once a year as photography there is spectacular. The rock is viewed here from the shore. From a distance it appears covered in whitewash, but closer inspection reveals a living mass of birds.**

Nikon FE2 with 300mm lens, 1/250sec at f/4, Fuji Velvia 50

Bottom left **July is a perfect time to visit a Gannet colony. The birds will have reasonably well-grown young, and the whole colony will be buzzing with activity.**

Nikon FE2 with 300mm lens, 1/250sec at f5.6, Fuji Velvia 50

Right **The Gannets can be approached to within almost touching distance, making Bass Rock one of Britain's premier bird photography locations.**

Nikon FE2 with 600mm lens, 1/60sec at f/11, Fuji Velvia 50

Hermaness, Scotland

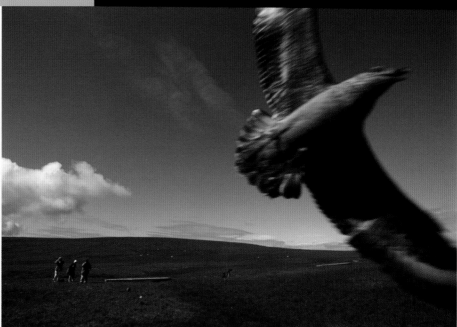

Above **Wander too close to a Great Skua's nest and you are likely to become a target. Holding a tripod leg in the air will deter the attacker.**

Nikon F5 with 17-35mm lens, 1/60sec at f/11, Fuji Velvia 50

Hermaness National Nature Reserve lies at the northern tip of Unst in Shetland. It ranks as my all-time favourite place to photograph birds in Britain. During summer evenings large numbers of Puffins come ashore to stand around on the cliff tops. With west-facing cliffs this is a great place for silhouette images, shot against the setting sun.

Away from the cliffs, blanket bog dotted with lochans and covered in Cotton Grass supports breeding Dunlin, Golden Plover and the other star attraction the Great Skua. Venture too close however, and they will rise into the air to dive-bomb you.

On leaving the car park, take the path's left-hand fork after the stream, and this will take you to a skua colony close to the cliffs. These are some of the easiest to photograph. From here, by venturing to the cliffs, you can turn left for a large Gannet colony, and on windy days flight shots of

these birds here are very good. Puffins occur all along the cliffs. By turning right the path will lead you to Britain's most northerly point, the rocks and lighthouse of Muckle Flugga.

When To Go
Late June is best. Puffins by this time will be coming ashore with fish.

Travel / Accommodation
Unst is reached by roll-on-roll-off ferry, from Yell. There is limited accommodation available on Unst, with the Baltasound Hotel being one of the few places to stay.

Bird Photography

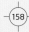

Mousa, Scotland

This small island off the southern mainland of Shetland is best known for its European Storm Petrel colony, that nests in the Iron Age Broch. In summer the island, which is a RSPB reserve, teems with birdlife. A circular route can be taken around the island, and there are a good number of photographic possibilities including Black Guillemot, skuas, Fulmar, Ringed Plover and Wheatear.

It is however at night that the island puts on its best show. I visit annually in June and it is normally at around midnight that the air around the Broch comes alive with the fluttering of European Storm Petrels, coming ashore to their nest chambers inside the building's walls. By standing a few feet back from the Broch, petrels can be photographed as they perch on the wall and enter and leave their nests. 'Focus on Shetland' photographic weeks are run by Shetland Wildlife (www.shetlandwildlife.com) each June, which incorporate a night at the Broch photographing the petrels. Flash photography is not allowed during scheduled public trips to see the petrels.

When To Go
Mid May through to mid July.

Above left Photographing Storm Petrels at night around Mousa's Iron Age Broch is best on really dark nights, when the cloud cover is low and drizzle is in the air. In such conditions more birds come ashore, as predators such as Great Black-backed Gulls find it harder to catch them.

Nikon F5 with 500mm lens, full flash, 1/250sec at f/4, Fuji Sensia 400

Above right Mousa is one of the best sites in Shetland for getting close to Fulmars. They nest at the base of stone walls and along the island's low cliffs. Visit in June and you can photograph them among thrift.

Nikon F5 with 500mm lens, 1/250sec at f/6.7, Fuji Velvia 50

Travel / Accommodation
A ferry runs from Leebitton Pier in Sandwick. Details of times can be found on boatman Tom Jamieson's website: www.mousaboattrips.co.uk

Accommodation can be found at the Sumburgh Hotel, close to the airport at Sumburgh. The cliffs here are an RSPB reserve and are quite good for photographing both Fulmar and Puffin, and in some years other species of seabird. The access road is very good for photographing Oystercatcher and Wheatear from a vehicle.

Site Guide

Key Birds Puffin, Great and Arctic Skuas. Other breeding species are more difficult. A visit in spring or autumn may provide migrants, although photographing these can prove hard work.

Fair Isle, Scotland

Above **Fair Isle can be full of surprises so be prepared to photograph the unexpected. In some years Crossbills originating from Scandinavia appear due to a failure in their food crop. This hungry male fed voraciously on thistle seeds and was typically tame.**

Nikon FE2 with 600mm lens, 1/250sec at f/5.6, Kodachrome 64

Lying 24 miles (38.4km) off the southern tip of the Shetland mainland, Fair Isle is owned by the National Trust for Scotland. Dramatic sea cliffs guard an interior of heather moorland, marshy fields and crofting land. Fair Isle is famous among birdwatchers for the migrants and rarities that make landfall here each spring and autumn. Many of these make confiding photographic subjects.

However the island is actually outstanding for photographing Puffins. One of the best sites is the clifftops on Buness, a promontory of land close to the bird observatory. Here in June, Thrift creates a pink carpet, making a wonderful backdrop for the birds that tend to come ashore in the late afternoon and evening. In July they will have beakfuls of fish.

When To Go
June and July.

Travel / Accommodation
Loganair fly to Fair Isle on Monday, Wednesday, Friday and Saturday; alternatively if you have good sea legs you can take the Good Shepherd, the island's supply vessel, which sails on Tuesday, Thursday and Saturday. Comfortable accommodation and good food is on offer at the bird observatory. For bookings contact FIBO, Fair Isle, Shetland, ZE2 9JU; www.fairislebirdobs.co.uk.

Key Birds Fulmar, Shag, Guillemot, Razorbill, Puffin, Kittiwake, Great and Arctic Skuas, are all possible.

Handa, Scotland

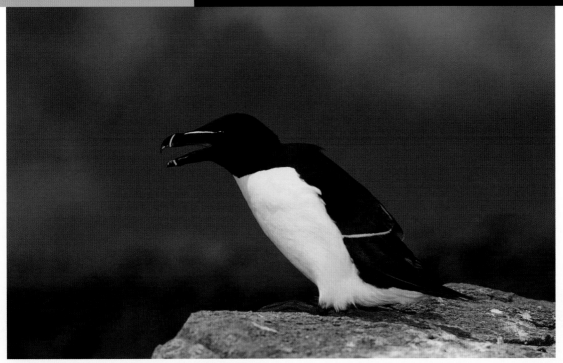

Above **Handa offers the opportunity for photographing a number of different seabird species. This Razorbill was photographed in the middle of the day. The light was too harsh so I used a polarizing filter to take away some of the glare, and fill-in flash set at -2 to put a catch light in the eye.**

Nikon F4 with 600mm lens, 1/60sec at f/5.6, fill flash

This small Scottish island is situated just a few hundred metres off the Sutherland coast, approximately 40 miles (64km) north of Ullapool. Cliff-nesting seabirds and both Great and Arctic Skuas are the photo highlights. A three-mile (5km) circular walk allows exploration. The Great Skuas are particularly tolerant here.

When To Go
Mid May to mid July.

Travel / Accommodation
The island is reached by taking a minor road to Tarbet off the A894. Boats leave from here from 9.30am to 2pm from April to September. Accommodations are few and far between in this far north-west corner of Scotland, however there are a few guesthouses and the odd hotel scattered about. There is a campsite not too far from Tarbet off the A894.

Site Guide

Key Birds Barnacle Geese and Whooper Swans. Good pictures can also be taken of Greylag Geese and various species of duck, particularly Wigeon.

Caerlaverock, Scotland

Right **Some excellent action images can be captured at Caerlaverock in winter. This Greylag Goose coming in to land was photographed through the glass of the heated observatory.**

Kodak DCS Pro 14n with 500mm lens, 1/1500sec at f/5.6, ISO 250

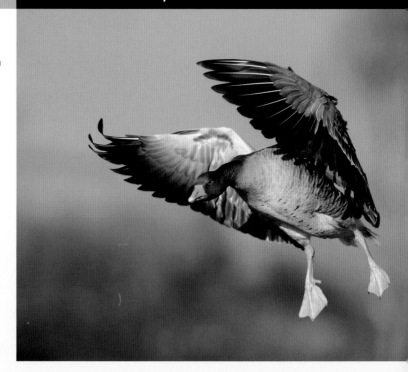

Amongst Britain's great wildlife spectacles are the wintering flocks of geese that in some parts of the country number in their thousands. One such spectacle is on show at Caerlaverock a Wildfowl and Wetlands Trust reserve on the north side of the Solway, on the English / Scottish border. The entire Svalbard population of Barnacle Geese winter in the Inner Solway, with the lion's share using Caerlaverock's fields to feed. They start to arrive in September, and peak in November when 25,000 may be present, which is the best time to visit for photography.

Hedge-lined avenues cut through the fields allow good pictures of over-flying birds to be taken. Various hides facilitate pictures of grazing flocks, and shots of flocks exploding into the air. The other big attraction at Caerlaverock are the overwintering Whooper Swans that congregate in front of an observatory. The glass is fine to shoot through (although be careful to avoid unwanted reflections), and opportunities for the swans and other species are tremendous.

When To Go
November is best for the geese, but any time in winter will be productive.

Travel / Accommodation
The reserve is eight miles (13km) south-east of Dumfries, signposted from the A75, via the B725. It is open daily except for Christmas Day. There is plentiful accommodation locally, including on site where there is a cottage to rent. Nearby Dumfries has many bed and breakfast establishments.

Bird Photography

Key Birds Although a good range of seabirds breed on the islands, Puffins are the species most easily photographed, along with the Manx Shearwaters and European Storm Petrels at night.

Pembrokeshire Islands, Wales

Right **Manx Shearwaters come ashore in their thousands on some nights, and are easy to photograph with flash, as they make an ungainly walk to their nest burrows.**

Nikon F4 with 135mm lens, exposure details not recorded, Fuji Sensia 100, flash

Consisting of Grassholm, Skokholm, Skomer and Ramsey Island, the Pembrokeshire Islands, off the south-west coast of Wales, offer the bird photographer a range of seabirds. Ramsey is the least interesting for photography. Grassholm is the least accessible, and contains the world's fourth largest Gannet colony with around 33,000 pairs. There are better places to photograph Gannets, particularly as landing is now discouraged, however it is worth taking the trip out as images can be bagged.

Skomer and Skokholm offer Puffins, and at night both Manx Shearwater and European Storm Petrels. On overcast nights when there is no moon, thousands of shearwaters come ashore to their nesting burrows. The noise of these birds emitting their coos, croons, screams and howls can be quite spine chilling.

Skomer supports the world's largest population of this species with over 100,000 pairs. The soft purring trills of European Storm Petrels can be heard from the stone walls on both islands at night too. These are more difficult to photograph, with Skomer giving the best opportunities. Overnight stays on either island are needed to photograph both.

When To Go
Any time from mid May to late July is best.

Travel / Accommodation
Boats to Grassholm, Skomer and Skokholm run throughout the summer, from Martin's Haven; reached by taking the B4327 from Haverfordwest to Marloes. Go through the village and proceed to the car park at the end. The boat goes from the quay at the bottom of the hill. For access to Skomer, boats for day trips depart at 10am, 11am and midday from April to October, daily except Mondays, with the exception of Bank Holidays. To organise accommodation on Skomer contact the Wildlife Trust of South and West Wales, 7 Market Street, Haverfordwest, Pembrokeshire, Wales, SA61 1NF, www.wildlifetrust.org.uk/wtsww or tel: 01437 765462.

For Skokholm, day visits are possible on Mondays from June to August. However for night-time photography a week-long stay is necessary. Accommodation details are as for Skomer.

Key Birds Red Kites, Raven, Hooded Crow, chance of farmland species at feeding station.

Gigrin Farm, Wales

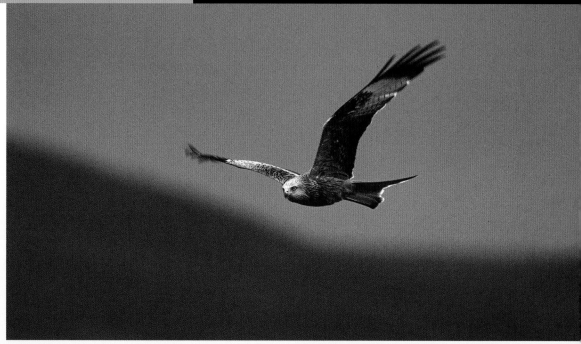

Above **Gigrin Farm offers a spectacular opportunity to photopgraph Red Kites as they swoop in for food put out for them. It is worth arriving early to secure a good spot in one of the hides, the kites are a popular attraction, particularly at weekends and holiday periods.**

Nikon FE2 with 600mm lens, exposure details not recorded, Fuji Sensia 100

Gigrin Farm in mid-Wales offers exceptional photography of Red Kites. Food is placed in front of a row of hides each afternoon. With a captivating display of agility, kites twist and turn plucking food from the ground, giving great chances for flight photography.

Gigrin is at its best in winter when large numbers of kites, sometimes more than 100, are present. It can be very popular, so arrive early to secure a good spot in one of the hides. The farm also has a feeding station for passerines.

When To Go
Feeding is at 2pm daily in winter, and at 3pm when the clocks go forward, until they change again in October.

Travel / Accommodation
The farm is on the outskirts of Rhayader, off the A470. There is plenty of bed and breakfast accommodation locally, and a hotel in the town.

Bird Photography

Key Birds Bewick's Swan, Mute Swan, White-fronted Goose (flock shots possible), Wigeon, Teal, Pintail, Gadwall, Tufted Duck, Pochard, Water Rail, Wood Pigeon, Moorhen, Coot and various woodland birds can all be photographed as wild birds. The captive collection offers further possibilities.

Slimbridge, England

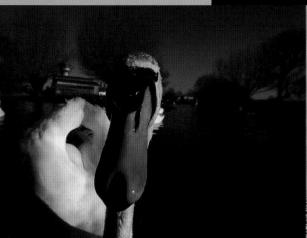

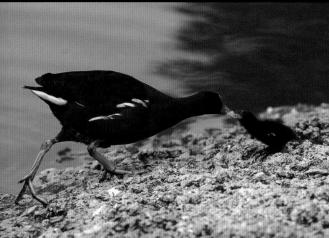

Situated on the banks of the River Severn, not far from Gloucester, Slimbridge is the HQ of the Wildfowl and Wetlands Trust, and is an outstanding site for bird photography. Slimbridge contains the largest collection of captive wildfowl in the world, and although these are an attraction, it is the wild birds, notably wintering Bewick's Swans and various species of duck, that are of most interest.

The swans arrive from their Arctic breeding grounds from mid October, however the main arrival may not be until much later. In mild winters they then leave in February, with the bulk of the birds gone by early March. The swans can be photographed at very close quarters, with some often attracted to the captive pens.

There is a small feeding station attracting woodland birds and in most winters a Water Rail or two. However it is very awkward for photography. Other than the wildfowl, the grounds are productive for photographing Moorhens, Wood Pigeons, and at dusk a spectacular starling roost.

Above left **When photographing birds I like to give the picture impact. Here I used my 17-35mm lens at its widest setting and enticed the swan by placing a piece of bread on top of the lens. I have kept the Slimbridge Discovery Centre visible in the background, as this shot was taken for a publisher to illustrate Slimbridge.**

Nikon F5 with 17-35mm lens, exposure details not recorded, Fuji Velvia 50

Above right **Moorhens are a popular subject at Slimbridge throughout the year.**

Nikon F5 with 300mm lens, exposure details not recorded, Fuji Velvia 50

When To Go
There is plenty to photograph throughout the year. For the Bewick's Swans and wildfowl a visit in January or February is best, particularly during a cold snap when wildfowl can be photographed on ice, and there will be many more wild birds attracted to the captive pens.

Travel / Accommodation
Slimbridge is easily reached off the M5 motorway. The reserve is open from 9am daily, except Christmas Day. Plentiful accommodation can be found locally, including the Tudor Arms Hotel on the access road to the reserve.

Key Birds Whooper Swans are the main attraction. Other possibilities for pictures include Bewick's Swan, Pochard, Tufted Duck, Coot and Barn Owl.

Welney, England

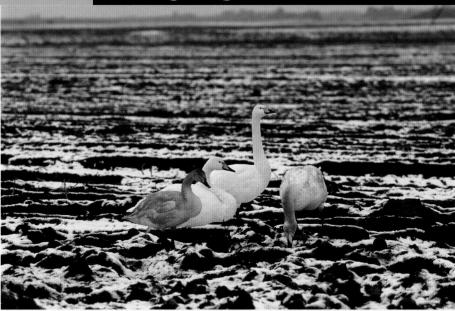

Above **Whooper Swans are the big attraction at Welney. Although most of the action occurs in front of the hides, I always like to drive down the neighbouring roads looking for feeding parties in the fields. The roads close to the reserve can also provide chance encounters with wintering Short-eared Owls and the resident Barn Owls, that often hunt along the rough grassy strips between fields and along the roadside ditches.**

Nikon F5 with 500mm lens, 1/250sec at f/5.6, Fuji Sensia 100

The Ouse Washes on the Cambridgeshire/Norfolk border flood each winter, creating a haven for wildfowl. At Welney, a Wildfowl and Wetlands Trust reserve, thousands of wild swans winter, tempted by the food put out for them twice a day. Excellent images of Whooper Swans can be made here, as the birds come to within a few feet of the row of hides and the heated observation room.

Bewick's Swans can number 5,000 but are not easy to photograph as they generally appear at dusk or after dark when floodlights go on. However, the Whooper Swans, that can exceed 1,000 birds, are present throughout the day. Other species of wildfowl present themselves too, with often great rafts of Pochard feeding close in. In recent winters Barn Owls have hunted along the edges of fields close to the centre, giving opportunities from a vehicle.

When To Go
Welney is open daily from 10am to 5pm except Christmas Day. For photography the reserve is best from November through to March.

Travel / Accommodation
To find the reserve, from the A10 at Littleport, turn off at the roundabout to the A1101 towards Wisbech. The road eventually follows the New Bedford River, and where it crosses, travel straight ahead. The reserve centre is a little further on, on the right. There is a very limited choice of accommodation in the immediate vicinity.

Bird Photography

Top **Spain offers a wealth of opportunity to the bird photographer. This White Stork was photographed sitting on its nest with a short telephoto zoom, from a window looking out on to the roof.**

Nikon F5 with 70-200mm lens, 1/60sec at f/16, Fuji Velvia 100

Below **Poland offers a range of mouthwatering species for the photographer, including the Three-toed Woodpecker.**

Nikon F4 with 600mm lens, 1/60sec at f/5.6, Fuji Velvia 50

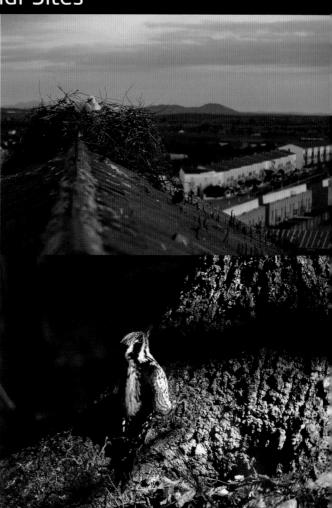

Spain

Coto Donana, Extremadura, Spanish Pyrenees – places that to a birdwatching teenager in the 1970s conjured up images of a far-off land full of birds I dreamt maybe one day I would see. In the 1970s a birdwatching trip to Spain seemed like a major adventure, and in many ways it was. Armed with a camera I finally set foot in the Coto Donana in the early 1980s, and it was this experience that opened my eyes to the photographic opportunities travel would give me.

Spain offers some great photography, but it has to be worked for. Even in places such as the Coto and bird-rich regions such as Extremadura, hides are often necessary. The country has some very special birds such as Lammergeier, Wall Creeper and Great Bustard to name but three.

For photographing many of the more common Spanish species, a trip to a region such as Extremadura, or the Coto Donana, will provide some great opportunities, particularly if a car is used as a mobile hide. April and May are favourite months of mine in Spain, when many places abound with wildflowers and birds are breeding.

Poland

Still largely unspoilt and providing some great birds, a visit to Poland in May can be very productive. Target species for the photographer include lekking Great Snipe, Aquatic Warbler, and a host of waterbirds. Some of the country's marshes extend for miles, with Biebrza Marshes standing out as one of Europe's top sites for birds.

Site Guide

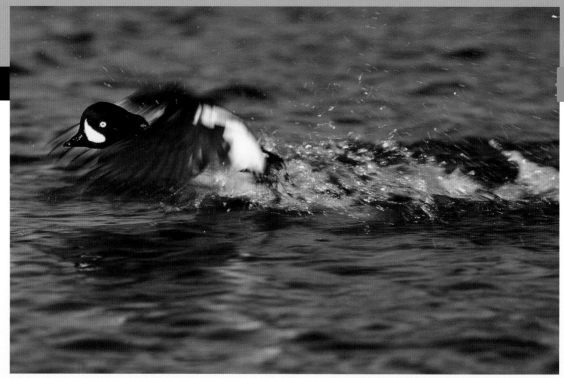

Above **One of Iceland's specialities the Barrow's Goldeneye can be photographed in summer.**

Nikon F5 with 500mm lens, 1/350sec at f/5.6, Fuji Sensia 100

Svalbard

Incorporating Spitsbergen, the Norwegian Svalbard archipelago lies more than ten degrees north of the Arctic Circle. Mountainous islands and drifting pack ice combine to form a beautiful landscape, realm of the Polar Bear, Walrus and millions of birds, drawn here to breed during the short Arctic summer.

Large colonies of Little Auks, Brunnich's Guillemots and Black-legged Kittiwakes throng the cliffs and, in the case of the tiny Little Auk, on boulder-strewn slopes. These starling-sized auks are one of the photographic highlights of a visit here. Other species on offer may include Pomarine and Long-tailed Skuas, Pink-footed and Barnacle Geese, King Eiders, Grey Phalaropes and, if luck is on your side, Ivory Gulls.

The only way of photographing in Svalbard is to join one of the expeditionary-style cruise ships, usually ice-breakers that operate in summer. June and July are when most dedicated wildlife trips go. It is worth seeking out a specialist photographic cruise, as these operate most years. Try www.photosafaris.com.

Iceland

The first thing to say about Iceland is that it is horrendously expensive. This puts many off as the big seabird spectacles, such as those at Ingolfschofdi, which include Puffins, can be photographed by spending far less money further south, particularly in Britain. However Iceland does possess some species found nowhere else in Europe, such as Harlequin Duck and Barrow's Goldeneye, and both of these can be photographed. Other potential species include the nesting Great Northern Diver, Whooper Swan and the confiding Red-necked Phalarope.

A ferry service operates serving a number of European ports before ending up in Iceland, and taking your own vehicle may be the most cost-effective option.

Bird Photography

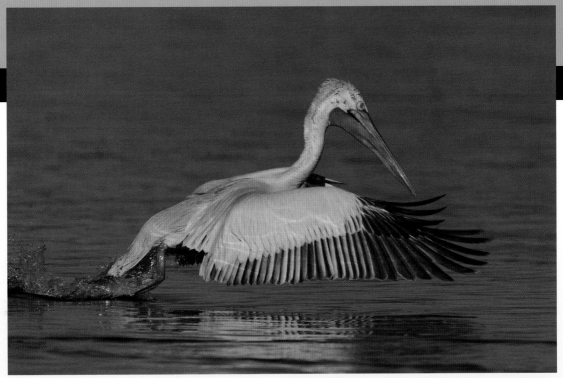

Above **A fishing Dalmatian Pelican on Lake Kerkini.
A winter visit is needed to capture images such as this,
and much patience too. Pelican behaviour changes daily
with some days providing a wealth of fishing
opportunities, while on other days there may not be too
much action going on. This is an adult in almost full
breeding plumage.**

Kodak DCS Pro 14n with 500mm lens and 1.4x teleconverter,
1/1500sec at f/8, ISO 160.

Lake Kerkini, Greece

Located close to the Bulgarian border and an hours
drive north of Thessaloniki, Lake Kerkini is well
know for it's birds, and is very scenic too, enjoying
an impressive mountain backdrop. Migrants are
a big attraction to photographers in spring as the
many driveable tracks that border the lake allow
plentiful opportunities.

It is less well known as the premier location
to photograph the globally endangered Dalmatian
Pelican. At the southern end of the lake, fishermen
have their camps and large areas of nets. It is here
that the pelicans tolerate people and gather around
the fishermen. A variety of images can be taken of
both the pelicans fishing in specatacular style, or
casually drifting around in groups. There is activity
throughout the day, however afternoons are best
for light and for the number of birds normally
present.

A visit between November and March is best,
and during this period a variety of other species
may be photographed. Another globally

endangered species the Pygmy Cormorant winters
here in good numbers, but hides are needed for
good images of perched birds as they are very shy.
Great Grey Shrike and Hawfinch are two species
that are easily seen and although shy are possible
to approach in a vehicle.

Spring is excellent at the lake, when a variety
of waterbirds notably herons can be photographed
along with migrant passerines.

There is a hotel in the village of Kerkini and
a much larger but more convenientlly placed hotel
close to the dam at the southern end.

Site Guide

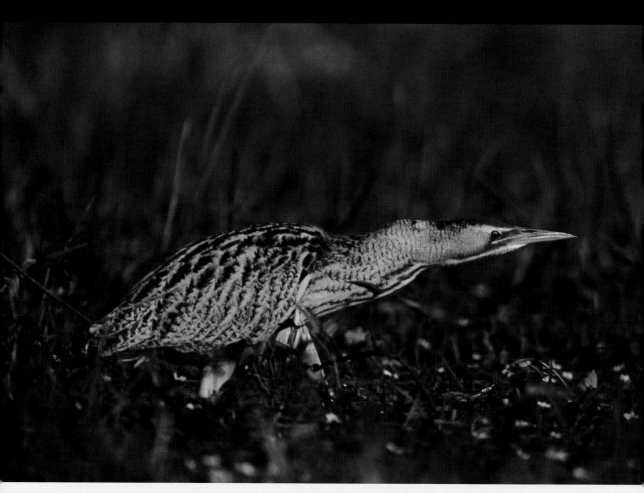

Above **Much sought after by European photographers, the Bittern remains one of the continent's more elusive species, requiring not only plenty of patience but a little luck too. This bird is stalking across a marsh, moving from one block of cover to another.**

Nikon F5 with 500mm lens, 1/500sec at f/5.6, Fuji Velvia 100

Opposite top **Driving down a mountain in Greece I spotted this Woodlark singing from a roadside boulder. On stopping it flew off, but with a quick burst of the tape it was back performing for the camera.**

Kodak DCS Pro 14n with 500mm lens, 1/750sec at f/8, ISO 160

Opposite bottom **A stunning male Ruff in full breeding dress, photographed at a lek in Scandinavia.**

Nikon F4 with 300mm lens, exposure details not recorded, Fuji Sensia 100

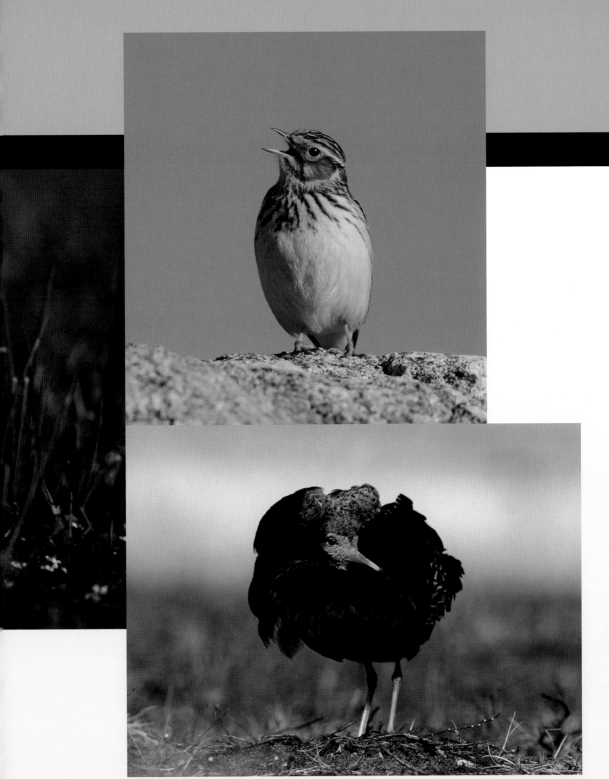

Africa and the Middle East Eilat, Israel; East Africa; Southern Africa Eilat, Israel; East Africa; Southern Africa Eilat; Israel
Southern Africa; Eilat, Israel; East Africa; Southern Africa Eilat, Israel; East Africa; Southern Africa; Eilat, Israel; East Africa; S

Eilat, Israel; East Africa; Southern Africa; Eilat, Israel; East Africa; Southern Africa; Eilat, Israel; East Africa; Southern Africa; E
Africa, Southern Africa; Eilat, Israel; East Africa; Southern Africa; Eilat, Israel; East Africa; Southern Africa; Eilat, Israel; East F

Africa and the Middle East

Variety, abundance and approachability all describe this region's birdlife. Add to the birds the amazing variety of mammals and often a quality of light like no other, and it is little wonder that it is perhaps the most popular destination for wildlife photographers on earth.

Away from the region's trouble spots people are friendly and there are well established parks with comfortable lodges. Just about every country on the African continent, boasts an impressive bird list. There are some sites that stand above others for either the spectacle they have to offer, or variety of species in such a small area. Take the vast flocks of flamingos that inhabit the Rift Valley Lakes of East Africa. I once witnessed an estimated half a million flamingos in the air at once, at Kenya's Lake Nakuru, an image that will live with me forever.

Offshore lie the idyllic Seychelles, said to possess the most perfect beaches in the world, the islands boast a variety of very photogenic species. From the Seychelles Magpie Robin, to large busy tern colonies, there is much to lure the bird photographer.

uthern Africa; Eilat, Israel; East Africa; Southern Africa; Eilat, Israel; East Africa; Southern Africa; Eilat, Israel; East Africa; Eilat, Israel; East Africa; Southern Africa; Eilat, Israel; East Africa; Southern Africa; Eilat, Israel; East Africa; Southern Africa;

Africa; Southern Africa; Eilat, Israel; East Africa; Southern Africa; Eilat, Israel; East Africa; Southern Africa; Eilat, Israel; East Africa; Eilat, Israel; East Africa; Southern Africa; Eilat, Israel; East Africa; Southern Africa; Eilat, Israel; East Africa; Southern

Eilat, Israel

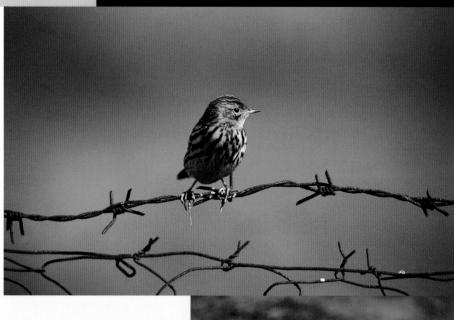

Eilat is a holiday resort at the head of the Gulf of Aqaba, an arm of the Red Sea. A wide variety of habitats in a small area, coupled with the area being on a main migration flyway, make the town a popular venue for birders, and for photographers too. Eilat is witness to a huge movement of birds of prey each spring, however they are often impossible to photograph due to their height. The big attraction are the landbird migrants, a variety of warblers, chats, pipits, shrikes and buntings along with waterbirds, notably waders.

Further attractions are the resident desert species such as Lichenstein's Sandgrouse, various species of desert-residing larks, White-crowned Wheatear and Scrub Warbler to name but a few. All are potential photographic targets. While a hide is useful for many situations, drinking pools work well in the dry regions. It is possible to photograph a good range of species from a car and by stalking.

Cheap package deals can be found for Eilat, and there is plentiful accommodation. Peak spring migration is from mid March to early April, and this is the most popular time to visit.

Top and above **Citrine Wagtail and Red-throated Pipit both migrate through Israel. Both these birds were photographed by using a car as a mobile hide. In Israel where water is at a premium, the construction of a drinking pool will act like a magnet for migrants.**

(Both images) Nikon F5 with 500mm lens, 1/500sec at f/5.6, Fuji Sensia 100

When To Go
March to early April is best.

Travel / Accommodation
Places to stay are plentiful in Eilat.

Bird Photography

East Africa

My first ever long-haul trip was to Kenya. What a trip it was; my first elephants and lion, an amazing photographic encounter with a leopard. But what impressed me most was the sheer abundance of birds. I remember seeing around 150 species one morning with our guide. The sensory overload of so many new birds in a short space of time meant I could not really remember any of them!

There are more wildlife tours on offer to East Africa than to just about any other region in the world. With good and abundant lodge accommodation too, there is plenty of choice. Where you go will of course depend on the kind of experience and opportunity you are after. For big game and a reasonable selection of birds, Tanzania is a good choice. Not so popular as neighbouring Kenya, the jewel in the country's crown is the impressive Ngorongoro Crater. Abdim's Stork is one of the attractions here, along with a good selection of waterbirds. Tanzania is also home to the much televised Serengeti. This enormous plain is famous for its game.

Neighbouring Kenya has some well-known bird photography hotspots. At the top of the list for sheer spectacle are the Soda Lakes found along the Rift Valley. Most famous of all is Lake Nakuru. Lesser Flamingos with smaller numbers of Greater Flamingo can number close to a million at their peak. The flamingos do move about along the Rift Valley, preferring some lakes over others, so if this is one of your targets it is worth checking when planning a trip as to where they are favouring. This is due to lakes coming in and going out of condition, for feeding and breeding. Nakuru is ideal due to good accommodation close to the lake within the park, and there are plenty of other waterbirds to photograph. Lake Bogoria is an alternative to Nakuru for flamingos, with many regarding this as a more spectacular setting with high cliffs and numerous boiling springs.

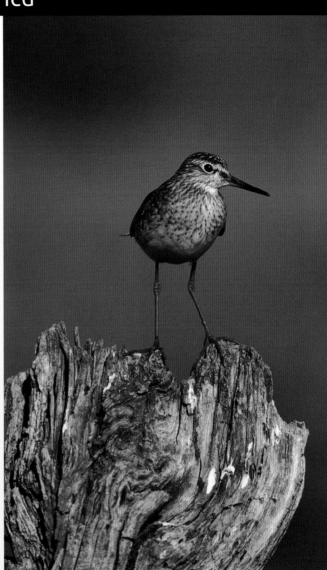

Above **Wood Sandpiper is one of hundreds of European species that winter in Africa.**

Nikon F5 with 300mm lens, 1/250sec at f/4, Fuji Velvia 50

Site Guide

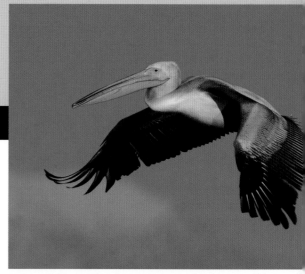

North of Bogoria is Lake Baringo, another birding hotspot that harbours photographic possibilities. Waterbirds around the lake, and landbirds in the lodge gardens, are popular subjects. The other major freshwater lake in Kenya known for its birds is Lake Naivasha. Only 50 miles (80km) from Nairobi, Naivasha offers some of the best bird photography in East Africa. From African Fish Eagles, herons, storks and ibises, to waders and landbirds in and around the lodges, there is much to occupy your time.

Other popular Kenyan destinations include the Masai Mara, Tsavo and Amboseli. All offer great bird photography, with the added attraction that they are some of the best big game parks in Africa.

East Africa and particularly Kenya does suffer from crime aimed at tourists. For this reason, you may decide you would feel more comfortable in a group. The good news is that there is a growing number of organised photographic safaris to Kenya. Joining a non-specialized tour, such as a birdwatching holiday or wildlife tour, is likely to prove highly frustrating. Many bird tour companies boast that their trips to East Africa are good for photography. They are likely to be reasonable, but what they cannot do is guarantee to give you enough time with a given subject to get good images. Inevitably the majority of the group will be wanting to move on once they have ticked off a species.

The alternative of doing it yourself is an attractive option. Some companies based in East Africa can arrange for a vehicle and a driver, and if there are two or more of you then this becomes a realistic option. Certainly in destinations such as this, it is nice to take away the added aggravation of having to drive and navigate yourself.

Above **White Pelicans are one of the attractions on offer in East Africa, particularly on some of the lakes in the Rift Valley. This immature suddenly appeared flying low towards me, so I quickly removed my camera from the tripod and panned my lens handheld as it flew by.**

Kodak DCS Pro 14n with 500mm lens, 1/1500 sec at f/8, ISO 160

Opposite **There are few greater spectacles in Africa than the flamingos found along the Rift Valley. This is Lake Nakuru with it's pink ribbon of flamingos**

Nikon FE2 with 135mm lens, Kodachrome 64

When To Go
All year although December weather may be worth avoiding. July and August can be busy, particularly in the Masai Mara, so advance booking is advisable.

Travel / Accommodation
There are numerous lodges in the parks.

Southern Africa

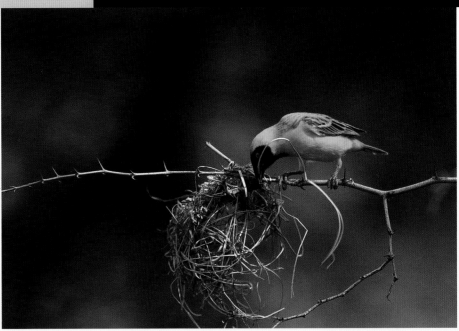

In contrast to East Africa, Southern Africa is a far easier region in which to organise your own trip, drive yourself and not have to bother with joining a group. In many countries the roads are good, there is plenty of accommodation and, away from a few well-known trouble spots, travel is safe. Both South Africa and Namibia offer good value for money, when comparing prices of lodges and tours made in East Africa. There are some great natural wonders from the Okavango in northern Botswana, one of the best wetlands of the world, to the Namib in Namibia, one of the world's great deserts.

Namibia, although with an impressive bird list, is not the easiest of African countries for bird photography. There are limited opportunities from a vehicle in parks such as Etosha, where bustards and a few species adapted to arid conditions are easy to photograph. Otherwise photography has to be worked at. The country does however offer excellent value for money, good quiet roads and a low level of crime.

Neighbouring South Africa offers some easier opportunities. In the Drakensberg mountains at the Giant's Castle, a hide at the 'vulture feeding station' gives possibilities for photographing both Lammergeier and Cape Vulture. Offshore from Cape Town, seabirds abound, and pelagic trips can give great chances with seabirds, while at nearby Lambert's Bay the Cape Gannet colony is worth a visit. Plentiful opportunities exist too in the popular national parks such as the Kalahari and Kruger; both offer good encounters with game too.

When To Go
Wet season is worth avoiding. Check for when this is in the area you plan to visit.

Travel / Accommodation
There is plentiful lodge accommodation in the parks, but advance booking is advisable.

Bird Photography

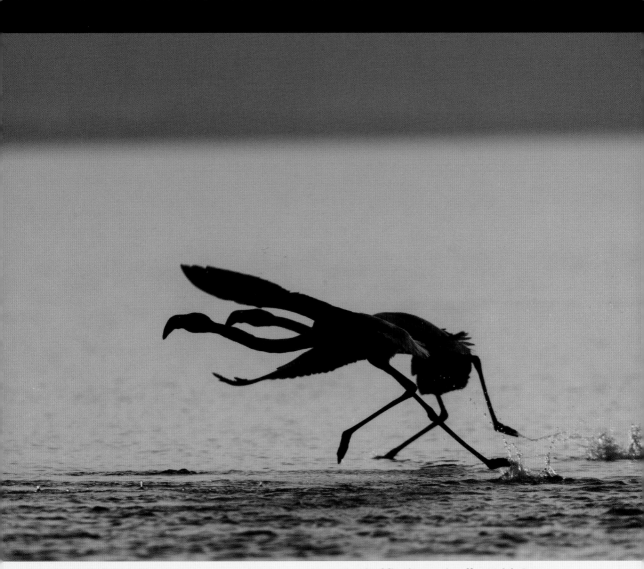

Opposite **Masked Weavers nest around many of the lodges in South Africa. This bird was photographed in Namibia, building it's nest just outside the room I was staying in.**

Nikon F5 with 500mm lens, 1/250sec at f/5.6, Fuji Velvia 100

Above **A pair of flamingos take off at Walvis Bay on Namibia's coast. I positioned myself upwind of the birds as they indicated they were about to fly and simply panned as they took off. The relatively slow take off allowed me to frame the birds so that they were running into space.**

Kodak DCS Pro 14n with 500mm lens and 1.4x teleconverter, 1/1000sec at f/5.6, ISO 160

Site Guide

Oman

Oman is the easternmost country on the Arabian peninsula and offers the bird photographer a mix of Palearctic, Oriental and African species. It is fast becoming popular with European photographers as an alternative to israel.

A visit between October and March is best, both for bearable temperatures and variety of birds. The country is well know for its raptors, notably eagles that are attracted to rubbish dumps and become easy targets for the lens. Greater Spotted and Steppe Eagles are most common. The most popular to visit is the Sunub rubbish dump outside Muscat.

The car is an excellent mobile hide in Oman, making it possible to photograph many species. Spring and autumn brings plenty of migrants particularly around areas of water, and there are desert species too including sandgrouse and species such as Hoopoe Lark.

If planning a trip an indispensible aid is the Bird watching Guide to Oman by Hanne and Jens Erikson.

Right **This Greater Spotted Eagle was photographed from a punt, by slowly drifting in close.**

Nikon F5 with 500mm lens and Fuji Velvia 50 film. F5.6 at 1/250sec

Bird Photography

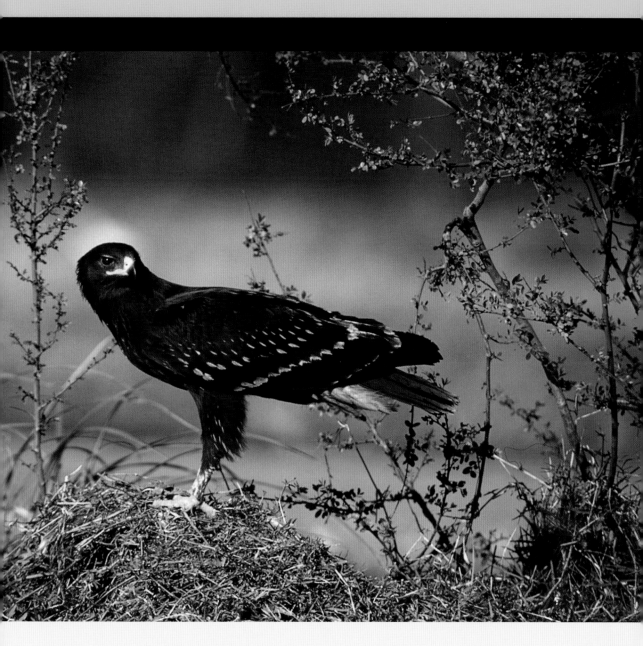

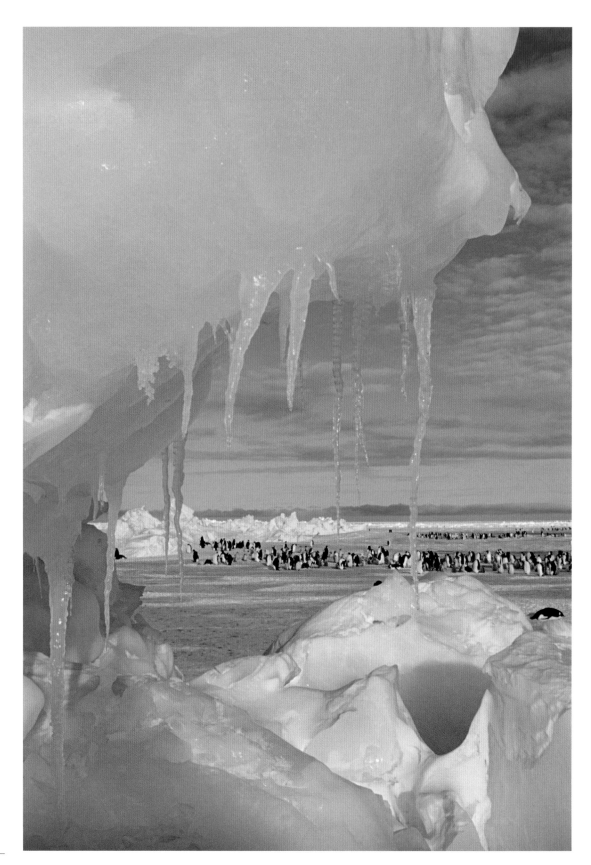

Acknowledgements

My thanks to Tim Loseby, Dave Kjaer and David Tomlinson for checking and commenting on an early draft of my manuscript. Many people have encouraged and helped me over the years. As a teenager Roy Coles steered me with both encouragement and provided numerous opportunities at a place that became a second home – Bough Beech Reservoir. David Tomlinson was also responsible for a great deal of encouragement during my formative years as a photographer, and latterly convinced me that a professional career was a very real possibility. Many more people have helped along the way, not least those who published my images in the early days. I am particularly indebted to David Cromack, editor of Bird Watching and Birds Illustrated magazines, who has been a big supporter of my images over the years, and whose backing helped to keep me going during the early days of my professional career.

I have been helped and have shared many adventures in the pursuit of bird images with Frederic Desmette, Roger Tidman and Jari Peltomaki, and I am indebted to my partner Jayne and young son James for putting up with the demands of a professional wildlife photographer. Finally I wish to thank Clare Miller at GMC for making the creation of this book such a painless exercise.

Dedication

To the memory of my father Alan Raymond Tipling who always encouraged me to walk my own path in life.

About the Author

David Tipling is a professional wildlife photographer who has a passion for birds. He has been photographing wildlife professionally for over ten years and has previously written five wildlife books and produced the photography for a further three.

His distinctive imagery has earned him many awards and his images have been used in thousands of publications worldwide: in advertisements, calendars, cards and on television.

David annually travels the globe in search of new and exciting images of wildlife, with his favourite destinations being in the far south and north, the colder the better! Birds Illustrated Magazine has described David as being in the advance guard of wildlife photographers in gaining acceptance of bird images as art. His pictures are enjoyed by collectors and wildlife enthusiasts worldwide; his limited edition pictures hang in galleries across Europe, Japan and the USA.

Books, greeting cards and prints of David's images are available to purchase, or just to browse, on his website: www.davidtipling.com

Opposite **Antarctica's stark beauty and tame birds make a heady mix for the bird photographer. This is a view of part of an Emperor Penguin colony in the Weddell Sea, viewed through a gap in a pressure ridge.**

Nikon F5 with 24mm lens, exposure details not recorded, Fuji Velvia 50

Index

Note: **emboldened** page numbers indicate main text entries; italicized page numbers indicate illustrations

Bird Photography

Index of Bird Photographs

Opposite **This close up of a male Long-tailed Duck's face was taken in a captive wildfowl collection. I wanted to bring some intimacy to the image so I gave it a tight crop to draw the viewer's gaze to the duck's eye.**

Kodak DCS Pro 14n with 500mm lens, 1/125 at f/8, ISO 200

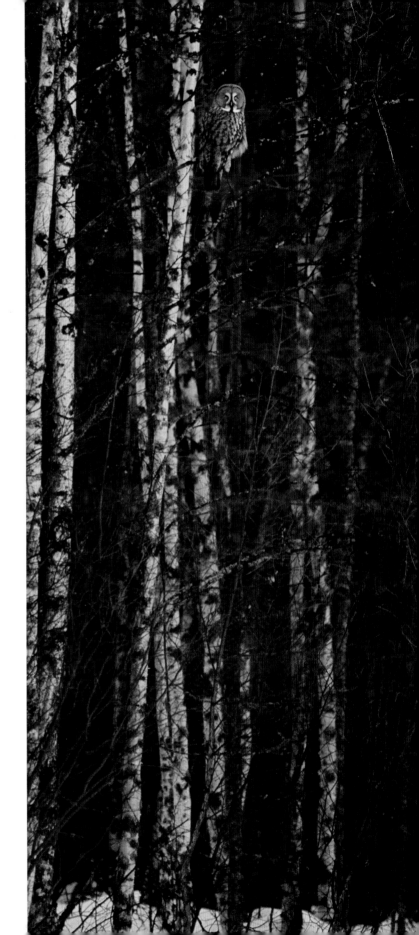

Right **Another of Europe's sought-after species, the magnificent Great Grey Owl. I used a panoramic camera in order to show the owl within its habitat.**

Hasselblad Xpan with 90mm lens, exposure details not recorded, Fuji Velvia 50

Opposite **The Great Bustard is just one of a multitude of once difficult to photograph species that are now more accessible to the photographer due to opportunities being provided by locals. Taken in Extremadura, Spain.**

Nikon F5 with 500mm lens, exposure details not recorded, Fuji Velvia 100